ONE
TON
GOLDFISH

ONE TON

GOLDFISH

IN SEARCH OF THE TANGIBLE DREAM

JUSTIN EMORY GARCIA

Le Rêveur

ISBN: 978-0-9961302-0-2 Paperback edition
ISBN: 978-0-9961302-1-9 Hardback color edition
ISBN: 978-0-9961302-2-6 ePub/ebook edition
ISBN: 978-0-9961302-3-3 Mobi/Kindle/ebook edition

Get the right digital edition for your favorite eReader: get the ePub for iPads and B&N Nook, and Mobi for Kindle and the Sony eReader.

Le Rêveur
LeReveurPublications.com

Cover fish photo by DollarPhotoClub © Svetoslav Radkov
Cover background by Justin Garcia
All images created by Justin Garcia

Book design by DesignForBooks.com

Printed in the United States of America.

I hope this finds you.

I know you are out there in the vast sea of humanity. I know you are asking the question. Gazing past countless boundaries, staring into the deepest abyss, searching for the tiniest glimmer of light in the limitless night sky. I know you yearn for more, daydreaming about purpose, reaching out to the unforeseeable frontier, waiting anxiously, eagerly, for whatever may come.

I know you, and I know someday this ripple will find you.

—OneTonGoldfish

CONTENTS

EDITOR'S PREFACE

There is no way to forecast creative synergy, no way of knowing whether each person's ideas will mesh or collide, or if opinions can be communicated without clashing too much or too often. All you can do is jump in, and see what happens.

In my first conversation with Justin—a two-hour phone call between Los Angeles and Houston—I quickly recognized what he was about. I had no idea if we'd be a good creative fit, but I knew I wanted to read his manuscript. After we spoke, I returned to my work on another project ... but I couldn't stop thinking about the unexpectedly remarkable conversation we'd had, replete with fresh ideas and noble objectives.

He was talking about creativity—the art that comes of it, and the science within it. He spoke about the "mechanics of creation," the methodology that he believes sustains humanity. He was speaking a language I love, with sincerity, humor, candor, and accountability.

I'd met a kindred spirit: an artist *with purpose.*

After I read Justin's story, I had a deeper understanding of his passion for the work. I wanted to help him craft the message, so others could have easy access to the source of his inspiration and claim it for themselves. A thoughtful, complex, evocative manuscript like his would require intensive work ... and I looked forward to digging in.

I must admit, there *was* another motivation: a delightfully irritating thought that this book has the potential to be an instrument of change. To be part of that movement would be an honor for me.

Everything I initially thought of Justin and his work after our first connection continued to be true for the several months we worked together on his manuscript. 98% of our exchanges were as positive and productive as one could hope. (The remaining 2%? Well, that's just a little proof that nothing in this world is perfect!)

What force conspired to connect an editor in California with a painter in Texas? At first glance, it seemed an inconvenient pairing—but we should never dismiss the powers of creativity when they call out to

be explored. We have only to be amenable to the possibilities. When we are open vessels, with a true desire to make a positive difference in the world, we are more likely to receive extraordinary gifts of wisdom and understanding.

It often comes in unexpected ways from unlikely sources. It appears in the middle of a crowded coffee house, in the midst of freeway traffic, after a random conversation with a stranger about nothing in particular, at the end of a dream. In a flash, or a snap, or a breeze, we receive a thought, completely unrelated to the moment, but inextricably connected to a higher purpose. And we would do well to pay attention.

We live in an era that gives us every opportunity, any device with which to create. Still, the true purpose behind the creation eludes.

Some are born to the breed. Others must escape their origins to seek and find their tribe. I am a member of the former, the daughter of a musician father and a poet mother. I grew up in New York City, surrounded by professional creators of all kinds, masters of their chosen craft whose lives were driven entirely by the creative process. I was one of them from my first lucky breath.

Justin, on the other hand, made his own luck. He had to drop almost everything he'd been given to receive everything he needed. And when he began to explore that experience, using his insatiable curiosity as his compass, he made exceptional discoveries along the way . . . about his work, about himself, and about the world.

Regardless of background or circumstance, we find each other when the time is right.

I'd seen much of Justin's collection online; though it's not the same as standing in front of an original painting, I could see his work was world-class. His *Focal Point Series* and *Creation Series* contain pieces I'd love to live with. His paintings are layered and nuanced, suggesting a thought or feeling, allowing the viewer to make his or her own evaluation, never forcing the idea, letting it take form within the individual's frame of reference, so they can tell their own story.

Like his visual art, Justin's writing is personal, heartfelt, uncompromising, practical, witty . . . and his intention is infused with the authentic passion of a true artist. This book contains subject matter for artists and connoisseurs, to be sure—but also for the spiritual and the scientific, the lay person and the scholar. He bridges those seemingly disparate

worlds with an intimate comprehension of the creative process, accessing each angle and connecting each point in a manner I've yet to see in other analyses. I envision it on bookshelves around the world, in high schools and universities, for sale in museums and music shops, finding its way into the home of anyone who longs to create, and is looking for practical inspiration.

Regardless of where we are on our journey, we're all eager to be inspired.

Two people occasionally joined us in our process . . . both of them formidable, accomplished women (I believe Justin's appreciation of strong women speaks highly of his character!). They fortified our efforts with unwavering encouragement and valuable insight.

Kim Jessup appears throughout this book, and provided a clear, straightforward perspective, especially when a particularly sensitive piece of the puzzle was missing. As she is in Justin's life, Kim was the critical counterweight in this undertaking; you'll understand her immeasurable importance the moment you "meet" her.

Whenever I work on a piece of writing—mine, or that of another author—I often consult with my mother, Evelyn Barnes. I'll read sections of the work to her, and we'll bounce a few ideas between us. Our brainstorming invariably reaps a reward. In the case of this book, her contributions go beyond language; she came up with the idea of giving the reader an entire page, completely unmarked on both sides. A place to sketch, to make notes, to respond to the previous chapter with their own drawings and thoughts. "It becomes their book, too," she said. She called them "palette pages"—and Justin embraced her suggestion without hesitation. That term instantly became part of our lexicon.

One Ton Goldfish: In Search of the Tangible Dream is a whimsically intriguing title, perfect for the irresistible expedition of discovery on which Justin takes us. Even if I hadn't worked on it, I'd love this book, infused as it is with Justin's creative passion and scientific vision. They belong together. They explain each other. When combined, they make sense of this preposterous life in a way that allows me to identify and pursue my passion with a vibrant understanding of its source.

I trust this book will do at least as much for you.

—Alexandra Barnes Leh
Los Angeles, California

INTRODUCTION

IN THE END, THERE IS THE BEGINNING

It's 7 A.M. I'm sitting in a coffee shop, waiting . . . waiting for something I can't explain. But I feel it, as if it has been expecting me for a long time.

It is curiosity that led me here, and I wait to discover the motive . . . sitting alone, staring out the window as the sun slowly rises, awakening the street.

I look down at the cappuccino I ordered, the quaint milk design swirling in my cup. "Please stay," it says.

The more I let go, the more easily I take in my surroundings. The quiet conversation between customers and employees creates a slow, soothing pace, accented by the obligatory hissing of the espresso machine. Alpha-wave music cascades from the speakers hidden in the wooden rafters. The Doppler effect of passing cars stimulates the superior colliculus. The aging walls, soft with stories that steadily grow in the sunlight, windowpanes still steamy, the temperature cool enough to wear jeans and a jacket, but warm enough for sandals. The refreshing chill in the air and the aroma of coffee beans begin to stimulate my senses. I pick up my cappuccino again, feeling the heat through the cup. With the first timid sip, a tingle of bliss reaches every hair on my limbs, down my back, up my neck, finally settling into my eyes, unwinding my gaze. I am relaxed and alert, a *Mushin* state I have heard about from martial artists, mind without mind. I have focus and clarity of thought, yet no apprehension about today, tomorrow or even tomorrow's morrows.

Intuition clicks in, movements become unblocked from the hindrance of overthinking. The natural state of being takes over. I know this state; but it's different this time. This time, I am not looking at a blank canvas with a brush in hand, but a pencil hovering over blank yellow pages, moved by the intention of putting thoughts to paper. I've never had this desire, not to this extent. An avalanche of thoughts suddenly pours out onto each line, leaving no air for the note pad to catch its breath.

All these theories and ideas I had been recycling in my mind, afraid I would forget, are now free. Nothing around me pierces the bubble, only reverberating sound waves that unlock a clear vision, stretching my thought process wide enough to configure large chunks of an enigma from my subconscious through the motor neurons controlling my hand.

I write, sketch, contemplate, analyze, theorize, then write and sketch more, over and over. Hours melt away, no breakfast, no lunch, no breathing . . . I am tapped in and do not want to think about tapping out. What if this moment is the *only* moment? I have to respect not knowing the answer and stay in.

Eleven hours pass, pencils now mere nubs of graphite. My thoughts become slower, sparks unable to connect them. Pieces of memories once lit now fade like stars in sunrise. My body is depleted of fuel; it's time to shut down. I feel alive . . . yet, hovering in the back of my mind is the fear that this will be the first and last time I'll have unlimited access to my thoughts, the last time they'll stream in and out with ease. I have so much more.

I sleep hard, wake up early, and slowly move about, trying not to overthink the importance of Round Two. I calmly drive to the coffee shop, sit in the same seat, order the same cappuccino, arrange my papers in the same spot, free my mind, then begin the process of re-experiencing my reality. I find it again. Now that I know where to look, I always find it.

This is the beginning.

LAYER 0

Prefix Relativity

A gasp of air. Eyes pop open, ears pinch back. Arms and legs, paralyzed. Heart pounds. Where am I? A chill creeps up my spine, and I know: I am safe in my home, in my bed, in the middle of the night. My eyes flutter and shut, alpha waves buzzing in my brain. I'm afloat in the space between . . . awake, yet not alert; asleep, yet not dreaming. A voice mumbles in the distance, I hear what it says, I feel an emotion underneath the unintelligible words, I see fragments of images from a dormant dream.

Reaching into the dark, I grab my sketchpad, grab a pencil, scribble like a child until the charcoal runs out, or the surge of the madman ends. I cannot see what I create; I can only feel.

This has happened before. But this time, I do not dance with elongated curves, I do not conduct a mellow symphony of poetic gestures. I am cold, frantic, angry, frozen with fear. I ignore the boundaries of the page with quick, sharp edges and even sharper angles.

The buzz softens to a hum . . . my hand stops sketching, the pad slips to the floor. In the morning, when I am fully awake, I will see this sketch, but I will not recognize its creator. And I will be curious to meet him.

LOST YEARS

By the time I was 21, I had never worked more than two years at any one job. I like to believe it was just coincidence but, deep down, I knew better. I wasn't incompetent; I was just bored. My eyes that had eagerly darted about, excited by the new atmosphere, became dull with the day-to-day routine. Once I conquered the ins and outs, and the numbness of repetition found me, it was only a matter of time before I made the inevitable move. It was never a *big* change; most of my jobs focused on bartending, a job that didn't require a resume, just a simple referral. It was unlikely that my time at a bar—or worse, a club—would last for more than two years. I took any job that offered minimal responsibility and fast cash. I was a hamster on a treadmill.

I lived a piecemeal life, traveling aimlessly down random roads, wandering off, wandering back, with the hope of finding myself somewhere along the way. Figuring out the definite could-not's and would-not's that might help light my path. I had no real guidance or direction, no skills—at least none I was aware of.

You could say my odds of becoming lost (or found) hinged on the same likelihood that a person stranded on the ocean will make it home, completely dependent on the uncontrollable tides. I took comfort in thinking mine was a search in which many people find themselves.

I was one of the Lost Boys, tortured by this search, striving for definition, yet scared to death of commitment. I was afraid of prematurely defining the man in the mirror, to later find the reflection was not mine—at least, not one that I liked. I was afraid of ultimately resenting my path and the years of development, unable to turn back time. I found that such thoughts cause paralysis in one's life, like a deer in the headlights: frozen, never moving forward or backward. A stasis that prompted me to wish for a return to the innocence of my childhood.

FOUNDATION PROBLEMS

I had seen devotion and commitment early in my life, from that of a high school colleague. Jim Wilson was a swimmer in high school; the best on our team and one of the best in the state. However, he was not a born swimmer with natural talent, that was *my* department. When I was breaking records at six years old, Jim was first learning how to swim. He stood just short of six feet tall, and was a year older than I. By the time he reached high school, his name was known in the district as someone to watch in the swimming world. When I became a freshman, just joining the swim team, Jim was already a sophomore star. Up to this point, I had lived on raw talent, enjoying a life outside of swimming. But Jim had that special internal drive to swim twenty-four hours a day, seven days a week, 365 days a year. By the time he hit high school, he had become an animal, a machine, far surpassing my original experiences of him. Dedicated to the cause, he was so focused on his goal, he had lost touch with the life of the everyday teenager. Jim was awkward and quirky; but for those of us who knew him, he was just a funny guy. We were in awe of him, and envied his deep conviction, as we saw how the results were paying off. With every race, his times just seemed to melt away. This required a schedule of swimming two hours before school and up to three hours after, with club teams year'round. I did not have it in me. Even though I would proclaim a fresh start every year, and try to find some focus and motivation, I never truly committed. My times did improve on a small scale, but the status of my swimming career beyond high school was nonexistent. My declining interest took me to an all-too-familiar burnout stage. But my colleague Jim remained relentless. I got it. I equated it to the focus of an avid gambler, addicted by this point. He had already bet the farm, so he might as well go all in and bet the house too. There was no sense in turning back.

By the time he was a senior, Jim's sights (and ours) were set on the state championships. Everything he'd done, everything he knew, would culminate in this moment. He had been coasting along, and unlike most of the other swimmers, had decided not to shave the hair off his body at the prior divisional meet to secure a spot in one of the coveted eight lanes. He was seeded second in the 100-meter butterfly, and he had an edge: his position was a prime middle lane, out of the washing machine flanks. He

did his pre-race warm up, double, then triple-checked his gear, performed his routine and superstitious stretching: three windmills right arm, three windmills left arm, three windmills both arms, clockwise left arm, counter clockwise right arm, then three windmills reversed arms. Wearing his parka to keep muscles warm, perfect condition, minimal social interaction, quiet and reserved, isolated in his nook, alone and reflecting on his years of dedication and servitude as he waited his turn. You couldn't ask for a better situation, or a person who deserved this more.

The moment arrives. Jim's up on the block, one of eight swimmers shaking their arms and legs, keeping their muscles loose right up to the very last second. Now, the weight of the air thickens. Noise tapers off into silence. The amplified voice of the starter is sharp and demanding, shooting chills into the thick tension. The swimmers wind into position, grasping the platform. Time stands still. Your heart skips a beat. The horn sounds. Simultaneously, the swimmers launch off their blocks. Jim's arched approach gives him a smooth slingshot effect as he breaks into the water, riding his propulsion downstream, angling ever so slightly back up to the surface where he begins his rhythm. Not flying out of the water too high as to waste forward momentum, going upwards, yet not so low, exerting extra energy from having to muscle through the water. Skimming right over the surface, flowing in and out, stretching each stroke from the pull to the throw of the arms, maximizing the distance. He's swimming only a few inches behind the two swimmers on either side. Cruising at full speed, but without stress in his movement. Rhythmic breathing hasn't started yet, indicating he has plenty of oxygen. A good sign. He's feeling comfortable now, coming into the wall. Hits. Rotates his legs in. Glancing down the lanes, checking his status. Takes note of the dark horse on the outside lane who's staying ahead of the wave created by the movement from the middle of the pool to the sides. Jim's got three swimmers to compete with heading into the third lap. His push off the wall weaker then the last, but still in good position to take over the race. Now coming into the third turn, hits the last wall of his life, doesn't check status; no point, no time. The last twenty-five yards left, the glide under water short, his breathing hits full rhythmic stride, stroke, breathe, stroke, stroke, breathe, stroke, breathe. People screaming and motioning p-u-l-l, p-u-l-l, in sync with their swimmer. His body stressing, now

muscling through, no longer stretching the distance, giving rest in between strokes. He's halfway home yet not gaining ground, still neck and neck with the dark horse, Jim's left and right lanes still slightly ahead. It's not looking good, but there's still a chance. It's gonna come down to the touch, he can still finish with a perfect full stroke while the others may need to pull another half stroke to finish, beating them into the final lunge. There in the impact, water hits the wall, splashing up white, creating a mass of confusion about who hit the wall sensor first. The thick air evaporates, everyone instantly stops screaming, jumping and flailing arms, staring up at the time board as times and places start matching up with the lanes. It takes a second to understand what it's saying, there's just so much to take in, who is where and what's what. But down in the water, realization hits the winner. He turns, stares back towards the pool, looks over to his cheering team, punches the air with both fists, grasping victory. Silence falls over our camp. My hero is not the winner. He keeps looking at the wall, running through the race in his mind, with only enough presence to congratulate the winner and the others. This invincible man whom I had never seen lose a race did not even retain his current position or time. This time, he choked.

I was distraught. I felt horrible and confused. I was mad at Jim for not doing more, I was mad at him for making me feel horrible. I didn't realize how emotionally invested in his race I was until he lost. He should be more tired, he should have won. *I deserved to see him win.* I wanted it for him and for me, for doing what I couldn't discipline myself to do. I wanted to regret wasting my talent, but I couldn't.

These feelings would cut even deeper in the moment that came after, more memorable than his swimming; a moment I wasn't ready for. When Jim got back to the team area, he wasn't mad, nor was he sobbing—not even a tear. He was speechless. He looked lost. His eyes were hollow and empty. It was the same look I saw years later on the face of a heroin addict. Like a man living in a coma, Jim awoke to realize this dream was not real.

I should have seen it coming; these thoughts were written all over his face. He finally found his voice to say, " All this . . . my life wasted for this." He was looking for something, yet found nothing tangible to hold onto, nothing that would ease his mind. Now, it was apparent that his whole cause had betrayed him, his unwavering, devoted servitude, all the things

he'd given up, just to have his foundation crumble as he stood helplessly, watching it sink under the water. In Jim's eyes, it was much more than a race . . . and I was scared, because I didn't want to be right about that.

Jim survived this moment and moved on. But that look in his eyes, the words spoken and unspoken, haunted me for some time. It was a stain that would never fade from my memory. Here was a man so certain in his definition, blindsided by mere tenths of a second, a breath of time that stole everything he'd worked for. I never wanted to feel that look in his eyes.

I have since learned, of course, that this kind of moment happens all too often in life, coming in many unsuspected and uncontrollable ways. Most are tragic; and when they are too close for comfort, we are unable to distance ourselves from our fears. We desperately grab hold of our own foundations, summoning the supports that define us—calling our loved ones, realizing our job isn't all that bad, making changes to better our lives—as we look upon the things we took for granted, assessing the relative importance of it all.

Although there have been many contributions to the fear of commitment that define me, I do place a great deal of importance on this specific moment. Unfortunately, it gave me a reason to justify my early choices. Whenever I'd become complacent, too comfortable in my surroundings, I would simply change venues, never allowing roots to reach too deep. I was always willing to learn and grow, but could never fully commit to who I truly wanted to be; a behavioral pattern I found fitting for the time, since it brought a pre-storm calm. I had just enough understanding to know that this way of life could not continue forever.

STATUS OF THE SITUATION

Reality has a way of revealing the ugly side of life, slapping you in the face when you least expect it. Just when you think you've reached the bottom, it takes you one step further, to the uglier side of ugly. When you realize that your worst has an even ghastlier brother, it really puts the possible unknowns in perspective. The irony of Door Number Two.

I developed an on-again, off-again relationship with college. As much as I felt it was normal to vacillate this way, I never quite found the enthusiasm I needed to go to college. Besides, it cost money, which meant

I'd be working when I wasn't studying. The real truth is, I had ambition—blind ambition, perhaps, but ambition nonetheless—and college didn't fit my goals. I had so many ideas running around in my mind, it was hard for me to sit still. I found it easy to put off college and try my hand at an assortment of business endeavors—from selling cheesy cellphone accessories, to pyramid schemes, to weekend catering gigs.

I'd saved up a lot of money (or at least I thought it was a lot of money) and, instead of putting it away for school, a friend and I started a T-shirt company. A year later, after a few flushes down the toilet, I was out of money and had to shut down operations. The only thing I learned from that experience was how to do everything wrong—and the realization that you will always go over your estimated budget, it's just a matter of how much. Had I stayed in school instead of blindly starting a company, my next courses would have been about finance, statistics, and entrepreneurship.

This revelation came at the same time the cash cows that had been bankrolling my endeavors ran dry. One was a weekend bartending gig in a downtown club, from which I'd soon be fired. The other was a "secure" bartending job at a well-known restaurant that would "secretly" close in a month. The most entertaining part about this gig was not when or why they were going to close, but how.

In early December, a clandestine meeting of managers, GMs, and heads of catering from both locations was called by the restaurant owner—who had gambled, womanized and snorted his restaurant's profits dry. In his delusional state, fearing for his life, and carrying a gun, he decided it was a good idea to keep things open until January 1, and try to reap as much money from holiday events as possible. As for the closing notice, he planned to simply put a sign on the door on New Year's Day—this is how he thought his employees should discover they no longer had a job. His "secret" plan did not stay secret for very long. Only minutes after the meeting, the word spread. And everyone's loyalty and ethics went right out the door, along with half the supplies and goods.

Employees started to drop out slowly, leaving everyone else to step in and fill the void. At some point, the GM simply disappeared. It was then I learned how to cook (not very well), upgrading my rank. Along the Green Mile of that December, when people stopped showing up for work and food deliveries simply never came, we would buy food to

prepare for our customers at the grocery store in the nearby strip mall. Until then, I didn't know you could pass off frozen crawfish tails as the lobster in lobster bisque.

Surprisingly enough, I stayed to the end. I didn't know what else to do other than live the day-to-day challenge of keeping a sinking ship afloat. It had become a kind of game. Each day was like reporting for duty in a war, facing certain death, and looking to see who would stand by you till the end. It was the only real excitement I had while working there. Sure enough, on January 1, the sign was on the door.

Before the restaurant closed, my normal routine consisted of working all day at the restaurant, then driving downtown to tend bar at the club all night. Now, with perfect timing, I was canned at the club, too—only because I'd honestly reported the full amount of tips I had earned, against the advice of veteran bartenders. They'd warned me of the club owner's paranoid, narcissistic personality. They encouraged me to stay off his radar by undercounting my tips. If *he* was screwing over everyone and everything, one could only assume that he thought everyone else was doing the same to *him*. Apparently, a night of good tips far exceeded the whim of his acceptable "tips to revenue" ratio, and had (in his neurotic mind) become clear evidence of stealing.

MOBILITY

My vehicle situation was another challenging issue. When your radiator breaks in Houston, and you find yourself in bumper-to-bumper traffic that ultimately results in your engine overheating, some part of your engine will crack—that is, if your bad luck is running per usual! Let's just say that the cost to repair the engine exceeded the cost of the car, leaving me with one option: a recently retired minivan/utility vehicle conversion that belonged to my mother and stepfather, a skilled contractor duo. This vintage van had been rode hard (but delicately), and had extensive experience hauling useful materials of heavy weight from Houston to Georgia. It was littered with plaster, sprinkled with saw dust, decorated with a smorgasbord of natural wood stains, built-in paint samples—and multiple screw-like objects for roadside MacGyveresque repairs.

Minivan for sale

A convenient, aerodynamic, ¾-inch foam insulation board, securely fastened with NASA-approved duct tape over an outdated, oversized side window, cuts down on weight for maximum pick-up. Spacious, with two race-car bucket seats, styled with a hardened cupcake-crusted top layer for maximum unique comfort. Mounted on the redesigned dashboard is a deluxe, hands-free, two-in-one fan and mister. Portable capabilities, water not included. State-of-the-art, economically savvy engineering, allowing multiple options of only five out of six cylinders to be used at any one time. Hitting 50 MPH in four minutes with a ten-second window before overheating never felt so good!

It was, though, way better than walking.

5-YEAR PLAN?

I stood in the middle of my world without a safety net. No likelihood of an inheritance, no savings account, no health insurance, no 401k and no C3PO. All of which had little or no significance to me, as I had never become accustomed to, nor had I had the pleasure of experiencing, like that, anyway. In my present situation, it would have been nothing more than a speed bump. Ignorance truly is bliss.

Perhaps you can guess that I was not quality dating material, on paper *or* in person. Even if I could charm a woman past the paperwork and maneuver her past my van, I would seriously begin to doubt her judgment. It looked like my 5-year forecast only covered 5 days.

INTERVENTION

The one ingredient I was missing in my downward spiral was an addiction—unless you consider my constant intake of sunflower seeds

and caffeine. Sure, I occasionally drank too much, but it seemed like an awful lot of work to become an actual alcoholic. I could maintain an extreme sleeping regimen well beyond the suggested hours, but the perpetual imbibing of alcohol felt like too heavy a schedule to maintain. I was never a good drunk; hangovers killed my energy and lightened my wallet. Besides, alcohol did not turn me—normally a shy and quiet guy—into a ladies' man, but a loud and sarcastic fool.

I once had the dubious honor of helping a friend's son who had a drug problem. The kid was fresh out of rehab, living in a halfway house, and I got him a job at the restaurant. I thought I was doing him a favor—but I was naïve to the accessibility and sheer amount of drugs moving in and out of such an establishment. It only took a few weeks for someone with his savvy to tap into the system. After the place closed, he disappeared. In a few months, I received a desperate phone call from him for help; he needed food and a ride. Of course, I responded. The man I met was 90 pounds lighter, grey-faced, sunken cheeks, erratic movements; a sad, unrecognizable stranger. I looked into his hollow eyes and flashed on my swimmer friend, Jim, in whom I'd seen a similar desperation, abandoned by hope. I thought I had *my* hands full trying to dig out of what I considered to be a deep hole ... but I didn't realize how deep a hole could go. Whatever curiosity I may have had about drugs quickly disappeared after spending only three hours with him that day.

In retrospect, this must have been reality guiding me into The Deep Trench of Ugly. Yet, I was about to meet its uglier brother.

INDIFFERENCE OF SELF-WORTH

After a few months without cash flow, I began to see the top of the deeper bottom—and fell in. My predicament and lack of self-identity prompted me to crawl back to bartending for the downtown club owner. Back to a person who, just like the restaurant owner, engaged in lying, cheating and stealing. I suppose it was nothing more than a game to them. Men who had no moral boundaries, ethics or loyalties ... at least, none that I had ever witnessed.

You would think the club owner would not have rehired me, but he hardly remembered me. He'd probably rotated through the entire

population of Houston bartenders before I returned. Surprisingly enough, he was relieved to see me, as he desperately needed people to run his newly-acquired midtown club. I was his newfound buddy.

I knew better, though; it would only be a matter of time before I went from "buddy" to "thief." Again.

That spring and the following summer were the hardest moral and ethical periods of my life. Among other transgressions, I was ordered to serve low-quality alcohol at high prices and watched as he tried to skim off any money he owed.

Deep down, I was a good person. But I was exhausted from the weekend-to-weekend grind and became indifferent to it all. There was always something wrong according to the club owner, and he inevitably accused the bartenders (especially me) of lying, stealing, or moving too slow, because we (I) must be trying to figure out how to steal something, too. I was constantly defending my name and protecting the money I earned. He always wanted some of it back because he felt cheated, or had a bad night—any excuse to justify giving him our (my) tip money.

Somehow, my fellow bartenders and I never got fired, and we would not quit—although we often came close. I knew this choice only justified and encouraged the status quo.

Near the end of my tour, I was made aware of a tactic that the club owner devised for any woman who would turn their attention towards me and away from him. He posted himself at the corner end of the bar next to my station, and whenever women paid more attention to me than to him, he would tell them I wasn't interested in women, implying that I was gay. He compounded that lie with another one: I was a drug addict.

Honestly, I didn't care. I suppose it was plausible to the casual observer that I might be addicted to drugs, given my appearance and my behavior. My eyes were sunken and I was underweight from my depressed state. I was numb and had little energy or motivation to entertain women, friends or anyone else. My resentment for all guests grew equally. I hated their demands as they screamed them at me. I just smiled and pretended I could hear them over the music. I was never happy to see my friends come in. I didn't want them to be engulfed in my resentment. But at this point, I didn't have many friends left. When I was at work, all I ever wanted to do was go home and sleep. My existence in my dreams was a much better place to be.

The owner's attempts to woo women were pathetic, but no more pathetic than the state I was in. I had no fight left.

It was a sadly familiar situation: a horrible boss, coupled with the beating I took in the conflict between my morals, dignity, self-worth, and the paycheck I desperately needed. We all know rats must be fed when they (we) choose to run that race.

The feeling you get when wallowing in a state of indifference, even though you know you're better than that, cannot be adequately explained. Unless you've experienced it, it seems impossibly foolish. I assure you, if you think hard enough, you can imagine having been in such a state at least once in your life. And you realize that, if you're not careful, it will slowly eat away at your soul.

I knew it was eating away at mine.

SUMMATION OF SELF-WORTH

When I was a teenager, I made a promise to myself that I would be a millionaire within ten years. That would be the benchmark by which I measured my success. When I made that promise to myself, I was *so sure* of it, that I *felt* it to be true.

Now, I reflected on the past few years: I'd put my education on hold, I'd risked what little I had by impatiently, stubbornly carving out my own path—and it had led me to the bottom of a deep pit. But in my contemplation, I discovered something: even with my driving ambition, I couldn't help feeling that I would have been better off doing nothing, instead of pursuing the dream of blind youth. I had learned many things in the process, but I saw nothing useful to show for it—at least, not at the time.

Now, every step I took was filled with doubt instead of ambition. Doubt is a scary thing. Even a small seed of doubt can take you as deep into the hole as you will allow. I began considering external things in which I could place my faith, like the lottery—pinning my future on impossible odds, blaming anything or anyone other than myself for the reason I'd been dealt an unfair hand, the reason for an empty life full of self pity.

This reasoning is simple: it's about deniability. When the odds are placed so far out of reach, even by your own doing, it makes it easier

to live with your low self-worth. A place without mirrors is a place of indifference.

INSTITUTIONAL LESSON

I was not sure how much longer I could last before I completely lost myself. I reached the point at which the prospect of going back to college seemed like a better choice. I needed out—but that left me with few options. I did not have enough money for classes. Signing up for more courses meant taking out a loan, and I was reluctant to put myself in that tight a financial bind. But I saw no alternative: I had to put my life in the hands of a student loan that would take full advantage of me in every possible way. It occurred to me that the smell of blood and desperation must ooze out of every pore when someone is willing to take out a school loan. It felt like I was taking out a contract on my own life. I could have made a better deal with the Mafia; I'd be offed quickly, and by a human. Instead, I opted for a lifetime of debt, and most likely bad credit (a slow death by numbers) before my life even began. Nevertheless, I succumbed to the belief that a diploma from an institution would get me what I wanted out of life. If not, then I could blame my unsuccessful and debt-riddled choices on someone else.

I managed to secure a loan for a semester that turned out to be my last. I had learned my most valuable lesson, climbing above the clouds to get a clearer perspective. My clarity came in that one semester, from an entrepreneurship teacher who divulged his own personal climb, each step providing a new lesson each week. His class was an exercise in contradiction: here was a teacher promoting the very institution that had, at one time, kicked him out! His counselor had advised him he might want to try a trade school, possibly become a mechanic. On his own and lost, he hit many speed bumps on his path . . . and ended up successful and wealthy, creating his own empire. He later decided to become a part-time teacher, to share his knowledge with those walking in his old shoes. He hoped to help steer young entrepreneurs clear of the challenges he knew would arise on their journey.

Ironically, his personal story was not reflective of the brand he represented: institutional education. He was a smart man, and he knew

it. He prepped his classes with the comforting knowledge that he would reveal the method to his madness at the end of the semester. He had quite a flair for the dramatic—his course was programmed like a soap opera, and my fellow classmates and I didn't have the luxury of a DVR. We would have to endure the commercials and obligatory product placement . . . but he promised us a satisfying conclusion.

And he kept his word. The successful, self-made entrepreneur who was not good enough for this school, gave us the gift he'd earned. "It's better to learn the mistakes here on paper than out there in real life. Bouncing back is much easier in here than out there. It costs less in time and money, compared to what you would spend in the world. Out there, one wrong turn can end a career, and can set you back for the rest of your life."

I agreed with his logic, after coming out of a failed endeavor financially and mentally devastated—though my brief bout with business was small potatoes compared to his. His conclusion contained clear, sound reasoning that seemed to please the masses. However, something still didn't feel right to me. The mistakes I learned did not compute on paper. Emotional failure + dependence on others to do their part + investing real money and never knowing if it will come back + studying competitors and market trends + rumor mill/hype + its inflated value—then obsessively plugging into all the facets—did not add up to what I experienced in class.

Real-world experience, especially all the mistakes, can be severe—but a process-on-paper will never grant you the raw physical and mental emotion of real-world lessons. They are only simulations. In the back of your mind, you know the consequences are essentially benign: after all your prep time, your Adderall-induced study sessions, and carefully doing things by the book, you'll merely receive a letter grade and, if you fail, you can try again. The rush is simply not the same as gambling all you have, learning and adapting on the fly, running naked and blindfolded through a minefield, hoping the route you take gets you to the other side and, more important, to the place you were aiming for. More often than not, fear distracts you, and you step squarely on a land mine.

In my observation, there are three types of people. The first jumps out of the plane without training, learning when and how to open the chute as they fall. The second learns these steps before they leap—and decides they'll have a higher chance of survival if they stay in the plane.

The results are the same: everyone ends up on the ground and back at the hanger. Sure, there might be a few casualties on both sides—even if Type Two doesn't jump, the plane could crash!—because nothing about skydiving has zero percent risk.

But my favorite type of person is the third type: the person who is patient and takes the time to learn before getting airborne, and is still willing to jump out of the plane. To me, *that's* a dangerously talented person. Unfortunately, I was *not* Type Three.

My professor's message was powerful, full of reason and logic. A perspective of choices in directions once seen as a blurred mess, now exposed a clear fork in the road. I identified myself as a dreamer, always thinking beyond the scope of the piece of paper called a degree. I was always doing things the hard way; I was motivated to overcome the challenge, regardless of the monetary reward. I realized that I only thrive when physically and mentally tested in the real world.

I was only moved by being raw and completely pure—and I was now certain of two things: there was nothing wrong with me or the way I thought. And I was not alone. Now, I could feel a sense of resolve. Now, I could stop explaining myself to friends in a feeble manner, meekly seeking approval. Now, I didn't have to make excuses for my aims and my failures in excruciating detail.

Retrospect is peculiar. You want people to like and agree with your ideas, but the true test comes when you are faced with the exact opposite, and persevere with a vision others can't see. The latter seems to drive people further. If you are willing to keep going, even though there are so many obstacles, you must really believe in it. You're driven to see it through to the end, for better or worse. A lifelong lingering "What if?" is a much worse outcome.

Even with that realization, I might not have known the path I would take. But I knew what worked for me, and I knew my general direction. The echoes of fear and doubt faded into the distance . . . for the time being.

It wasn't much, but enough to assure me that anything I did next in my life, whether it was a success or a failure, would be done my way. It was the only choice I could truly own.

GRIND FOR A FUTURE

Even though I did not know what "that" was yet, I knew it would take money to do it. They say it takes money to make money . . . and, judging by my last business adventure, I believe there should be full disclosure to anyone following this adage. It *should* say, "It takes money to make a penny, with the hope your pennies will eventually fill the hole of debt at a faster pace than the hole grows."

The only thing I knew would make me enough quick money with very little downtime before I could land a good paying job was tending bar. As much disdain as I had for it, my field of expertise included nothing else. Fortunately, a bartender colleague made me aware of a new piano bar; the GM was one of the veteran bartenders whose advice about tips I had not taken. I got the gig right away.

The honesty that had gotten me fired years before came full circle, landing me in what could be considered the best job in that industry, solely due to the crew and leadership in place. They were good people—which made the task of preparing for my future much easier to contemplate. This was a good sign . . . and a huge relief.

FINDING MY PURPOSE

I cannot recall the moment I discovered my next venture, my dream to chase; I can only identify the triggers and signs that came into view. It was as if I were at the edge of the treeline, gazing at the vast distant land, slowly walking backward into the forest, still focusing on the deep, open space. At some unknown point, my perception shifts, my focus adjusts, and the realization of my new surroundings becomes apparent.

It might have been the emotional sketches I used to make after suddenly waking up from a dream. I'd awaken and blindly draw in the dark, feeling and not seeing, falling back to sleep with black powdered fingers and abstract scribbles for the next morning's analysis. I enjoyed the game of deciphering the dreams the following morning, through a subconscious connection. Sometimes, I forgot I had sketched at all.

Or maybe it was the assortment of works I'd created, strewn about my room. An evolution of landscapes, figures, and paper abstract sketches.

A garage stacked to the rafters with materials, my own personal paint store stocked with acrylics, oils, watercolors, stains, the latest homemade compound textures cooked up in jars, glazes, sheens, building equipment and supplies.

Or the gossamer memory of the murals I painted when I was a teenager, happy just to be making a little spending cash. I had no fear of painting—even though I'd never before painted clouds on the ceiling of a porch overhang with a 12'x8' spread. Or a river flowing from a waterfall through a colorful forest and under a bridge on a bathroom wall. Or Bolivian mountains in a restaurant banquet room. I never doubted myself when I was painting. It was never a matter of whether I could do it, but how far I could take it. I always embraced the challenge; the harder it was on me, the more I dug in, the more stubborn and committed I became. It never occurred to me that I had any limits as an artist.

Or the moment in which I created my first true abstract, *The Beginnings*—void of reason, strong in turmoil, fighting my way through every stroke, intrigued and perplexed by the first signs of texture in my works. Unlike my still lifes, landscapes and figures, it didn't readily divulge its motive to me, or anyone else. It promoted in me more curiosity and drive than anything I had created thus far. All of these images that floated in the back of my mind made me realize that the only sure, consistent thing in my life had always been capturing an idea through art. It was a language I could translate.

One thing I knew beyond a doubt, without fear or limitation: there was nothing I couldn't do when it came to conceptualizing my imagination. I thrived on the challenge of creating. It never repeated itself, and I never found myself burning out because of it. I was always dreaming big; but never until this moment could I find the one thing that contained and connected all the pieces I carried in my mind. This was a foundation strong enough to support so many ideas, a place I could start to define myself. Now, I could construct the beginnings of a dream.

GRIND WITH A MISSION

A few months into my new bartending gig, I came to the perception of my reality. I quickly began building the foundation to support my

goals. I had been living on my own, but reluctantly moved in with my mother and stepfather to cut down my overhead costs. At the time, it was hard—knowing I would be there a lot longer than originally anticipated. I had analyzed the move that would allow me to save the most money in the shortest span of time and, unfortunately, this was it. So I bit the bullet, swallowed my pride, my dignity, and any hope of a social life, for a minimum of a couple of years. This living situation motivated me with an overwhelming desire not to have my future look the same as my present. I found comfort in the hope that positive changes were soon to come.

I devised a savings plan that played to my strengths—a strategy I do not suggest, unless you like to play games with your money. I would keep all of my tips in singles, wrapped in stacks of fifty, never to be unwrapped. Then I would line them up side by side in my sock drawer. At first, it was simply to see if I could make a row. It was a great feeling to open the drawer to see that I had reached my goal. Then two rows (success!). Three rows (*more* success!). Wow, I'm *four rows deep*! Now, let's try double stacks. This process gave me something to focus on and a sense of accomplishment. I never wanted to touch it; just seeing it reinforced my will power in times of doubt. I knew how detached a person could get from their hard-earned money. The ease of plastic cash seems to be all it takes to come between someone and their valued future. Ironically, I found it was much harder to spend when there were fewer degrees of separation—unanticipated, but surely appreciated—just as planting a tree from a seed and watching it grow makes it harder to cut down, or even trim.

Quarters also suffered the same scrutiny as my dollar bills—dropped in a bucket, not to be touched until the last day of my job. I counted the mound of quarters alone: one thousand, seven hundred sixty-four dollars and seventy-five cents of sheer gratitude. This was my reward for learning patience—a value beyond monetary gain that I will never forget.

The cash was good, but I was now faced with a glaring dilemma. I knew no one in the art world—no fellow artists, art dealers, collectors, curators—nor did I understand how juried shows worked, or the significance of show rooms and galleries. I was completely unaware of the fickle business practices within the art world. The closest to town I had lived to town was a stone's throw away from the outermost loop of the city. Outside the box, but pressed right up against it.

For some reason, this lack of knowledge didn't bother me. Whether it was confidence, naïveté, or sheer indifference, I felt these things would somehow work out in time. I was once told that if you wait for all the lights to turn green before moving forward, it could be an indefinite wait. So I pushed on, no real goal at hand, no time of readiness at which to aim, no direction or guidance. I let the conscious idea of doing something purposeful prevent me from wasteful oversleeping, wasting money on empty indulgences, and for once, I was making smart investments in myself. This was my starting point, my first experience of what it takes to be an artist.

A PLACE TO PAINT

My mother and stepfather had been renting a non-climate controlled, all-purpose boating storage unit, a 25'x10'x15' tin can one-quarter mile from their house. The front half of the tiny space was used for their supplies, tools, parts and a trailer; all of my belongings were rotting in the back. Good timing was on my side, though, as my stepfather had just built a storage shed of his own on some extra land in their backyard. This is where they moved their belongings, which left me with a place to paint. I got approval from the managers who lived on the premises, and set up shop. It was a large enough space for me, but had limited resources. There was only one electric outlet with minimal electricity, no restroom, and a sheet of metal for insulation. But it was everything to me, my home for the next two years. In this place existed an idea of myself and a way out. My future finally looked brighter.

I would work twelve-hour days at the piano bar, close around 4 A.M., and make the long drive home with a detour to the nearest 24-hour fast-food drive-thru joint. I would head straight to my storage unit "home," and paint until I ran out of coffee or couldn't stand any longer—whichever came first. I had uncovered my couch from the back of the unit and flipped it around to use as a bed for the many nights I slept there, too exhausted to drive home.

I hated seeing the rats crawling on and around my only possessions. Stockpiled in boxes were all the things that summed up my life, decaying from the heat and humidity and the critters that I could hear nibbling

away at another memory. I split my electricity needs between a fan and light during the brutal Texas summer heat, or a space heater and light for the cold winter nights. On occasion, I'd paint by flashlight during the blackouts from our seasonal coastal hurricanes.

These conditions only made me more obsessed with the storage unit and its meaning to me. The proximity of my physical reality put things into perspective. This was the creation of my beginning; devoid of any real social life, painting day after day and night after night. Every piece was a part of my sacrifice, something to show for myself. Doubt was not welcome here.

LAYER 1

Reality

I think it's Tuesday, but it could be Sunday. It doesn't really matter . . . every day is a work day for me. I hate this moment; my mind is so weak, my will power is so low, my motivation is so diminished. I am easily lulled back to sleep, to dream until my need is satisfied. I shift my body, pretending I'm not awake. I shift again, trying to ignore the whisper in my mind, "How bad do you want this?" The question nags at me; now I twist in a bed of guilt. This will be the death of me. But this morning, I rise.

I sit up and orient myself while unwinding my leg from the sheets. I stand, hunched over, dragging myself to the bathroom. My blank stare into the mirror is unfocused. I'm waiting to see the sunrise. I'm waiting to see the belief in what I'm doing. I'm waiting for my eyes to tell me I still want it. I see the dried paint on my forehead, and it reminds me of what I do. It's time to work.

THE ROOTS OF COMPLACENCY

It seems to me that when we do something long enough, we become accustomed to it. Whether it's something we enjoy, or something we don't like, it becomes all we know—familiar, easier, and supposedly safer than the unknown. The desire to change may not mitigate the desire to overcome the fear of change. It's almost easier to find the logic that justifies the complacency. We surround ourselves with those who agree; to do the opposite would entice the fear hiding behind the bush.

I'd been tending at the piano bar for a couple of years . . . a job that allowed me to work on my future in comfort. Now I had a definite direction and a definitive goal to achieve. Holding a carrot out in front of the corpse of my once living, breathing body, I was so focused on the idea of grabbing the carrot, but unsure of what I would do with it. It was obviously time to leave. I had saved a good amount of money, and had created numerous art pieces. My next step: follow my original plan to break away from the dependency of bartending. I wanted to see the beginning of the end—but I feared there would be a quick end to the new, long-planned beginning. I could feel complacency taking root. I was dreaming of a future rather than living the future dream. I wasn't sure I could contend with another failure. It's sad, when contemplating the "What ifs?" and "What could have beens?" becomes easier than trying to make your dream a reality.

Yet there is a point of change, an unwavering cold turkey, a no-questions-asked moment. Rock bottom has a different depth and form for everyone. A mere idea reaches its climax in your brain as an epiphany blooms, instantly and completely changing the scope, direction, even the purpose of an idea or mindset. At this point of contention, whatever it may be, and whenever it may occur, that's the impetus to overcome the fear of change.

After a couple of years, I found myself short of epiphanies; I simply could not leave. I had a great job, compared to other jobs. But, no matter how great a thing is, when an object—or a human being—is forced into a purpose it was not made for, it will inevitably wear down. The very job I depended on for financial sustenance was slowly and painfully killing me inside.

My eyes were turning dull and grey again. I would open the bar at 3:00 P.M. almost everyday; a constant and blatant reminder of my own

akrasia. The opening shift was an unattended happy hour, which is how I liked it. An empty bar meant I would be cut first, usually around 1:30 A.M., if I was lucky. I was rarely lucky. It was not the desired shift, but it was the only way I could get through the night, as I used the comparative peace to think and reflect. Before each shift, I would sit in a white plastic lawn chair placed just outside the front doors under the covered patio entrance. It was a small space, mainly for smokers and the door guy to stand under whenever it rained. I would arrive at the bar by 2:30 P.M., quickly doing all my setup and cleaning, allowing me just enough time to sit out front and quietly watch the world pass by. I would leave the final task on my list 'til the last minute, as it was ultimately the worst part of my day: unlocking and opening the crosshatched accordion-style metal front gates that closed off the patio to the outside world. Those ten minutes before opening were my favorite, and saddest, moments.

EPIPHANY OF OBSTACLES

During one opening shift, while sitting in my chair, eyes glazed, I happened to find myself staring intently at the building across the street—a building I'd seen everyday. I'd even had the pleasure of cleaning their parking lot a few times after we closed. I had noticed it before I started this job; the memory was lodged somewhere in my mind. I recognized the architecture from a photograph I'd once seen, especially the formation of the windows from the inside. I thought about it all day and all night, and all during the following day, while sitting back in my plastic chair. Then I had a memory from years before, at that horrific summer bartending gig in the midtown club. An artist and frame worker came in while we were setting up, to discuss with the owner business unrelated to the bar. While he waited, he showed me some installation shots of his framed work, and in the background were those windows. *Those windows.* They bounced around in the back of my mind over and over, at last becoming distinct, and it hit me: for nearly two years, a gallery I had been staring at had been *staring at me*, from right across the street! But I was so focused on the carrot that I couldn't see the many signs. Now I knew that, if I stayed in this place, it would be the irony of a swimmer drowning in a bathtub, in a tragic novel Hemingway might

have conceived. But this, I said to myself, will not be my story. I was thankful for the job, but would not let my roots reach any deeper here.

After this realization, it took me two weeks to find the courage to tell my boss about my intention to leave. His reaction was important to me; I believed it would set the tone for my future. A rocky ending might create a rockier start. I had heard such horror stories from others, when their personal dreams conflicted with their jobs. But I think the hardest part comes from the meaning behind the spoken dream, when you commit out loud to taking the first steps of never turning back, and leap into the abyss of the unknown. For me, this was not a blithe transition, not a random act. I meant this to be a forever change; and that was something I had never considered doing . . . until now.

It was just another happy hour shift. As usual, my boss would pick up the day's money and hand off my portion for the register, then leave. He wouldn't return again until around 7 P.M., and he'd stay for the rest of the evening. This time, I asked him to join me outside. "Sure," he says.

My heart rate spikes. Light-headed, out of body. I'm about to jump out of the plane. I realize I'd planned it, I took the safety class, boarded the plane, and I'm in it . . . the blood drains from my face, I'm standing at the edge of the door that leads to nothing but sky. I'm paralyzed. I want to jump, I don't want to jump, I can't take a breath, I'm holding on, I want to let go.

I shift my feet and clear my throat; that buys me enough time to find my voice again. My first words were an open-ended, quasi-rhetorical question. "You know I won't be here forever?" He looked perplexed. "Well, I certainly hope not, we open in ten minutes. I don't need you to be sitting out here scaring off all the customers. At least let them get inside first. If they're too lazy to be at work, then they're hopefully too lazy to get back in their car!" I smiled. He was one of the funniest people I knew; I'd given him an opening, and he took it. For me it was a sign of normalcy, and it calmed me. I began telling him about my dream outside of the nightclub, my desire to take my art to another level, to let it define my life. "If I'm going to do it, I'll need to resign soon." He listened quietly, generously giving me my moment. I'm sure he knew I needed to say it for myself more than for him. I guess it was an outward self-validation, as well as a search for approval. I walked toward the gates of the patio, grasped them, and gazed at the gallery across the road. I explained that

the gallery symbolized where I was in my life, and the idea of where I wanted to be. I knew that I was not sounding very appreciative for the job I currently held, so I stopped talking. I didn't turn to look at him while I waited for a response, which seemed to take forever. He responded with what I first thought was a question: "You have the keys." I wasn't sure what he meant, but I slowly nodded in agreement. Then he said, "You merely need to open the gate." I closed my eyes and struggled to catch my breath, as the moment of complete change became my new reality. I was suddenly overcome by an inexplicable weakness for which I wasn't prepared, and received the epiphany I'd longed for: the only prison was the one I created. And I had the keys.

I continued to work at the nightclub awhile longer, to handle all the loose ends and earn the rest of the money I needed to prepare for my first exhibit. He never asked me when I was leaving, he never cut my hours or showed any resentment towards me. In fact, he reacted in quite the opposite way—he cheered me on to the very end, even allowing a crew of employees to stop by my opening to express their support while he covered their positions at the bar. I never got to truly thank him for that in the moment . . . only now can I fully reflect on its significance.

THE BEGINNING OF MY FOREVER

My first show took place at a local Bohemian bar with eclectic furnishings—walls, couches and hanging lanterns straight out of 1930's Paris. Church-framed stained glass windows hung in front of the "in use" industrial windows, an island bar fitted mid-room and, in back, the owner's personal stone sculpture garden. Serving great wine and an even better sangria made with a special recipe, local musicians flowed in and out while riffing with fellow players. It was a great place to see and be seen. The owner was very relaxed, and allowed me to have the run of the bar. I designed an elaborate hanging system and an even more complex lighting scheme. This is when I became a stickler for lighting; every piece must have lights on it. The only person who disapproved was the fire marshal, but I managed to disappear whenever he came around. If the complaint had been severe, the owner would have done something, but "no extension cords, six foot and under" didn't seem like a "close your

doors until fixed" issue, and I'd be damned if I was going to get up into the rafters to replace twenty six-foot cords with eight-foot cords. Instead, I wrapped the connecting cords with a lot of duct tape and made them one giant spiderweb-like cord over a hundred and twenty feet.

The show went off perfectly, and the house was packed. The music that flowed into the room had an eclectic, low-tempo Paris lounge vibe . . . it wasn't overpowering, it didn't force an energy that would have been too frenetic for an art gathering of this type. I ended up selling multiple pieces that evening (always a good sign), but the best part was the response to my work. My moment had finally come, and it was met with overwhelming approval. Until that day, no one had seen my works in person. I'd been so wrapped up in perfecting the layout for the show— lighting, music, marketing—that I had completely forgotten that fact. For my anxiety's sake, it was a good thing to forget. It was like finishing your first marathon and seeing all your friends and family at the finish line, some clapping and smiling in celebration, some simply offering a nod of approval. I wanted nothing more and nothing less. I was at peace with how far I had come, my inner turmoil settled for that evening. I had done something right by myself and, as I looked around at my works that night, I knew I'd earned it.

I would quickly find out that a first exhibit or any grand opening has a high success rate, unless you are completely inept or unlucky. Friends and family will be there to support you, but their attendance will slowly taper off throughout your next exhibits, only stopping by occasionally. They don't buy often, if at all, but it's comforting to have familiar faces in the room and bodies to fill the void if the crowds start to dwindle. The hardest part of any business is to keep the train moving; for me, it was getting my work in front of new people. Another tough part: always presenting something fresh without changing who you are. I began to notice that those who are prepared will not necessarily be successful, but will have a much better chance of survival.

Even though the night of my opening was blissful, I knew I had not chosen an easy road on which to pursue my dream. At the end of the evening, I asked: okay, what's next?

And this is what happened:

LEFT BRAIN *meets* RIGHT BRAIN

I

KIM

We met through a mutual friend who was a board member for the Houston Arthritis Foundation, for which I was the executive director. I was hosting and working on a gala, called "Art for Arthritis" and the board member, Cameron, knew of an artist who might be willing to donate some artwork. So he connected me with Justin, who was having a show. Cameron invited me to see his work. He told me Justin was up and coming, and told me to bring my marketing materials, and he would make a quick introduction.

JUSTIN

I knew this guy named Cameron who came into the bar when I was working happy hour. He had come in to meet a friend of his, and while he was waiting, saw I had my little iPod with photos of my paintings, and asked me to show him my work. These were some of the biggest pieces I had done. "Omigosh, they're great," he said, and I told him I had a show coming up. "I'd love to come, and I know a woman who is looking for some big pieces, and I'll bet you can sell a few to her. I'll get her over here, don't worry, she'll be able to buy, she's got the money, it's all fine." I'm very shy, and he's very aggressive, so I just said, "Oh, well, okay, I'll meet you whenever you say," and just followed his lead. I was standing at the bar, I had a glass of wine ready for her. And I waited, watching as they both came in. I was dressed nice, trying to be smooth, to be very proper. That's how I first met her, I was offering her a glass of wine. It was a white wine, because it was hot outside, and Cameron was a white wine drinker who told me she's a wine enthusiast . . .

KIM

My expectations of the meeting were to meet Cameron, meet this artist that he wanted to introduce me to, tell him about the event that I was having, the logistics, the nature of the cause, see some of his work, and find out if he was interested in donating a piece of work. I was 100% business.

JUSTIN

I went to the meeting with no idea
that she worked at this place,
and that there was any kind of show,
or any gala, or anything going on.
It was like, these two gigantic pieces are a done deal,
she already knows the wall space she has for them,
and she's looking to buy to fit those walls.

KIM

I'd been in the market for art, but I had already pretty much decided on the artist and was commissioning a piece at the time. And Cameron was helping me, because he also knew that artist.

JUSTIN

They left to go look at another artist's work . . .
right after our meeting.

KIM

Cameron and I went to go look at the other artist's artwork. Cameron knew I was looking for artwork. But I wasn't considering Justin's work. He took me around the room and explained each piece . . . and I kept waiting to hear, ". . . and this is the piece I'm gonna donate."

JUSTIN

I spent money and time talking about each piece
and being eloquent and artistic
and explaining every piece . . .

KIM

Justin said, well, are you interested in some work? Leading me to believe that I might be interested in buying his work—and I said, I'm not in the market to buy right now, but I do have a gala coming up. And I had my marketing material folder with the stuff in it about the event, and I said we're doing this event about arthritis, would you be interested?

JUSTIN

So, I'd pretty much worn myself out talking about all the pieces . . .
and I'm shy, this is my first major show, I don't know how to sell.
There's that barrier between explaining the art and saying,
okay, are you interested? I was never that blunt.
So, I hemmed and hawed around the point,
and there was this awkward moment . . .
and she said, "I've got this gala coming up,
and I have my paperwork . . ."
And I was just shocked, I didn't know . . .
I thought maybe there was still a possibility of selling my work.
So I was nice, and listened.
And she gave me a pamphlet, fully prepared and ready,
and a contract for me to sign my life away . . .

KIM

He didn't sign it then, he gave me his business card and said he had a very good friend, a girl who had arthritis, and he was familiar with the disease. And that he would do a piece.

JUSTIN

My mind was somewhere else,
still wrapping my head around donating
instead of selling . . . I was bewildered . . .
and I didn't know Kim and Cameron were leaving
to go look at another artist's work.
I still thought she was going to think about buying a piece.
So, there was no commitment on either side, really.
It was just a little dancing around,
trying to figure out what was going on.

KIM

...and I was off to my next venture. At that point, it was just another meeting in my day. I thought he was nice, it was fine, but I have a checklist of things I need to accomplish, and he happened to be one of them. I checked him off and moved on.

<div align="right">

JUSTIN

I was exhausted. All this talking,
and all this explaining the work,
and all I got was a pamphlet to look at.
I walked into this thinking
I was gonna sell a piece of work,
and now I'm giving away a piece of work.
How did *that* happen?

</div>

<div align="center">

II

</div>

KIM

Justin just showed up at the office one day.

<div align="right">

JUSTIN

I contacted Kim . . .

</div>

KIM

My assistant came in and said, "Justin Garcia's here." And I said, "Huh?"

<div align="right">

JUSTIN

I brought a piece . . .

</div>

KIM

He didn't bring anything. He just wanted to check things out . . . and I said, "You can bring it another time." I was on the phone, and he paced back and forth in front of my desk in my office. He was looking at my books, and I was on the phone, thinking, "What's this guy doing?"

<div align="right">

JUSTIN
It was awkward . . . I was just trying to busy myself . . .

</div>

KIM
It was awkward. I'm talking on the phone and watching him go back and forth. We had most of the art in the conference room, so I got off the phone, and answered his questions. He told me then he was going to donate. I took him to the conference room and he looked at the artwork we'd received. I said he could do whatever he wanted.

<div align="right">

JUSTIN
This was my first charity. I didn't know what to do . . .

</div>

KIM
So, that was our second encounter. I don't remember him calling. I was not prepared for him to be there. I didn't know he was coming.

<div align="right">

JUSTIN
I don't think I just stopped by. I called.

</div>

KIM
My assistant may have gotten the call and didn't think anything about it. We had a lot of artists dropping off artwork, and he was just another artist coming by.

<div align="center">

III

</div>

KIM
I had emailed him about the deadline for the art and the description for the program, and he responded with a phone call. He had a bunch of questions about logistics. He called while he was driving, and he sounded weird, and I asked if he was okay. Not that I cared about his personal life, I was just thinking there was some hesitation about donating . . . maybe he was having second thoughts. And then he apparently drove off the road.

JUSTIN
There was a lot going on for me at the time . . .
I was just about to leave my job, I'd just done the big show,
I'd sold a couple of pieces, I didn't know what to do
or where to go next. This was all a new process to me,
and I didn't know protocols. I was still in my storage unit.
I hadn't created a entire series, yet. So, everything was just new . . .
I was trying to do everything right,
so I could get my name out there in the best light.
And I called Kim about the logistics . . . because I don't like emails.
I like talking on the phone or in person.
I just needed to go over the list one more time,
and I needed to hear it from somebody by voice.

I was driving towards the freeway and talking,
and my speech was broken, train-of-thought-wise.
And that's when she asked me if I was alright.
I was unaware of my voice giving off that
I was all over the place, and her question threw me off.
So, instead of getting on the freeway,
I drove over the freeway,
and had to turn around and go back.

I'm always the one getting called and giving advice.
So, for someone to notice something in my voice—
especially someone I hardly know—kinda scared me.
I thought, "Oh my gosh, am I coming off like
something's wrong with me?" It shocked me.
It was an outside look at who I really am,
instead of being a normal guy.
That one question made me calm down
and look at myself.
It was the first time anyone had
asked me that question in quite awhile.
And I just told her I was okay,
I just had a lot on my mind.

IV

KIM

He brought the pieces to the office before the show. I was surprised he'd done two things: an actual sculpture of his own hand and a painting of his hand, symbolizing the fact that rheumatoid arthritis affects the hands. I thought that showed vision and creativity. Both were donated.

JUSTIN

I thought about what I was good at
that would fit the charity. I wanted to do something
that people who have arthritis can relate to.
So, during Hurricane Ike, I did the painting of my hand . . .
and when the gala got pushed back two weeks
because of the hurricane, I created the sculpture
and painted it the same color as the background of the painting.
I donated the sculpture as well as the painting.

V

JUSTIN

I'd invited my friend who has arthritis to be my guest . . .
and she brought her sister and her sister's friend.
At the gala, Kim and I got to talk more.

KIM

We didn't talk at the gala. Not socially. Just logistically.

JUSTIN

She invited me out after the gala was over.

KIM

I had seen him at the beginning of the event, sitting by himself at one of the tables in the back. Then I saw him at the end of the event—he was still

sitting at that table. He pretty much sat through the whole thing by himself. The staff was going out to celebrate after the gala, so I just invited him.

JUSTIN

Years later, I found out it was a pity invite.
She said she saw me sitting alone all night.

KIM

I didn't see his friends with him all evening.

JUSTIN

Were my friends even really there,
or was it all imagined?
Apparently, it was like *A Beautiful Mind.*
I thought maybe she and I had talked . . .
I thought there were people around me, supporting me.

KIM

I never sat down and talked with him at that table in the very back of the room. Then we were all cleaning up and ready to go, and there's Justin, he's still sitting there. I said, "Well, let's go see if Justin wants to go out with us."

JUSTIN

We went to a hotel for a bite to eat.

KIM

We went to a hotel and then to a wine bar. I didn't get much of an impression of him while we were out. Everybody else knew each other. While the rest of us were in conversation, he'd get up and wander around the room, looking at the art work. He was gone, I'm gonna say, 75% of the time we were at the restaurant in the hotel. Then when we migrated to the wine bar, he was away from the table at least 75–80% of the time.

JUSTIN

I was looking at some of the art, and I walked outside,
and a famous artist was out there.
I knew him, and the person he was with,
and we started talking, and got carried away.

KIM

So he really didn't make much of an impression, except that he came. And
that was it.

JUSTIN

I was trying not to be quietly hovering,
trying not to highlight my weakness
of not being a social person by just sitting there.
I'd come in and out. Everybody knew each other.
I didn't know anybody.

KIM

He never became engaged in the conversation.

JUSTIN

The less I'm just standing or sitting there,
the less awkward I seem.

VI

JUSTIN

Cameron invited me, and Kim, and another person,
to a place downtown—a bar where they play live jazz.
I think that was where she and I
first got a little more one-on-one time.

KIM

We were at Sambuca, a restaurant that has a stage where they play music, and I mentioned there was an event coming up the following week at a wine bar called The Cork, and that I was going with my best girlfriend Lauren. I asked if he wanted to go. And he said, "Oh, yeah, that sounds like fun." I emailed him later than night and said, "This is where we're going, we're leaving at this time, we're meeting at my house." So, *I'm* probably the one who asked *him* out. I was interested in the artistic side of him. I wasn't interested in dating anybody. I don't recall asking Justin out because I expected to start dating. I liked him, we got along.

JUSTIN
We sat on the stools at the bar
after Cameron had stepped away
to talk with his other friend,
and we got to talk more in depth.

KIM

I'd taken off my glasses, and he put my glasses back on my face. He said he liked the way I looked in my glasses.

JUSTIN
I walked her back to her car.
I was very intrigued by her. I saw the business side,
but there was also a very soft side to her that I really enjoyed.
I kinda saw it from the beginning,
but it wasn't until we went to Sambuca
that we got to sit and talk, and I got to be myself.
We weren't with all those other people,
and I got to open up a bit more.
She was very receptive to that, and she opened up.
It was very comfortable.
And that was why I was willing
to go to the event at The Cork.

VII

KIM

Our first official date was at El Tiempo, right around the corner from my house.

> **JUSTIN**
> El Tiempo was the first date, where we
> specifically set a time to meet, with nothing else going on.
> And we got to share a lot of things about each other
> we probably hadn't shared with anybody . . .
> and really saw how much we have in common,
> how well we could relate.
> It didn't feel awkward. It didn't feel different.
> It brought us even closer.

KIM

We went to a restaurant not far from where I lived, and he came to pick me up. He brought me something he'd made for me . . . flowers out of napkins. I thought it was sweet.

VIII

KIM

I have so many walls . . . I think I maybe was in love with him before I could say it. Being in love and admitting you're in love are two different things.

> **JUSTIN**
> I had a lot of walls up. I hadn't dated anyone,
> or pursued anything serious, in a long, long time,
> because I had a goal. I knew what I needed to do,
> and that had to be the most important thing to me.
> How could I give myself to somebody and commit to them

if I need to figure myself out?
It's selfish—and I didn't want to be with somebody
who couldn't understand that.
So there was no point in trying.

I knew we were there for each other more than just dating.
I felt there was something a lot deeper there.
And I think both of us were a little too afraid—
at least, I was—to openly admit,
to be that vulnerable again.

KIM

The most attractive quality I found in him was his ability to talk. To talk
for hours and hours and hours, through the night, sitting on the couch or
wherever, just talking . . . until it was suddenly 3 in the morning, and he'd say,
"It's 3 o'clock, I have to go to work." And out the door he would go. That was
the thing I wanted most: somebody to talk to.

JUSTIN

She actually listened. I had this feeling . . .
with her, it was very comforting.
I could take her word for what she was saying,
because I knew she had felt the same things I had.
After talking with her,
there wasn't this doubt that seeps back in.
So, I loved that she listened.
I like that she cared about me.

PIECES NEEDING TO BE WHOLE

For the next six months, I poured myself into show after show, while
adding new pieces to my body of work. They were very different from each
other, but a consistent consideration of philosophical ideals tethered each
piece under the surface. Every piece a thought; every thought, sound—but
on the surface, none connected with each other . . . much like my life before

art. I was okay with the scattered works for the time being. It was a much deeper commitment than anything I had previously done. I see now, I didn't realize what I was doing. I wasn't wrong; I was just not looking at my work as part of a much larger process. Reality is a picture show composed of many pieces that come together to be experienced as a whole. If I were to paint my reality, I would need to step back and put it all into perspective. I was only scratching the surface; I felt an inner unrest, pushing me to answer the next questions. To define an idea, not by each piece but in a collective series, I'd need to steady the mind and learn to focus across multiple pieces. That would give me stability and control over my foundation.

I had realized my direction through art, but had not harnessed the ability to focus it. Focus takes patience. All along, I've been playing checkers, and it was time to play chess. Creating a series (or learning to play chess) seems easy, on the surface. Learn the steps, learn about the things in the painting (or the chess piece) that make them unique, and recreate them on every new canvas (or chessboard). The mechanics can be broken down by process, and that's it. Simple, simple, simple.

But there's more to playing chess, and there is more to creating a series of artworks. I discovered that creating a series is a much harder process than I had originally thought. In its truest, deepest form, a series is one idea expanded over multiple canvases, and one must keep it fresh in one's mind for an unnerving amount of time. In retrospect, what I had been doing early on was simply contemplating a two-dimensional square, which was somewhat easy. But a series is the contemplation of multiple two-dimensional squares, seamlessly connected to form a cube projected on canvas from one's mind. The mental power it takes to sustain such a process, to think across many surfaces, each one different, but fitting to precise measurements, is a daunting practice. For me, it could only be fueled by deep emotion. And I had been numb for so long, deep emotion was something I did not have at the time; I only had enough energy for short spurts of creativity. On top of that, I had another problem that slowed this process: a bottomless lack of patience. I even resented the *word*. It took me back to the child whose father would make a promise for the future, until the future became the present . . . which would arrive with an excuse that echoed through the hollow promise. I was raised not to trust. For me, patience was nothing more than a sadistic practice.

I realize now this was a major stumbling block to formulating a series around a thesis. I was in trouble. Apparently, I had not read the artist manual: part of the process was facing certain repressed feelings. I knew a series meant more than just a collection of paintings expressing a central idea. While I had no patience, I had plenty of stubbornness. No matter how many canvases I might go through, and sleepless nights I would endure, I would force myself to move forward. A person on an undefined path is more of a fragile plant with weak roots, like those of a weed, not the roots of a tree with a solid, defined foundation. I did not want to be without purpose, so easily removed and forgotten, like a drifter, moving wherever the wind takes me. After all, not all places the wind goes are desirable. I had drifted once before, doing whatever work came my way just for the money, constantly carrying a chip on my shoulder, occasionally sweeping it under the rug so no one would see.

I needed to discover who I was for myself, and who I was to the world. Knowing how I was perceived, as well as what I projected. This endeavor became more than art; it was a roadblock I had to dismantle before I could break through and move on. If I couldn't overcome this, then the art was pointless for me. It would flatline.

This contention required an agonizing stretch of patience on my part. I resorted to searching for answers on the Internet . . . but quickly abandoned that idea, as the first search led me to a slew of Bob Ross instructional videos. If I'm painting a tree, I'm painting a *tree*; I will not designate another tree as its friend. I might later use his friend to paint a log cabin, so I don't want to get attached to the tree, it would just be sad and awkward between me and the other trees.

I may have gotten something out of the impromptus, though; I felt Ross had deep emotion coming from somewhere, and that was more than I had at the moment.

A TRIP TO WONDERLAND

Kim was with me through my agony, watching me try to create a series and then see it progress unproductively. It was painful for her to watch, and she decided it was time for us to get away for a few days. It was good

timing for both of us; around the corner was the anniversary of the death of Kim's mother, so the idea of taking my anxiety and her grief to a place where we could forget it all seemed right. We were weak and vulnerable, so we needed peace and reflection. We needed a safe place. We needed . . . Las Vegas.

We were first-timers, and not just to Vegas. This was our very first trip together—always a rigorous test for any new relationship—with Kim, the political consultant in a pressure cooker and me, the struggling artist. Compared to everything else we were facing, this little vacation would be a breeze!

Kim had booked two shows for us to see: The Blue Man Group and *Le Rêve*. I had little interest in going to either. I was too engrossed in my thoughts about creating a series to let myself be so distracted. But we were in the honeymoon stage of our relationship, so I followed the wisdom of every magazine article titled "How to have a healthy relationship." In other words, "You're right, honey."

Le Rêve (*The Dream*), was an entire show dedicated to the interpretation of a single painting by Picasso. Kim thought that, given my skill set, I would enjoy seeing it. But I have to admit, even the description didn't intrigue me. I was a movie guy; I knew very little about the theatre. I gave plays and other live productions little regard. Whenever I attended a show, I didn't really know what I was seeing—to me, it was either silly (*Barney on Ice*) or foreign (Shakespeare). At that point, the only live performances I understood were those of standup comic Jeff Foxworthy (I have since diversified my portfolio of comedians).

We were on vacation in the most decadent city in the world, so I was, of course, bubbling over with champagne. As romantic as that might sound, it made me playfully obnoxious—which did not create a romantic night out for Kim. She'd upgraded to VIP seats, and was dismayed when the delightful chocolate-dipped strawberries were accompanied by *another* bottle of bubbly.

The house lights dimmed and the spotlight hit the stage. My eyes were drawn to the center of the room, where I saw the curtains magically pulled up into a black hole over us. This immediately commanded my attention, creating a small opening of sobriety in my consciousness. I couldn't move. I stared at the stage like a baby absorbing its surroundings

for the first time, a child's first glimpse of Fantasia in surround sound. What I experienced was phenomenal. I was overtaken by the atmosphere, the sounds, the movements, the fluidity of figures and forms. There was so much emotion and drama pouring over me that it became surreal, overwhelming my senses. The show reverberated in perfect synch, it seemed to hit me without and within, unlocking a secret part of me, immediately marking the starting place at which I would begin to access my own deep emotions. For the first time in my life, I vividly witnessed an event with nothing but raw emotion. Although I had experienced those feelings in my own life, most of those moments had long since been suppressed. I was never able to separate the pieces that summed up the event; they were only a blur of unwieldy parts, leaving the cause of the emotion a vague recollection.

I could see it now, it was masterful; the ability to unify two worlds is such a powerful tool of control. One foot in the physical state of being, and the other foot in the cognitive state. This was what I was feeling, what I was seeing. The art of theatre is the act of unification, the conduit for simultaneously creating reality and translating reality.

This show, or my experience of the show, had all the elements I needed to construct reality through emotion. I felt like I was shooting the rapids while maintaining vision and confidence, flawlessly negotiating the most unyielding and treacherous conditions of Mother Nature's flow. I was part of it, yet watching it from the third person, witnessing the build.

Now, I was aware of the components I needed to compose a series . . . or I knew what to look for, at least. That revelation stuck with me for the rest of the trip. The morning after being immersed in *Le Rêve*, I was fully decompressed, and we enjoyed the rest of our Vegas escape.

I couldn't help being curious about this personal phenomenon. I discovered that you can access deep realization even in a place like Las Vegas—if you stay open to the possibility. The show and my decision to attend can only be fully grasped and weighed from the consequences of a question based in curiosity: *what if I had never seen it?*

REALITY FINDING ITS DREAMER

I was eager to get back to work—which I did, relentlessly, for a month. Then, in one shining, early-morning moment, after I had been up all night trying to finish a piece, I saw it: all the parts resembling the emotion I felt from the show came together. I gazed at the painting for hours, breaking it down layer by layer, pulling the elements needed to formulate the deep emotion that would drive a series forward. The process was clearly marked in my mind, embedded within a core of purpose and reason.

The soft undertones of sporadic color spread over the length of the canvas, then masked with layers of textures hushed across, like aging walls. I tore up my abstract charcoal dreams drawn on sketchpads, now carefully broken apart and collaged in minimal fashion, allowing the background to breathe. The severed black and white dreams began to form fresh lines that flowed into newly-acquired spaces in between, feeding a sense of connectivity. Each dream fragment collapses from edges into background, with the fading of colors that once dominated the canvas, yet are subdued underneath the layers of texture, formulating a subtle indication of evolution. The colors moved like any good trend, circling around to face a new generation. The movement of angles along the integrated dreams demanded change, becoming an over-bowing, unapologetic line, pulsating in the livelihood of their fight for existence. Taking that which was into what will come, birthing new dimensions from pieces once whole, as abstract dreams become pieces of reality.

For all the years I had sketched emotionally-driven dreams, to find a purpose for them, I didn't know that, to form my whole self, I would have to break up those dreams. And the connection of this subconscious stimulation guided me to, and through, a show appropriately named *Le Rêve*. It was always there, just waiting for me to catch up, and all it took was keeping my eyes wide open and an unwillingness to settle.

I could see it now, the carelessness with which we play. The importance of this moment for me—not just as an artist, but as a person finding his reason—was the reveal of a practice that cannot be met in aimless direction forever. We meet these moments of emotion with countless questions, so many misunderstood, asking for answers, impatiently listening to nothing. We tend to force an answer beyond our reasoning, beyond our control, one we profess to believe, but most certainly doubt inside, as we passively pursue

life. I'm speaking of the experiences that shape us, though we never look to see how they *become* us. To blindly live in fragments is not living. Until this revelation, my works represented such a disjointed condition. Raw, uncontrolled moments that came without warning . . . they were all I knew, and I accepted it. In turn, the sporadic paintings amongst them never fully defined the big picture, they never grasped where or how they connected. Although I was building a foundation of art, it was weak and shallow with no clear structure, just as it existed in me. It left me little control of my life, no understanding of the reality in which we live. But the new series gave me an understanding of something bigger. In a world that gives us more footholds than we need for exploring, we climb, then complain and destroy the very mountain that supports us . . . while never truly knowing why we climb, why we complain, and why we destroy. Reality is easier to swallow with a glass of indifference and a blind eye.

I thought, Okay, I can do this, if for no one else but myself, I can lead this life. I named my first series in honor of becoming whole—the artist, the painting, the show, and myself. *Mélange de Rêveur.* Mixture of the Dreamer.

Mélange de Rêveur Series sketch

LAYER 2

Magnocellular

It's warm in here, stuffy. Hard to take a good breath. I roll to the right; no help. I roll to the left, and hit the tarp on the concrete floor. The hard crackle is a dead giveaway: I've fallen asleep in my tin can studio again. It's cooler down here, so I stay low and try to focus my sight on the light breaking around the edges of the door. I'm mesmerized by its purity, and rise slowly, never shifting my half-mast gaze from the light. I crack open the door and let the light spill in, still too bright for my sleepy eyes. I shut them tight and let the warmth bake my face, arms, hands, feet. This is where I belong. I hear my own voice: "I am a creator." I peer into a small mirror perched next to some paint cans, I want to see the rest of the sunrise, I feel it will be a good one this morning. Now I can breathe.

A BIPOLAR NATURE

The *Mélange de Rêveur* series fascinated me. For months, I was sustained by its emotion and, when it was all said and done, I was completely wiped out. Like the third helping of a Thanksgiving turkey, it induced a coma that lasted for nearly two weeks. I would look back at the paintings in triumph, but couldn't begin to understand how I made it through. I was on an emotional roller coaster: exhausted, yet in a state of nirvana, comparable to the feeling you have after sex (as long as you've gotten to the finish line), then doubt (if your partner *didn't* make it to the finish line). I began to think about the judgment my paintings would face when they left the safety of the studio and were exposed to the public. Like Dr. Jekyll and Mr. Hyde, the artist and the businessman went back and forth about what to do.

The fire of fear begins to burn, kindled by unreasonable questions: "Will they hold their compatibility? What if I can't create another series like this? Is this all I have? What next? Has my mind overheated, shut down and burned out from this series?"

Then the water of pride douses the flames, the satisfaction of having made it through the process with something legitimate to show for it. I had been studying the paintings for a long time . . . maybe it would be good for me to get them out of my sight. I need the space and the money, so I can continue creating.

Then, *No, no, no!* I don't think I can part with them; they are my link to that moment, what if I get lost again? These are the road maps back!

But we *have* to sell these works. Selling them solidifies my foundation as an artist. They *must* go if I am to continue . . . it is the cycle that must be endured.

But I'm not sure. I don't think I can break them up. They belong together as a whole. To fully comprehend the series, you must see them together. Separating them is not an option, they cannot live as orphans. This series is not a cake to be served in slices.

Then, the businessman sitting in the back of my mind whispers sweet warnings from the catalog of street smart recipes handed down from father to son: "You can't have your cake and eat it too, right? If you do, you'll soon run out of cakes to eat!"

At some point, the roller coaster comes to a stop, and you come to terms with what you have to do. The highs and lows of the whole experience—before, during and after creating a series, or even a piece of the series—is a phenomenal feeling. It always keeps you guessing. Like any drug, I loved to hate it, hated to love it . . . and I couldn't imagine it any other way.

THE FAVORITE CHILD

How do you put a price on a work of art? I'd infused each of my pieces with my blood, so this was like labeling a part of my body with a price tag and selling it off. It was unreasonable, but I thought about requesting applications from, and reviewing the resumes of, each buyer before every sale.

In the beginning, it's hard to let go. You get so caught up in the moment, you forget what comes next. In the early stages of an artist's career, you can always recognize their favorite piece or pieces . . . they're either a milestone, or the Alpha dog of the series or exhibit, because they are inevitably priced much higher than any others of similar size. I always smile when I see this; I know those feelings when it comes to pricing my own work. You put it up for sale, although you secretly don't want it to sell—but no one (including you) can say you didn't put it out there. If someone wants it badly enough, and is willing to pay five times the price for a piece the same size, or smaller, then you can find a way to swallow that pill and sleep through the night.

Fortunately, I wasn't allowed to do the same thing I'd done before with previous pieces; Kim's sound reasoning gave her the ability to talk me off the ledge and not allow me to go crazy with the pricing of this series.

THE MOVE[2]

I took a long, hard look at my progress thus far. The success of my previous shows and the new *Mélange de Rêveur* series helped me make my next moves. Kim and I decided it was time to take the next step in

our relationship, so we moved in together. Unfortunately, my furniture didn't make the cut . . . with one exception. "If you really must keep the lamp with the fishnet leg, I have a room for it." The room was the attic. Kim has a real knack for compromise.

It was also time to find a "real" studio near downtown Houston. One with air conditioning and a minimal amount of critters.

Yes, I was taking on six times the overhead with a year lease and no inkling of the next painting or series in sight. As for moving in with my girlfriend, I'd heard that was what people do; apparently, it *wasn't* a rumor or an old wives' tale. I guess until a brave soul jumps over the fence and takes the plunge into uncharted territory, one will never know.

Kim did some research and found a warehouse that was being renovated into artist studios on the edge of downtown in the old historic warehouse district. There we found a 600-square-foot studio space with twelve-foot ceilings, wooden rafters, aging brick walls on three sides, concrete floors stained with ring patterns from what looked like cases that held cans of some sort. I later found out it was once a storage facility for liquor.

I immediately knew this was a good fit, and quickly staked my territory before they finished dry-walling the fourth wall that would enclose the space. A month later, after the endless cleaning sessions in which I tried to remove all the dry wall dust off of the concrete floors (which I will never do again), we moved all my stuff into the new space. It was a big space to fill, so practically everything useful from the storage unit came to the studio. Half the room was laid out with the furniture that had been rotting away in the tin can. My robust, worn, soft brown leather couch—Robo-Plump was his name, always good for a nap— arrived first. His sidekick was a matching leather chair, Mini-Plump. In the middle of the two Plumps sat my center-cut redwood coffee table with a twisted root system as the base.

One of my best friends and I had been roommates at the time we acquired the table. We'd split the cost of a flat screen TV and this table, and when we decided to go our separate ways, we obviously couldn't cut Old Red or the flat screen in half. Let's just say I won that coin toss; only one of those items appreciated in value.

Underneath the coffee table lived a black and white cow rug, a gift from friends that didn't quite fit their motif; poor cow. Sitting opposite

Mini-Plump was an antique mahogany desk I picked up from a friend who didn't realize it doesn't matter how good an estate sale deal is, if you have nowhere to put the bargain. On top of the desk sat a cigar box, and underneath the desk was an old CD player that I programmed to belt out the likes of Tony Bennett, Frank, Dean and Sammy, Satchmo, Nina Simone, Billie Holliday, and the very sexy Mildred Bailey.

I sat in Robo-Plump and imagined myself conducting a very important meeting with my personal League of Extraordinary Gentlemen: Tim "The Tool Man" Taylor, Chuck Norris and Alan Quartermain. We discussed high-powered studio lights with dimmer switchers, the best security systems, and which taxidermic big game animals would grace the rafters above, gazing down like Sistine Chapel angels, blowing away the slightest whiff of feminine presence that dare waft into this very masculine half of the studio. Kim brought in a manly-scented candle (I'll never know how they get wax to smell like leather and sawdust) and placed it squarely on Old Red. "I think this will be a nice addition to your space, don't you?" "Uh, well, I was thinking that's where I'd put my fishnet-leg lamp," I said. She stood back to admire it. "I think this will be a nice addition to your space, don't you?" She really does know how to compromise.

All I needed was an unassuming antique globe that, when opened, revealed a bar filled with scotch, pop-up book pinup dolls, and a leather-bound encyclopedia of survival guides, covering everything from the Apocalypse to Zombies, authored and autographed by MacGyver himself. Throw in a library of iconic war movies with a minimum kill rate of one person every five minutes and documentaries on the making of moonshine, and I believe I would have myself the beginnings of a man cave. A "boom-boom room" the Great Gatsby would enjoy. Life was good.

Then, I burned my thumb trying to light the damn man-candle with a cigar match and came back to reality. I *knew* that candle would cause trouble.

I sat back on my couch and saw the duality of my environment, in very clear black and white. The chamber in which I sat was entirely different from what I saw across the room: an empty space, washed out by florescent light, one lone easel in the corner void of canvas, a few paintings in the opposite corner that were not being shown with the rest, as they did not meet my standards. A pitiful handful of paints that

once looked like a lot, now huddled together on the cheap folding table, swallowed by the space.

What have I done? A sinking feeling hit me, with not even one primed white canvas in sight to give me hope. From my throne, a seat that didn't feel quite as comfortable as I had pretended, I took in the view of my kingdom. I started to doubt the studio move; but when I allowed myself to look at the bigger picture, I couldn't imagine the storage unit being more than a dim memory. It reminded me of what I was willing to do for an idea I had believed in so long ago. As hard as it was to bear, I couldn't find any reason to doubt my decision to move forward. Which didn't make it any easier.

PAINTER'S BLOCK

I desperately needed to hit on something, *anything* that would spark a stroke on canvas worth making. I tried everything: I rearranged the painting side of the room . . . I categorized my paints by color, then by size of containers . . . I built a shelf system in the closet, a two-hour project I managed to stretch over a week . . . I organized stuff on those shelves . . . I painted my door . . . I had studio track lights installed to change the mood . . .

. . . and I sketched, however inauspiciously. If I changed this, or moved that, surely I would find the right frame of mind to create. I kept studying the *Mélange de Rêveur* series, hoping I could retrace my steps and find that moment of change. Most of the time, I would just sit on the couch, too embarrassed to go home early. Eventually, my brain would overload from trying to force emotion, and in a drug induced depression, I would crash on the couch to get away from it all. Every time, I woke up with a small ounce of hope that something in my dreams had given me anything to work with . . . or at least a subconscious sign that it's not all that bad, I got *some* work done. The only thing I ever woke up with were extremely itchy, red, sandpaper eyes. It made absolutely no sense; it was only in my studio that my eyes itched so badly after sleeping—nowhere else, not even in my car. I figured it was my studio punishing me for sleeping on the job, my own man cave working against me. It was the only logical explanation I could invent.

I'd go to the bathroom fifteen times, hoping that, when I returned, those four minutes away would give me fresh eyes on the canvas and I would have a new series epiphany. A few days later, I gave up on using the bathroom as an excuse for my insanity. Instead, I stood outside my door, playing peekaboo with a canvas across the room. Open, close, open, close, open, close—my effort to stimulate primal urges of the superior culliculus. If I heard anyone coming down the hall, I would start cleaning my door and mumble out loud, "Yep, yep, gonna need to paint over that spot again." It was awkward enough that I wore a white robe to paint in (I found the pockets to be very useful, and it served as one giant paint rag to boot). Heaven forbid another artist brings a collector into the complex and catches this guy staring at his door through red itchy eyes, unshaven with a case of impulse disorder, open-close-open-close, mumbling to himself.

When Kim found out about my robe, her response was predictably firm: "This simply won't do." I stuck my hands in the pockets. "But you won't ever see me wear it." She smiled and batted her lashes. "True. But just outside our home is the street, and just down the street is the freeway, and just down the freeway is a warehouse, and in that warehouse is your studio, and in that studio is a wild-eyed escapee from a mental institution with a scruffy beard wearing a nasty white robe. And when they come to take you to the loony bin, *I'll* be the lucky woman who gets the call to claim you . . . or *not*." I knew better than to call her bluff . . . so the robe disappeared for a while.

I wasn't getting anywhere with creating a new series, and my tactics were failing me. But I did learn that, when I was stuck on an individual painting—not knowing what color to use, or where to add a texture— whether or not it's finished, it's best to just leave it alone. I'd put it in a place where I could see it the instant I opened the studio. I discovered that my first instinct when looking at it, after five or ten minutes, or even overnight, is the one worth going with. I noticed that I *felt* it more than I *saw* it . . . and even if by chance it's not what I wanted, I knew the outside world didn't influence it but it was purely from my gut, and I could live with that.

Week after week went by and, although I kept circulating from show to show on the outside, my work in the studio was sporadic. Every painting teased me, getting my hopes up. Like jump-starting a car, it wants to turn over, I can feel it . . .

Okay . . . give it a minute and try again . . .

Alright . . . it's cranking . . .

It's revvin', I think this is it . . .

. . . nope.

Nothing I created sparked a series in me. Maybe two or three pieces were good as understudies or, at best, a mini-series, but there was nothing to build on. I couldn't sustain the emotion long enough to create a full body of work. It didn't feel the same as it had in the last series.

TRIP II

On the home front, Kim and I had been planning to travel to Italy—a trip she'd always wanted to take. As an artist, it was an opportunity I couldn't pass up. But at that point, I didn't have the resources to help fund this particular journey.

Kim loves to plan a trip almost as much as she loves to travel; she began plotting our Italian adventure the moment I said, "Yes, let's do it." She had started saving for it well before we met, and was ready and willing to take on a larger chunk of the expense.

I didn't like being unable to afford the trip. Call it male pride. Call it radical independence. I wanted to pay my own way, at least. But I would have to set aside my pride in favor of the timing. I foresaw an occasion in which I would be able to make it up to her.

They say it takes two or three days to transition into vacation mode. I could see that being the case in a normal situation. But Kim had filled every day with activities. Our first visit was Rome, and from daybreak 'til the time we fell asleep, we walked and toured, through a church, a museum, or both at the same time. I wish we had stayed in Rome for more than three days; even if we had been there for two weeks, I doubt we would have seen everything.

This was more like a working trip or studying abroad than a vacation. The art was as amazing as I had expected it would be; but what really stood out for me was the architecture. The transition of buildings into art completely changed my perception. I had never looked at structures in this way before. I always viewed them as simple structures serving the most primal purposes—shelter, office, grocery store—so I never looked

deeper, never questioned it. How do you even begin to imagine such an intricate form would be used everyday and withstand the aging world around it, constructed as a work of art, yet still utilitarian? Inducing art into workable monuments. Perfect lines, every angle exact, how does one think on such a large scale? I've never seen a right-angle ruler the size of a skyscraper. I can barely level shelves for paint cans. To think I had been looking at buildings as menial forms, never truly seeing the art of even the simplest structures.

In the old world, some cultures made the architect stand under the bridge they built while the last support was removed. That's *really* living or dying by your work. When it came time to hoist the columns of the Pantheon, each a solid slab, the architect waited outside of town on his horse, fearing death if something went wrong and it fell.

Through the entire trip, I couldn't get over the sheer engineering feats I was seeing. I had never before examined the connection between art and primally-purposed structures. To me, they were always disjointed, and I realized I'd been missing so much more of what they could become, and how they could connect me to my surroundings. When we returned to Houston, I began to see things differently, suddenly noticing things I'd always taken for granted.

TEACHER'S TEACHER

In middle school, I received a hard lesson from a great writing teacher. As many teacher-student stories begin, I was not her biggest fan. She challenged the class, made us work beyond textbooks, and I failed a semester for the first time ever. My mother thought there was something wrong; I had never gotten a lower grade than a C. So she sent me to an independent tutoring facility where I was tested over a four-day period, reading passages and answering multiple-choice questions. Wouldn't you know it, I aced every test! They were testing me by the textbook, and couldn't understand why I failed the semester yet performed perfectly on their tests. It's easy to pass when you're spoon-fed. The thing is, this teacher, Miss C, was eager to connect with everyone, she was the female version of Robin Williams' teacher in *The Dead Poets Society*. Sitting in her classroom was the first time I had ever heard of *carpe diem*. She was

the type of teacher who took notes while watching a movie, analyzing the symbolic nature that the artist strived to represent.

Everyday we walked into Miss C's room, she would have two questions written on the board. Sometimes, they were relevant to a past lesson, sometimes they were off topic, which was meant to challenge us, give us a broader scope. Always requiring more thinking than I'd planned, both questions had to be answered with a full paragraph and turned in after the first ten minutes of class. With every damn question on her board, it was clear she was searching for something of meaning within our answers. I didn't want to read about animals on a farm, or a guy playing with his mouse. I didn't care why these boys were playing God with flies. I *hated* writing and hated reading. And I *really* hated thinking about what to write and then having to write it.

I had been slipping through the cracks and I hit a solid concrete slab with her. Unless I wanted to transfer schools or take a summer class with another teacher, I was stuck.

She used the same practice on us that she used at home: she'd have us watch a movie first, then analyze it, then write about it. The movie she had us watch was *First Knight*. I had just seen it; it was good, the typical King Arthur, good guys fighting bad guys, some sticky situations only Richard Gere as Sir Lancelot could fix. I was prepared to analyze with only those thoughts in my mind; there wasn't much else to it as far as I could see. It took about a week to watch the entire movie, after which I thought there would be some writing and that's it . . . but no. We answered questions based on our first overall assumptions. Then we broke it down into different parts and analyzed what they meant. I was getting pretty frustrated; how much of this could there be? Honestly . . . I'm running out of material, and soon she's gonna see right through me. After a week of Q and A, she did what I imagine any teacher would be frowned upon for doing today—it was definitely not by the book. She took us step by step from the thoughts we had about possible meanings, and then metaphors we did not consider. She had us theorize about deeper explanations, connecting everything we had seen. King Arthur's castle as Heaven, Lady Guinevere's quaint village in the woods filled with innocent people as Mother Earth, and the antagonist with his army living in a bleak decrepit cave, Hell. The antagonist, a former member of King Arthur's round table, was now an

outcast. One fighting to protect Mother Earth and the people, the other seeking to destroy it along with an idea, knowing it was the only way to get to King Arthur and take his kingdom. She had us consider the side conflict, that the Camelot Law set by Arthur was now challenging his ideals as his wife Guinevere and Sir Lancelot break these laws and cause King Arthur an internal dilemma. The major fight scene portrays Arthur's Knights as angels with their uniformed shining armor in the moonlight, while the antagonists' army was down the hill, wallowing in a muddled, disorganized mass in the midst of burning haystacks.

This complex analysis explained so much more than I'd considered, presenting clear and sound reasoning for me to contemplate.

Whether it was what the artist intended or not was beside the point. It was a plausible theory connecting an idea and representing it in another form. I didn't know this was possible at such a deep level and, from that moment, it created in me a spark of curiosity, causing me to dig deeper into the meaning of things. No matter how simple they seem, they can offer so much more. Miss C wasn't necessarily teaching us how to write, but how to find something worth writing about, showing us how to uncover the relevance in everything by being willing to look deeper. Learning to write is easy when you have something to write about. That was how I came to understand *carpe diem*.

She believed in never giving up on her students, yet never giving in, either. Her lessons were hard, but she knew it was important not to let a student like me slip through the cracks. I respect teachers who go beyond the textbook, with lessons that can be used to help an adolescent throughout their life and not just for the short run. That takes guts, a lot of patience, and love for what they do. I can't imagine a teacher being able to use such tactics nowadays, and that's sad.

AT FIRST SIGHT

Our trip to Italy revived that lesson for me. I now knew what my next series would express. I owed Miss C that much, and planned to pay homage to the architectural world that brought me back to a place of importance.

I was now back at the studio with a clearer vision of what I wanted for the new series. It was just a matter of how to go about it. The idea was

to incorporate the abstract world I was familiar with, and merge it with architectural structures in a seamless fashion, depicting the two worlds meeting and interpreting each other. As I had found with the last series, reality is made of abstract pieces becoming whole, but the first step to seeing it is in the formation of primal lines and shapes.

I felt the structures should remain in black and white, focusing on the bold presence of primal purpose and form, letting my textures speak of soft tones flowing in and out of form, contrasting each conceptual point, but pulling into the same creation.

I first started to sketch the intricate structures in their entirety and, after much iteration, I could not find myself at peace with the idea. The structure had already been created, and any recreation would never do it justice. It did not fit my interpretation, as it came from the place of contact between the two worlds, not the re-creation of both worlds, thus missing the mark and ruining the whole concept.

If I couldn't make sense of it, how could I expect others to?

I decided the structures would have to remain predominantly untouched, captured on the canvas without rendition or alteration. This would prove to be a challenge. My usual textured layering process was not smooth, and the torture of mineral spirits and water from layering would limit many mediums from transferring. On top of that, I did not want to use wood as the substrate; I wanted it to be on stretched canvas, which offered up its own set of problems. I even tried an old-school technique with acetone transfer from an overused library Xerox printer, as I heard they release the ink easier. I finally settled on an altered collage process, one that would be able to handle itself well, while allowing me to concentrate on balancing the timing of layers in and around the structure.

After creating many understudies, the composition of the structures had to consist of at least 3/4 to 4/5 of the canvas, to fully represent the sheer magnitude of the structure itself. I found that the eye prematurely forms a relative idea of size based on the structure's relative size to canvas.

Coming to this conclusion had a drastic effect, as all canvases then must conform to the structural dimensions, rather than the structure conforming to its surrounding space on canvas. The source images were extremely limited, the scrutiny of angles, shadows, tourists, buses, trees and other buildings would all become variables and had to be considered. I'd have to bring hundreds of images down to a handful. I assume the

photography world faces this challenge everyday, and it is one I do not wish to share.

I ruined many understudies and paintings in formulating the right approach, slowly smoothing out the process until I was satisfied. Finally, I found my rhythm in bridging the two worlds of structure and texture. I used ink, oil, and charcoal to form fine lines from the structures, off into loose angles of open textured spaces. The transition was pulling one in and out of the two worlds through the most primal purpose of lines, while keeping the respect for each standing independently.

The only thing missing had been the public test—not whether they liked it (irrelevant, but always nice if they do), but whether they ask if it is a collage or a sketch. If they started inward moving out, or started outward moving in, the moment of seeing one as the other and the other as one, triggers the curiosity of looking deeper. That is all that mattered to me, and it is when this question was asked that I knew I had done my job as an artist. I named the collection of paintings, *Exploration Series*.

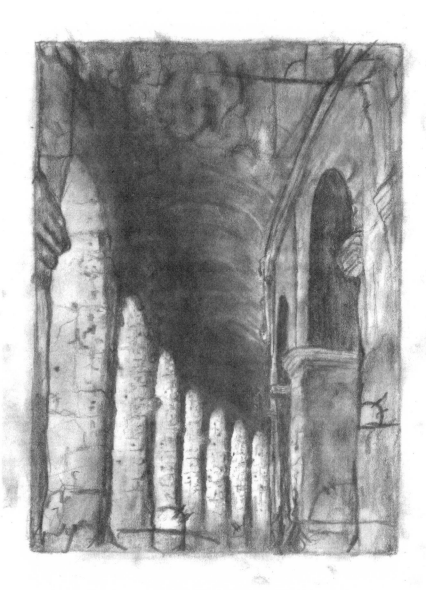

Exploration Series sketch

INTERLUDE I
Notes from the trenches

The inspiration to create any work of art comes from within, and is said to be an activity generated in the right side of the brain. But the motivation to make a sustainable living as an artist is an external process, and requires organized, strategic thinking. Both sides of my brain contain a vast collection of data . . . but my left brain is the side that sorts it out, keeps track, and takes notes.

> *"The first quality that is needed is audacity."*
> —WINSTON CHURCHILL

What's the content of my next show? Focus on a new series, a new theme? An assortment of new works? A collaboration with another artist?

Where will my next exhibit be shown? What's the budget for the show? Is there a fee for showing at a particular venue? What's the incentive for the venue to host my exhibit? Does the venue charge an upfront cost? Do they want a cut of total sales—a 50/50 split, or an 80/20 split, with an upfront fee? Is the venue hungry enough for my business to send more than a social media invitation? What's the estimated attendance? How long will my work be hanging in the venue?

How can I light this venue to best show my art?

Will I have to hire bartenders and caterers? Do I want live musicians or a DJ?

Will we need valet parking?

Who'll handle the PR and marketing? Who'll design the invitation? Who'll print? How much will that cost?

Can we get sponsors for the event by cross-promoting their alcohol, food, other products or services?

> *"All generalizations are false, including this one."*
> —MARK TWAIN

Pitch from venue: "We have over 5000 email addresses and social media followers." Really? Break it down: the percentage of people who open the email invitation is maybe 10%. Out of that 10%, 5% might attend. Percentage that actually shows up? 2%. So: how many of those "5000 email addresses" are real or bought? How many times do they email blast their people? Look at what they've done for others. Go with your gut.

> *"What kills a skunk is the publicity it gives itself."*
> —ABRAHAM LINCOLN

I don't have the energy to think about building my brand . . . I'd rather retreat to my studio and work. But it doesn't matter how good I am if nobody knows who I am. So . . . who can I trust to get me Out There the way I want to be Out There without my having to go Out There too much?

> *"Location, location, location."*
> —ANY REAL ESTATE AGENT

If the event isn't easy to access, we won't have a good turnout. Red flag: your own grandmother won't make the trip to the venue.

> *"It's always about timing. If it's too soon, no one understands.*
> *If it's too late, everyone's forgotten."*
> —ANNA WINTOUR

Scheduling the event. Stay away from summer—too many people on vacation. Thanksgiving? No thanks. Christmas/Hanukkah? Ho-Ho-No.

Day of the week—Thursday or Friday evening? Saturday night? Call publicist to plant us on the "must attend" list.

Watch the weather: steer clear of the rainy/snowy/hurricane/tornado seasons. Check on street closings for construction and marathons. Pray for no earthquakes or other unpredictable Acts of God.

"To love beauty is to see light."
—VICTOR HUGO

Lighting is everything. Do I want to use a bluish tint (closest to daylight—but watch for the overhead florescent look) or warm, yellowish tint (like home)?

Light fixtures: pin spots or floods? Make sure not to light the wall and the art the same (like a wedding in which *everyone* is wearing white).

Check the distance of the spot from the artwork . . . too close burns a "hole" in the work and leaves half of it in the dark.

Check the angle of the light on the work . . . not so sharp that it casts a horrific Frankenstein shadow. But sharp enough so viewers aren't blinded and try to sidestep the glare. The angle that the light travels to the painting is the same angle it reflects back towards the ground . . . give or take a few stray beams.

Adjust light intensity according to ceiling height.

If the venue doesn't want a well-lit show ("It'll clash with our ambiance") my work will hang in the dark. Yeah, *that's* not happening.

"Music doesn't lie."
—JIMI HENDRIX

Lighting at an art event sets the mood. Music sets the pace.

With few exceptions, music needs to fit the style of the art. The rhythm and the tempo of the music in the room should be chosen to support the art and direct the way viewers move through the room. When people are engaged in the environment, they connect to the work.

DJ? An easy choice. Versatility of tracks. Generally less expensive than live music. Give them an arrival time earlier than everyone else is called.

Choose a spot in the room with ample room and plenty of electrical sockets. As the night progresses, a DJ can get carried away by the response of the audience. The music might get louder, the tempo can change, random music may get slipped into the programming.

Live music? Smart choice for a very specific ambiance. A single harpist or acoustic guitarist, a jazz trio, a string quartet. Classy. And costly . . . maybe recruit students from a local college.

Zero music budget? Program your iPod.

> *"Look at that subtle off-white coloring. The tasteful thickness of it.*
> *Oh, my God. It even has a watermark."*
> —PATRICK BATEMAN, AMERICAN PSYCHO

Labeling artwork makes the same statement as a business card. Simple black print on white stock. Or little framed price tags. Or clear labels— stuck straight to the wall or mounted on a small piece of Plexiglas raised slightly off the wall. Or handwritten.

~~Or tiny white push-pins with a microscopic number on them.~~ (No! . . . unless you're going to provide a magnifying glass.)

In any case, expect to be putting them up at the last minute. And expect at least one typo in the bunch (just make sure you haven't left off a zero at the end of the price).

> *"I kind of like being in a minivan and people not paying*
> *so much attention to me."*
> —GEORGE CLOONEY

Early days: I once had to wrap my art in a blanket and (because the pieces were so big) strap it to the hood of my car. I'd drive down back roads with one hand on the wheel while hanging on to the work with the other. Every gust of wind took my breath away. I'd park down the street and around the corner from the venue I wanted to impress. After I invested in the creepy white van, I parked in front.

"The photograph isn't good enough. It's not real enough."
—DAVID HOCKNEY

Must remember to photograph my work for documentation . . . and not with my smart phone. Professionally lit and shot at high resolution, the photos have to be exceptional in depth and detail, to make a good first impression on my website and others. Not everyone can see the work in person . . . so the photos have to represent.

"A man's kiss is his signature."
—MAE WEST

Should I sign my work on the front? Does that distract the viewer from the purpose of the work? If I don't sign it, does that mean I'm not very proud of my work? I have to believe my work stands on its own without my name in the lower right hand corner . . . but I want to claim the work. Who cares, as long as the back is signed and dated for authenticity?

Maybe the reason a painting has no signature on the front is simple: the artist just forgot to sign. It was the last thing on his mind.

"Wine hath drowned more men than the sea."
—THOMAS FULLER

It has always baffled me that people at art shows and gallery openings can hold a plastic glass filled with cheap wine in one hand and write a $10,000 check with the other . . . as if the euphoria and rush of committing to a piece of art overtakes all sense and sensibility and allows boxed wine to go unnoticed.

"What is called good society is nothing
but a mosaic of polished caricatures."
—KARL WILHELM FRIEDRICH SCHLEGEL

Art shows, museums, fairs, galleries, open studios provide a rich opportunity for anthropological study . . .

The Overly-Curious-About-How-It's-Made Artists—I can spot them the minute they walk in the door. They can't get close enough to my work. A detailed examination of the work from every angle. At an open studio event, they'll take a hard look at any materials in view. They stroll around the room, I see their minds working out how to do it themselves. They seek me out, ask about my every choice. I like to confuse them with ratios of mixes and multiple-option products, and rant about controlling the temperature for perfect drying times until their eyes glaze over. I never lie; I just hide the needle deep in the haystack.

The Familes—I like kids, I really do. Really. *I* was a kid once. I love teaching kids about art. But when parents bring their children to a show and let them run around the space, scooping all the sweets from the refreshment table, collecting business cards as if they were baseball trading cards, and (worst of all) *touching the paintings*, I see them as little savages sent by a competitor to wreak havoc. I realize they don't know any better . . . but if I can't ask the little critters not to trace their sticky little digits all over my work, who *can*?

The Insiders—Not artists, collectors, groupies, or gallerists. Usually affiliated with the media or an art-based organization. They keep a complete dossier on all the players in the art world. They're at all the invite-only events and can talk shop with the best of us. A good source of information about art scene politics. Whose gallery is closing, which gallerist isn't paying their artist? Who won't work with whom? Who just got a huge commission or a new installation for public display? Which collector is shopping for a new artist? What are they saying about *me*?

The Groupies—They attend every art event in the city. I like to believe they appreciate art—but I never see them buy. They *do* appreciate the free wine, fruit platter, and bowls of mixed nuts (cashews go first). The Groupies' calling cards: an empty nut bowl and a naked grape stem.

The Students—Look for plaid and khaki. Awkward, whispering to their friends, shy about asking questions. But when they do, it can last all day. I get it. Behind the canvas, I'm that kid, too.

The Peacocks—Brave and bold trendsetters, you can't miss them. Floppy polka-dotted bow ties, bright blue suede shoes, Big Bird-yellow suits.

Art exhibits are safe havens for those who like to make a visual splash. Sometimes, I'll break up my usual shades of grey with cherry red pants. Just to fit in.

The Young Professionals—Dressed to impress, right out of GQ or Vogue. Dipping their toes in collecting. They'll look at it and think about it—maybe buy—but there's no guarantee. If they don't leave with a piece of art, they'll leave with a pretty person . . . or the pretty person's number.

The Young Couples—No better way to impress a date than by taking them to a free art exhibit. The philosophical conversations! The creative enlightenment! The free wine and appetizers!

The Married Couples—She's looking to buy and he is looking to keep her happy. Works for me.

The Collectors—Easy to spot. Poised, confident. Always talking to the right people . . . not because they seek them out, but because the right people seek them.

The Artist—Coming to check out the exhibit, pay respect to a fellow artist—and get out of their own studio for the night. Sad to say, it's the only time most of us cross paths. We're dressed in black and grey. We might need ironing. We might have paint under our nails. *Note: this is the only time and place a socialite in a cocktail dress and a hobo-chic artist have equal clout and can be found comfortably conversing.*

The Ambulance Chaser—Scavengers. Attending a show to collect collectors. Passing out business cards or invites, promoting other shows on someone else's dime. I guess that's how it's done. But it's not how I do it.

LAYER 3

Parvocellular

THE PROVERBIAL EXAM

As the story goes . . . a professor of psychology announced to his students that their final exam would be an essay . . . and the topic for the essay wouldn't be given until the day of the exam.

Quiet, nerve-stricken students slowly filled the classroom seats that morning. Since there'd been no chance to prep, some had desperately sought comfort by pouring over all the notes they'd taken throughout the semester. Others tried to deduce which lesson the professor would have them access. A few found the lack of prep less stressful, clinging to the belief that, "If we don't know it by now, we never will." But everyone was on edge; after all, they'd been told there was no real way to prepare for an exam that would count for 40% of the total grade.

The students shifted in their seats, pale and perspiring, as the professor casually strolled in, wearing a smirk on his face and dragging a chair behind him to the center of the room. He looked at everyone and paused, then said, "Tell me about this chair." He took his own seat, raised his feet to rest on his desk, and buried his face in the latest issue of *Mad Magazine*.

Confusion spread among the students, their hushed astonishment rustled through the room, the smell of anxiety seeped out of every pore. There was no context; just an open-ended question about a chair. It was such an easy topic, yet so hard to contemplate, it blew everyone's mind. They had three whole hours to write about a damn chair.

Do you write about the history and evolution of a chair and it's significance to humanity? It's unlikely you'd be equipped to cogently explore that subject. Unless you were a chair maker's son or pursuing a career as a furniture designer, it's not a topic one usually studies. One imagines the students started to think of what they knew about chairs and their place in society. Perhaps they thought of the chairs pulled up to King Arthur's round table, for instance, and the hierarchy of the placement as it applies to most tables, in the board room or the dining room: at the head sits the King, the patriarch, the alpha dog, the Don, the CEO. It's possible that some broke down the chair into parts, finding symbolism for each piece. Maybe some formulated a deeper meaning for clichéd phrases like "having a seat at the table."

It's easy to picture the students squirming in their own chairs, as if it were the first time they'd ever sat down, hoping their asses would give them clues. Three hours to write about one simple chair; the mind begins to obsess, thinking it must use up all the allotted time—which only supplies the fuel for an attack of panic.

The chair is a vital, everyday object. The professor posed an ingenious question, creating an even playing field for everyone. But not everyone knew how to play.

And then, after twenty minutes had elapsed, one student stood, approached the professor, and laid his paper on the desk. The answer to his riddle was offered with a two-word question: "What chair?"

With 40% on the line, the student made a bold move. He could have pulled from any context, his choices were wide open. And he chose to question the very existence of the object.

When DaVinci was asked to prove himself a master artist, he drew only a perfect circle. Genius.

The chair is so commonplace. We forget that, just because we know of a chair, it doesn't mean we have asked the right questions to help us understand it. How did this object become such a crucial part of our lives? Are we really so complacent that we can accept the chair without further investigation? We reach for the stars, we dream of the things we don't have, and we understand so little of the things we do.

THE JOURNEY

The Exploration Series received a great response. People began to see a consistency in my work, and I could feel it. I began to paint with less stress, letting my subconscious take over, trusting the outcome to be succinct. It was very much like my memory of learning to ride a bike. I understood the parts it was made of, made the connection to riding it, got over the emotional shock involved with it, fell a few times, got some bumps and bruises, but nothing more painful than a small scratch to my ego.

Now I began to feel comfortable, looking around instead of down, letting my subconscious guide me to new places. I had built a strong foundation; now it was time to build up, be seen and see more.

The starting point normally began with me standing in my studio. The once-empty room was now filling up. Eight-foot by four-foot wooden rolling tables custom-built by my stepfather Bob the Builder were centered on the painting side of the studio. I now had an addiction to collecting paint—way worse than a woman buying shoes with a limitless credit card. I had stacks of colors everywhere. Walls were lined with primed, white, stretched canvas, with even more stacked in the closet.

I will tell you there is nothing more intimidating than a white canvas staring back at you, like Rocky meeting Apollo Creed in the ring for the first time. Don't show fear, but don't show disrespect, either.

With warm studio lighting in place of cool fluorescents, music vibrating off of the brick walls, I start to use fancy footwork around the ring. I study my opponent until I am ready to make a move. When I hit the canvas, I start in hard.

Techniques confident. Moves of the brush a mere glimpse of déjà vu.

I'm looking for something. Like digging into an old chest, I won't know what it is until I see it.

I'm looking for something. Painting my way through. Staining the canvas. Losing my surroundings. Curiosity drives me deeper.

I'm looking for something. Feeling through each choice; stains become darker. I go deeper still. Time displaces, and food becomes irrelevant.

Then, I can go no further. I must come up for air. For now, the fight is over. I step back, taking in the work in its surroundings. I am weak, with paint-stained hands, brush still dripping. I can't make sense of where my creation came from.

I had not traveled anywhere, bringing conclusions to the madness. I had no epiphanies, just flooded with emotion. I had realized it while standing in my fluffy white robe, it had come to me, calm and controlled, but not by any conscious means.

In the beginning, there were five pieces. A three-week stint went by in a wink. I still had no idea where they were coming from, and I did not like that feeling, unable to identify their reason for being. It didn't matter: the work felt right, they showed something new, not just the technical aspects, but a sense of growth in a person. I aptly named the first five works and the rest to come, *Creation Series*.

But the underlying question still lingered: "What am I looking for?" I had not yet answered that, and it ate at me. I knew that somehow the answer to that question would lead me to understanding the series, give me the *reason* I was painting these works of color bleeding on the foreground leading into the pale background. The soft transition of a horizon, calming in its movement, every part of the canvas steadfast in the depths of emotion. The silence between chaotic texture and stagnant color were balanced with gravity long enough for a stain to plague one's curiosity.

I'm looking for something. I knew it, and I could see and feel it in my works.

I was at it for months, staring at them hanging on the wall, studying them for hours at a time. I found myself asking why, why are you my obsession, what is this endless river of emotion channeling from somewhere upstream? I am looking for something when I see you, an answer, a key to unlock the door to something familiar . . . yet I do not know what I seek.

I remember this moment, void of sleep, gazing upon my works under the soft lights, the foregrounds full of color igniting my emotions as I journeyed deep into the backgrounds, pathways leading to the answer. I had been assembling a map guiding me forward in a process, subliminally vexing my curiosity. It was my subconscious communicating an idea through to inception.

I began to reach an understanding of the works, each painting had a different foreground color feeding me emotion as I passed through and was pulled into the background. Although the emotion was different between each piece, the journey was consistent and the process still led me to look for the same answer.

The longer and deeper I stared, the stiller I became, drifting down into the rabbit hole. I could hear my mind contemplating the reason, and the words of a question rose louder and louder: *What do I desire?* I am one person, one painting. Across multiple paintings, the question remains the same. A series, a whole, not one person, not me, but me as a *whole*, the *greater* whole, society, humanity, the series, not just the individual journey, but the desire from which all journeys derive, regardless of the foreground emotion that shape each differently. A deep echo answers from the abyss: "Yes . . . *desire."*

The primal instinct of human nature is survival. How does an organism survive? I could feel my eyes begin to relax as my mouth began to mumble the words, "It must evolve." Evolution is derived from the desire to survive, the will to live, to further one's knowledge beyond stagnation.

In the process, on the journey, through the surface of objectivity and convolution of subjectivity, I had looked right past it; so simple in its purpose, yet with a limitless complexity. I felt my brain unlocking reasons, expanding my gaze. The student, the essay, my paintings— what did we ask of them? A question. The key is the question. So, the birthplace of evolution is predicated by the simplicity of asking a question. To think, the evolutionary concept of gravity came from a falling apple and a man who dared to question it. Would there be a place for us if we still thought the world was flat?

Something inside me knew this answer. Deep in my subconscious, trying to show me the way, using all the clues, triggering my curiosity, pulling me in and connecting with what was there all along.

Where had I been my entire life, if not for this moment alone, with my paintings teaching me something about myself, about humanity?

It had always been there, we have always had it; as children, there was no greater reward in life than to fulfill our curiosity, so we used it often. As we get older, we still question—but we smother it with an excuse, using flimsy reasoning a child can see through. Our minds have endless capacity, yet we are content with sitting still on a white plastic lawn chair, staring through the gates and watching the world go by.

LOST IN TRANSLATION

I was relieved, but I felt alone. It was hard to swallow; the moment was intense, like watching a person be born, grow old, and die, all in the blink of an eye. How do you explain such a thing? How do you find the words to respectably give meaning to a moment like that?

I had long since given up on explaining the meaning of my works, chopping things up into an elevator speech. I used to give an in-depth explanation for each piece, even formulating a short paragraph to accompany the work, bringing curiosity to question. I had thought in the beginning this was required of all artists; I would never show my work until I could make sense of its existence.

Early in my career, before my first series, I made a painting I called *Stressing of Time*. It was my pride and joy, a highlight of the exhibit, and I priced it accordingly . . .

On the evening of one of my shows, a gentleman inquired about the meaning behind the work. I explained it in great depth, maybe not in the most eloquent manner, but it was the story he'd asked for. When I was finished, the gentleman thanked me, and told me he really enjoys my work, but he asked no questions. I smiled, thanked him for the comment and for coming, and cordially left him in Kim's company. As I walked away, I heard him say to her, "I don't understand any of that, I just like the pretty colors!"

I know he didn't mean anything by it; I know it was a simplistic response to my involved explanation of my work. His were nothing but light-hearted words; the man worked all day and was there to relax. I know art isn't everybody's obsession. I know that leading the proverbial horse to water doesn't mean you can make him drink.

It was more than that for me, though; the principle of the matter was still buried in the sand. I didn't understand why he even asked. If he didn't get it, why didn't he question my explanation so I could help him understand? Why didn't he argue a point of his own against mine? He just nodded to be agreeable. I can see how an artist would become jaded and make up stuff about his work, because nine times out of ten, this empty exchange is all that happens. It doesn't give either party an incentive to explore the work more deeply.

When you're viewing an artist's work, you should *want* to ask questions. Bring your thoughts on the issue, find common ground, discuss how it might relate to your world, challenge the artist—not in a deliberately cruel manner, simply out of curiosity. This symbiotic relationship certainly stimulates me as an artist, and helps to develop my thinking, expanding my view as well as yours, pulling the best out of us both. What else do we have to lose? You don't have to agree with me, and you don't even have to like my work—it is a subjective means of communication between people. And it's free.

Later that evening, Kim reminded me that people are not always in the mood to think that deeply. They simply need to relate to it; it can't be a long, drawn out explanation, or their eyes glaze over and you've lost them. This made me feel like I needed to be a politician at a show, not an artist. I was pouring every ounce of myself into the art *and* into an idea behind it that sank deeper than the surface. It's art. Why do people ask if they don't want an answer? I prefer an awkward silence to pointless questioning. It's a waste of everyone's time. I'd rather spend my time trying to figure out how I got a paint stain on the new pants I bought an hour ago when I haven't worn them in the studio.

(Clearly, I had to learn that nothing more than my expectations were feeding my bitterness and setting me up for disappointment . . . but I wasn't there, yet.)

Unfortunately, as a result of that evening, I succumbed to silence. At future shows, I stopped volunteering information, except when asked—even then, I got very good at knowing who really cared and who didn't. With the latter, I'd skim the surface and shorten the depth of the description. Most of the time, in the middle of explaining, Kim would send me a signal, or I would notice their eyes start to fog. Either way, I knew it was time to wrap it up. Depending on my mood, I might throw

a curve ball and let them deal with it. I did manage to develop a short synopsis of my work in a twofold artist statement. I did this only because of the question it would present to the audience. It was an ironic ploy, like an Andy Warhol joke, which made it worth writing.

> *"Unexpressed emotions serve as*
> *the subject of my art.*
> *I believe the creativity of the mind is endless,*
> *the only way to understand ourselves*
> *and the world in which we live,*
> *is by exploring the inherent curiosity*
> *that lies within each of us, and*
> *that unrelenting urge to ask, 'Why?'*
> *The work thus becomes the*
> *doorway in discovering the answers*
> *behind the question."*

I settled on this; it was vague enough to grasp and light enough to read. Most who read it were satisfied with its sound reasoning, so everyone just glanced over it and never thought twice about it.

On the surface, it literally begged to be questioned, leaving cookie crumbs for those to follow, if they were curious enough to do so. Those were the people I would wait for, the ones who dug deeper, who asked, "Wait a minute, what about that, or what about this?" The one who would take my questioning and apply it to a piece of my work. Contemplate the name of the piece against their reasoning, and then question me about it, and ask me why. I loved it; it wasn't about being right or wrong, it was about creating a tangible object that opened up a process, observing the process, where it came from, where it's going, and how to get from A to B in the process. I already knew what it was for me—humanity works on incentives—and I knew the only way to reach people was through their own curiosity. Without this realization, an artist can be driven to mediocrity—complacent at best, jaded at worst.

THE DILEMMA

As an artist, my source for inspiration is the world around me: the love, the hate, the unknown. As long as I have access to these, and to the materials with which I paint, I can create.

But at this point, I was conflicted. The business side of my brain was having a hard time understanding certain actions and decisions I had been making. I spent so much time studying my work, perhaps more than painting them, continually evolving my understanding, writing for myself, constantly dissatisfied, wanting more. The people who truly questioned me were just a handful compared to those who didn't. My work sold in any case.

I began questioning some of the things I'd been doing. This was the season that turquoise paintings were extremely popular, and anything I made with that color sold. I had noticed it at other shows as well. This should have excited me; but once I realized it, using turquoise bored me. I would tell myself it was no longer a challenge. I saw the angle, I thought about it, even attempted it . . . but the work became a drag, it just didn't interest me, and I would have to change it or throw it away.

A company that sells originals in their store and had multiple locations across the United States once contacted me with an offer. I decided to meet with them and see what they had to say. They would choose the ones they liked, and request that piece in a certain number of different sizes to be repainted at a minimum 95% likeness. I'd receive all payment up front before sale. In the middle of the sales pitch, the salesman's boss called. It felt like Big Brother was calling. "Yes sir, I have him here right now, sir, yes sir, will do." The salesman hung up the phone and said, "I am instructed to let you know that, on certain occasions (meaning any occasion that will get the artist on board) we can send your work to a facility out of the country (China) and have some people recreate (not print, but repaint) the painting there." He continued, 'You also don't have to sign your paintings, or you can use a pen name, if that works better for you. We have some well-known artists who do that.'"

This was freaky; I had *just* asked him about prints when the boss' call came through. I asked him a few more questions, then left. I never went back. Even though I wouldn't have to bust my ass creating new work, I'd no longer have the anxiety of putting on shows and the stress of being

poor. Even though I'd just sit back and let them recreate whatever they wanted. Even though the money would have been nice . . . something didn't feel right.

Around the same time, I had established a relationship with a national print company based in Austin and could have sent them everything I had. I could have painted hundreds of turquoise paintings for both wholesale and prints, painted whatever I wanted under pen names, pulling in solid royalties. But I stopped painting turquoise and never went back to the wholesale store. I chose instead to submit selected pieces only to the reputable national print company. As my first step into the print world, I offered understudies from the development of selected series that represented a milestone, an idea, or something I had learned that I wanted to share.

I can paint anything—villas in Tuscany, the mesas of Santa Fe, seagulls in Galveston—and could easily have done so for these companies. Yet, when given the opportunity, I declined. And my continuing relationship with the Austin-based company is more satisfying because we have a mutual creative understanding. But it took a deeper comprehension of my own psychology to appreciate the value of this relationship.

I started to feel that maybe I was afraid of success; running from the chance to make money and become successful at it. I felt that there was something wrong with me, that I was ungrateful for the chances and the gifts I had been given. Even with all the labor, the trudging through the trenches, all the days and nights lost, dreaming about more and slapping opportunities in the face, I was floating in mounds of debt, from one 0% promotional APR credit card account to the next. It was as if I *wanted* to be miserable. I'd been living on the edge of income for so long, maybe I didn't know how to live any other way.

The millionaire promise I had made years before was still the way I measured success. Now, I saw a way to achieve that challenging goal and the path that could lead me to it. And this was my dilemma: how do I choose between the intrinsic value of art and the extrinsic value of commerce?

There was something missing, some lack of fulfillment still weighing heavily on my mind. Money seemed to be a relatively insignificant measure of one's success, of one's purpose in life. I had come to realize through my journey thus far, that making a million dollars was relatively

easy; all it takes is giving something in exchange. It can be anything—an object, your time—but making that million might mean trading your morals, dignity, and self-respect.

I now knew that the only goal truly worth striving for, and worth achieving, is respect. Respect for one's self and for one's purpose—which, in turn, garners respect from others. It is the one thing you cannot buy or inherit and (most important), you have to give it to get it. To have your worth tied to your word and a handshake, to know those around you speak highly of you when you're not in the room.

In my youth, I naïvely chose the one thing that had no real bearing on true success; a monetary goal that, when achieved, gave no weight to self-worth. When I finally came to this conclusion, I felt lucky and foolish: lucky to have found myself at this moment in my life, foolish to have thought there was any other way to live.

I wanted to achieve greatness, and I would welcome financial success. But at the end of my life, I wanted to know I had chosen to live and work with respect for myself and my art, and had earned respect from others along the way.

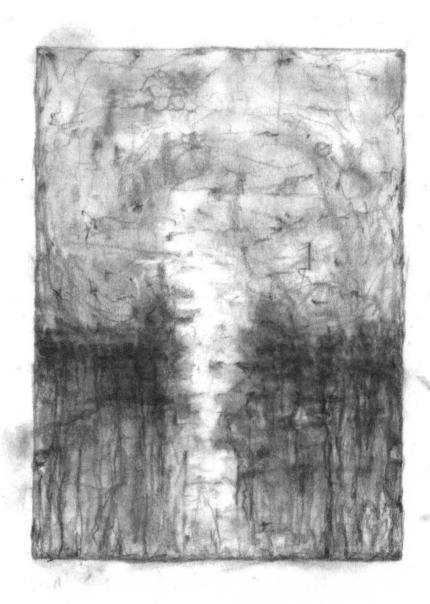

Creation Series sketch

LAYER 4

External Filters

SMOKE, MIRRORS AND PULLING STRINGS

The realization armed me with a new perspective and a fresh confidence in the way I wished to conduct my business. At the same time, Kim attended a local charity auction where she bid on an opportunity to have lunch with a woman (I'll call her "Amy") who had recently published a book about Texas artists. Amy was an insider; well-known on the publicity side of the art world. She had donated the item that Kim won. We hoped to pick her brain for a different perspective on the industry. This was a great opportunity for me, as I still had many unanswered questions.

Within a few weeks, we nailed down a time that worked with everyone's schedule. The venue Amy had chosen was a sandwich shop, with high off-white walls, polished concrete floors, Art Deco chairs, and

hourglass-shaped tables. It reminded me of a school cafeteria with only four tables; in my mind, it was not the ideal place, but I thought it best not to complain. Amy had told us she'd invited an art consultant/art dealer to sit in on our lunch . . . so, anywhere she wanted to meet was going to be fine with me. I was looking forward to this meeting, and wanted to be fully prepared. I brought my iPad and my list of questions. My curiosity level was high.

Kim and I arrived on time, with a little bit to spare—just enough not to be late, but not so much that we'd look overeager, with empty coffee cups in front of us. I think it's rude not to order anything while you're waiting, so if you've finished the drink you ordered when you arrived, it's always a telltale sign of desperation. If the place is packed, and you see the person you're meeting already has a table, it's most likely not because they got really lucky.

Unlike us, Amy chose the fashionably late route. She was obviously a regular at this establishment. She strolled in, eyelashes fluttering (I wasn't sure if she had something in her eyes or was blinded by the paparazzi-like glare streaming in from the window). One hand was raised as if she were being sworn in, the other hand popped up like a royal wave at the row of fans to her left. Naturally, she followed that with a dramatic hello and thank you to each person in the shop; she seemed to know them all, and they were all named "Darling!" Kiss-kiss, hug-hug. Only after the commotion died down did I get a personal face-to-face, hand-on-my-hand, "So, how are *you?*" But, as soon as I started to answer, her hawk-like eyes spotted someone across the room. In Hollywood, it's six degrees of Kevin Bacon. Here in this Houston sandwich shop, it was six degrees of Amy. Off into her world she went. I gave up trying to answer her question and paused just long enough for her to spot someone else. She had been fifteen minutes late and, at the pace we were going, it was going to be another fifteen minutes before we were able to politely corral her to order. I had never met anyone like her before—so, as frustrating as it was, given the importance of the lunch, I was rather entertained. She played the part perfectly; on any other day, I wouldn't have thought twice about it.

We were thirty minutes into Amy's red-carpet arrival, and the art consultant/dealer hadn't shown up yet.

After Amy gave her subjects a final blessing with a royal floating kiss, we all sat down and began our conversation. One moment later,

with perfectly choreographed timing, her art friend (I'll call her Zelda) waltzed in, and the blessing ritual started all over again. Zelda was a very different character than Amy: all sorts of unhappy, not just a temporary unhappy, but a lifelong kind of unhappy. Bone-deep bitterness, with an infectious quality that could only come from having been wronged in a past life. It was obvious she did not want to be there, and it became even more apparent when she proceeded to carry on a separate conversation with a gentlemen sitting at another table across from ours, opposite from her and behind me, long distance, right through traffic. You could tell by the look on his face that he was mortified (along with the rest of the table) by this blatant dismissal. He did his best to redirect her rudeness by engaging all of us in the conversation and trying to end her line of questioning with, "Well, I'll let you all get back to it."

It was interesting to watch Amy ignore this situation like a mother would ignore an obnoxious child who won't settle down while the grownups are talking. I could tell this train ride was not going to be a pleasant one. For the life of me, I could not understand why these ladies were friends. Other than the impressive entrance by Amy that was a little over the top for my taste, I liked and respected her. If I were Amy, I would have been utterly embarrassed to have the crude and bitter Zelda as a friend and colleague. But that seems to be the cost of doing business in the art world.

The tension was very high, everyone could feel it; I felt sure that Amy regretted inviting Zelda. Nevertheless, we managed to make it through the lunch. I admit, I had to bite my tongue while smiling. The reality was that I wanted to slap the misery out of her, as if performing an exorcism.

Kim and I were starting to wonder if this "prize" was worth the money we had bid.

I managed to show Zelda some images of my work; after she gave them a brief look, I could tell she was not impressed. It was inevitable; she seemed unimpressed with *everything* around her. She humored me by asking the price point for my pieces. I replied by providing her with an average price based on price per square inch. She immediately scoffed and called me "poor sweetie." Then, as her nose hit the ceiling, she barked, "You don't price art in such a manner!" I grinned and thought, "Is this really happening?" My tongue was too sore to continue biting down on it any longer.

I knew this type of person. She was not interested in what I had to say unless it was something she could use against me later when I tried to defend myself. Justifying my position with excuses would just lead to a dead end. It was clear I was not going to get any of the answers I had originally come to find. So, I played stupid. I thought, "If she wants to push me in the water, fine, I won't try to get out. I'll just pull her in with me and see if she can swim."

I said, "I don't understand," and kept the " . . . please tell me why, oh Wise One?" to myself. Just thinking it helped me force a grin. As I expected, she didn't assume I'd accommodate her condescending words.

"Well . . . well, you just don't *do* that, it minimizes the artwork." She fidgeted with her fork.

"Oh? How come? What do you do, then? I'm curious." I calmly stirred my coffee.

"It's different, we just make it so, you don't apply a number like that." I could hear the edge in her voice sharpening.

"I see, okay. Where does this number come from? I don't quite understand what you mean, please explain."

"It's just, uh, it's too . . . menial, not the right way." She was having to reach pretty far, now. "Um, it makes it seem too much like a product." Yeah, okay.

"But a price does exist, right?" I feigned confusion.

"Yes, but it's *different*," she snapped.

"I agree it's different from a product, but it does hold a price at the end of the day that varies on some scale, so . . . please tell me then, Zelda, what is the *right* way?" To my surprise (and everyone else's), she was out of answers.

What she was alluding to was that pricing is based on the market, the status of a particular artist and what their work can go for. The smoke that can't be measured.

I wanted to ask Zelda, "Where is the line again? Which one is different? I'm a little lost, could you please explain? I wouldn't want to get mixed up with the wrong crowd." Instead, I sat quietly and grinned. I didn't think I was asking that much, especially given Zelda's high-falutin' title. After circling around and around with her, with no sound reasoning coming from her, I saw no need to continue. I got bored with pulling her leg under water and watching her splash about. She finally chose

the "Because I said so" maneuver, and delivered her *coup de grâce:* "If you want to be a fine artist, you can't do both. And if you can't afford to be a fine artist, then go get a day job."

I felt personally attacked, and I was not happy. I didn't fight tooth and nail, devoting every part of my life and my truth, and with respect for myself and the art community, to strive for part-time artistry. I was deeply insulted by her disdain for any artist she could not hold under her thumb. With no justification for her position, no straight answers, no logic, she still had the gall to make a definitive pronouncement: *if one door opens, the other must close.* That day, she slapped the face of every artist—every *person*—chasing their dream. She slapped *my* face. Fine. Challenge accepted.

I understood the age-old question about how to price art. I went through it myself, starting some random place with an arbitrary price, valuing my work and self-worth by finding a reasonable place to start based on my brand-new career. What I found most curious was why there was so much fumbling around; just state your price. You make it up, at least in the beginning. But it grows from some system of pricing, people keep track somehow. And if you believe in your work so much, why is it so hard to speak its monetary value? Why the secrecy? For an art aficionado or someone who represents an amazing collection of work, I'd think this would be easy to answer. What is there to hide?

I didn't understand why Zelda was afraid of a price point based on square inches. It isn't a scary thing . . . many artists use it. You can just as easily price by small, medium, large, or triangular and round-shaped pieces; it doesn't matter. A price exists in the end, no matter how you cut it. It's just a guideline that doesn't make it to the general public— not because it's bad, but it's not needed for the price tag. It's simply used to keep everything straight and aboveboard. When someone asks me the price of a certain piece, and I don't remember off the top of my head, I don't make it up. I have a particular point of reference, and I do the math based on the given criteria—different mediums such as prints, works on paper, canvas and others. A sculpture made of gold would be priced differently than the exact sculpture made of stone. This wouldn't be a shock to anyone. People want a starting point they can trust. Sure, if the particular piece in question is a work on paper and there are only three sizes you use, than you don't have to worry

much. But it's a small world, and if you lose track and go willy-nilly, selling one 40" x 40" to a client for $8,000 and the next day sell the same size to another client for $5,000, that puts you on the fast track to not being trusted. Not only that, people will automatically assume your price is up for bargaining, like a used car salesman.

The art world is already plagued with the ominous idea that there should be a discount when buying artwork, as if you're in a third world country bargaining over produce or silver. Thank you to whomever started *that* trend. I deal with enough people who assume a discount is customary. You just don't do that to collectors. Most important, it keeps the artist in line, with less time to price every piece on a whim and more time working. Most artists are not good financial managers, so anything that brings more clarity and less confusion would be in everyone's best interest.

The price—wherever it starts—comes from somewhere, and Zelda didn't want to admit that. It would be even worse if she didn't know. All she left me with was that art couldn't be associated with the same measurements as "lowly" products, and to do so would be considered blasphemy. She might as well have said to me, "How dare you question the process? You just price art, and it is what it is, no strings attached." That doesn't work as an answer for me, but it was the fear in her voice and her defensive demeanor that intrigued me more than anything. Something was not right; there was a much bigger underlying issue, and my curiosity grew by the minute.

The conversation began to digress into a rant about commercial art vs. fine art. While I had heard discussions about this before, no one could ever adequately explain the difference, even though many often questioned it. I knew this was about to get good, so I posed the question. Of course, she never gave me a straight answer. Every time she said something, I would counter with another question, and she'd come back with, "Well, that's different." I'd had enough. It was time for me to lay it all out for her: "You say some of it has to do with where the work is shown, but Rauschenberg showed his work in Macy's department store windows. I've seen many artists represented in a museum who have shown their work at bars—does that count? You use the example of working with interior designers as being commercial art, yet Mark Rothko's work was once considered 'designer art.' Is that different? Is

it about who sells your work? If your gallerist sells art to be installed in a corporate building and you work with the people that place the art in that building, is that okay? I've had my work placed in many commercial buildings and didn't use a gallery or art dealer or agent for the placement, but I guess you think that's different." I took a breath. "Is it the type of people who buy the work . . . or *why* they buy the work?"

If a designer walks in with a $10,000 check to buy art for a client who is too busy traveling and making deals to make the purchase himself, who trusts his designer to make his art buying decisions for him, I don't think you care what their title is. I don't think you initiate a screening process, as long as they are buying art from you. It doesn't matter. You can uncover million dollar pieces of art at a garage sale, if you're lucky. Is it the time that it takes and the effort put into the work? Van Gogh bragged about finishing a painting in one day. Rauschenberg said artists should do one piece every day. These guys were no shmucks.

Are we there yet?

I've wiped my feet on a doormat decorated with Mona Lisa's face before entering my home, in which I made a drink that I placed on a coaster of Andy Warhol's Marilyn Monroe, noted my exhibit schedule in my Picasso calendar, then took a shower behind a Van Gogh *Starry Night* shower curtain. I don't think the estate of these late artists, who make royalties off of the sales, are concerned with the difference. The last time I checked, each artist's original art was still selling at auction for multiple millions.

THE PROBLEM

If this was the future of the art scene, I was in trouble. It seems I always learn the hard way, and taking this on was all I could think about. I was too curious, which roused a fear that appeared to float around Zelda, and everyone else. After that lunch, it was even more evident, I just hadn't looked at it this way, as blasphemy that promoted a *sub rosa* segregation. Artists and even gallerists feared being blacklisted as "commercial," as if we were back in the days of the Salem Witchcraft Trials . . . except now, we'd point and cry, "COMMERCIAL ARTIST!" and hang them.

But, like Zelda, nobody really had a handle on what the differences were; depending on who you asked, it was always changing. There were always examples that would disprove the thesis.

The meeting plagued me for months. I was well into *Creation Series*, and started to feel like it was affecting my painting. It hovered over me, and only brought on more questions.

I understand the term "starving artist." It's hard to put down the paintbrush, switch gears and think about business, or go to events and talk about yourself and your work to strangers. Getting your name out there in this manner is a miserable practice of vanity. An artist with showmanship is a hard act to follow; I would have hated to follow Salvador Dali. You don't think his long curled mustache was an accident! He was showy, brilliant at captivating an audience, able to turn it on and off and still paint with such deep conviction. Think of all the public figures who are constantly "on" in public. There is no down time, at least none that anyone can see. For an artist, the show is the last thing we want to be thinking about.

In the beginning, I found myself painting one quarter of the time. The rest of the time was spent on all the "fun stuff"—website design, maintaining an event calendar, uploading new art images. It's time-consuming to create postcards and email invites for exhibits, wrangle vendors for sponsorships, deal with charities requesting a donation, inventory, packing, shipping. Until an artist gets to a certain point, there isn't enough money to hire an assistant. But you can't *not* do these things, or you will never get where you want to be. It doesn't matter how good you are if nobody knows who you are. Most people don't realize that being an artist of any kind is a challenge, when facing your demons is an integral part of your creative process.

I tried reasoning with Zelda's thought process, looking at it from as many angles as I could find. I didn't want to simply accept the convoluted way in which she viewed the art world. Maybe I was just naïve or too stubborn to accept it; whatever the reason, it didn't feel right. I couldn't forget her words; they stained my mind. They were said with such abject judgment and such conviction. I couldn't let this pass. She believed it, and the art community really feared it, and people were making decisions based on that fear ... which ultimately gave them nothing substantial to justify their belief ... and this just ate at me.

I knew I couldn't avoid it. I couldn't wait for something to transpire. I had to stop painting and take some time to think this through. The more I thought, the more I realized all I had was a hunch. Sure, I had seen contradictions to her statements and beliefs. Sure, I could speculate all day long, knowing there was something wrong, but not knowing how to identify it. I had not tested this myself, so I had no ground to stand on, either.

THE HYPOTHESIS

This puzzle gave me a reason to start a new series. It had, to some degree, already begun. I just didn't know what I would be painting, and how it was going to help me with my resolve. What I did settle on was that this new series would drive me forward.

I remember looking around my studio, trying to latch onto something that had a sound base to build from. Nothing seemed to have enough weight. I began to think about the heart of the problem. I was literally trying to tie down the unknown and indefinable. I couldn't think of how to paint this, how I would represent this idea. I thought back at what I had learned from my last series: sometimes the answer is the question and the question beckons the problem. Maybe trying to define it from the beginning wouldn't work. Maybe I should be taking a different approach. The direction in which I had been looking didn't show me what I needed. I was trying to utilize answers I didn't have, but I couldn't define what I didn't understand. Moreover, this was an external problem that didn't just concern my opinion, but the overall scope of the predicament. This was something I couldn't answer on my own.

I started to reason that this next series had to be an experiment: vague, crossing all lines, where nobody could define it as one thing or another, just like the problem itself. It could be fine art *or* commercial. It could have endless depth of meaning, personal meaning, or a meaning as purposeful as wallpaper.

It could be a figment of the imagination, it could be worth a million dollars or fifty, it might look good above a urinal, or in its own room in a museum behind eight inches of glass.

And, like the problem, it must be completely void, giving it nothing to hold on to.

Yes; that could work. I needed something to fit that mold, mimic the problem and turn it on itself—then see what comes out. This was going to be a "problem solving" series.

Now, I was getting somewhere. It all started to come together. Then, like a little old lady in a game of Bingo, I saw the numbers line up. The answer was right in front of me: lining the walls of my studio was *Creation Series*. This is where I found the question that was the key to the next step.

Since the series was a journey to that answer, now would be a good time to paint *the question*. What is more vague, but infinite in depth, than that? It seemed too perfect. It was the chair in the professor's final exam all over again.

I had a theory. If I observed the outside world against my proposed work in a manner that left nothing but one's imagination to hold on to, maybe I could go deep enough—yet step back far enough—to see the bigger picture behind the curtain. What strings really exist, and which ones are imagined? If I could mimic the problem Zelda proposed, I was sure I'd find the answer by using my work as The Question.

I had already kept my shorthand artist statements going in this direction. All I would do was take the experiment one step further and put it on canvas. I was no longer enticing the question through writing; now I was painting it. Well . . . *thinking* about painting it.

Although I had worked out everything in my mind, how in the world would I paint the all-encompassing act of questioning?

The obvious choice would be to go bold and literally paint a question mark . . . but that would be too on-the-nose and cliché. It must be universal *and* subliminal; it could not have any subjective or objective means that would directly lead the viewer to what they think they should see. I did not want to taint the experiment.

Should I just leave the canvas blank? This was going to take a bit of contemplation. Everything had to have a sound reason, or it wouldn't work. Like writer's block, my body wouldn't allow me to paint. And I certainly couldn't force motivation; that's when you start crapping out bad work. People can smell the stench.

THE PROCESS

I started sketching in charcoal, random nothings, to allow my brain to be elsewhere. I gazed at the paper, looking past it. It began simply, the idea rooted in what I had learned from processes thus far. If I am to capture the essence of a question, and I am to do this by only having imagination to create from, without any bias, then I must trigger curiosity. Curiosity leads one into the act of questioning, and if imagination is the only thing I leave for people to hang onto or pull from, then that is where the origin must exist.

The last time I imagined something, or dreamed of something, I pieced it together from memories. If I want to represent the act of questioning, I must paint the trigger of memories. This is where the process began. The paintings must not be a specific memory. It must contain only the basic primal parts of a memory, to give the viewer complete control of their imagination through their thought process.

I knew this was extremely important and would be the hardest part, as the key to the "experiment" is the process itself, which must not be stained by my personal vision. Its existence must be as pure and unbiased as possible.

I reviewed all my *Creation Series* and previous works, studying the basic elements, and began formulating the evolution of the new series. I stripped out the landscape from *Creation Series*, leaving nowhere one could settle with familiarities of a specific time. No journey; no past, present or future. It would consist of no man-made perfect edges (as in *Exploration Series*). I stripped the background to pale colors, bringing maximum contrast to the foreground.

A memory is like a stain, and it will exist as one on canvas. I will break it down to the basic parts of vision found in the basic aspects of art. Depth, movement, shape and color. This will represent a memory.

What began to take place looked like a silhouette of shape and color stained on the canvas. I started with two, then moved to a consistent three silhouettes floating on the washed-out backgrounds (they seemed to fit better on the canvas). I kept the strokes sporadic, without any object in mind, leaving as much distance as possible between myself and the mark-making process. These gestures were like the ones I had sketched in charcoal. I was keeping inconsistency consistent. The strokes of shape,

depth and movement were random, but their randomness constituted the act of consistency.

The constant in the "experiment" could be assumed as the depth, movement and shape. However, I chose to change the color in each piece, allowing it to exist as the variable. The variable could easily be changed to another element, allowing versatility of study, as each of the four elements could be separated and analyzed as an independent or dependent study. Once created, each silhouette was repeated over and over. Staining the canvas in the way an experience stains a memory into your mind. Like a stain, it may fade with time, but will never go away.

I named these works *Imagination Series*. It seemed appropriate for the underlying process, but also vague and open-ended, detached from the artist or any tangible concept, in keeping with the thesis.

I had considered naming each piece *Untitled*, but felt I could find something better that would allow me to remain vague. *Untitled* seemed to go one way or the other; some people don't think twice about that name, while others hate it and think it's a lazy cop out. It wasn't worth the risk. And I could not interject a name based on what I saw; the viewer would be predisposed, or prompted to constantly look for the title in the painting.

THE BLUE DUCK COMPLEX

Early in my career, I had seen what the power of suggestion could do early in my career. Before I completed my first series, I had created an abstract piece, one that I was very excited about. I brought it home to the family and let them marvel at my work. I leaned it up against the wall, stepped back and admired it from a distance while standing alongside my stepdad, grinning ear-to-ear. He smiled, pointed his finger, and said, "I like it, and it's got a blue duck diving into the water right there." My smile quickly faded. I had not seen the duck, but now it was glaringly obvious. I flipped it over on every side, but I could not get that damn blue duck off the canvas. It was all I could see for days. This was not good; I had to "fix" it. So I made it disappear.

I definitely did not want to impose the same power of suggestion with this new series. Instead, I kept it simple: I named each work after

the color I used as the main silhouette stains. All I left on the canvas was a process. Emotion stimulated by color. Form gave the emotion an identity . . . movement created the dynamic existence of emotion . . . and the depth through the textures gave way to the connection of reality.

All things are made of layers.

This was important. I wanted the viewer to feel comfort in the work, an unknown familiarity. These elements would formulate that familiarity into a memory through the viewer's imagination and into curiosity, validating the process of questioning anything or everything.

It took many weeks to work out the details, making sure it fell in line with the bigger picture while still being consistent with who I was, motivated by a purpose aligned with my work thus far. After much iteration, I finally settled on a process to be carried out among the works in the series. It stood to reason, every part had a specific purpose for a greater whole, all built for an idea. This felt right; the kicker was where it might lead. That, to me, was what it was all about.

THE EXPERIMENT

I felt confident, yet it was an eerie moment. I was afraid to speak about it, everything seemed to fall into place too well. I've never seen a puzzle come together like this, definitely not from anything I had ever done. I couldn't have planned all the parts laid out in front of me, but there they were. Even if I wanted to explain it to people, I don't think anyone would have believed me.

I had already been experimenting with my artist statements, observing and testing the outside world with my words, and the tone of my works was already being affected. At first I saw it as a bad thing; but looking at it now, my statements seemed to be converging into this series, coming full circle in the development of the work without my realizing it. If the meeting with Zelda had not gone as horribly wrong as it did, who knows if I would have been set off in this direction.

I wonder how many coincidences it takes before you start to think there might be a bigger plan. In retrospect, we may see everything was laid out for us . . . but does that mean there was a bigger plan to begin with? All I knew was that, for once, I didn't question the process. I just

painted and observed. It was a risky move. Most of the time, nobody knows the reason, and that's the scary truth. But I couldn't help myself; following rules never seemed to get me anywhere, anyway.

When I introduced *Imagination Series* to the public, it was a very different experience from the other shows I'd done. I did not make a big deal about it, and it went off just the way I wanted—not too slow and not too over the top, it floated right in the middle. There is always anxiety about what people are going to think . . . but after awhile, what others *thought* of my work wasn't on my mind. Instead, I was fascinated by watching the *reactions* to the work. I saw intrigue, confusion, curiosity. People loved it, hated it, thought nothing of it, some connected with it, some didn't get it. I'd left nothing for them to grab hold of other than their own imagination. It was interesting to see how people came to their conclusions about the work, how they tried to define it for themselves. The lines were blurred, and I noticed this seemed scary to some of the viewers. They were accustomed to being led, and without anything to attach to, they struggled, searching for reason and logic to take hold. When people tried to define the work, they would reach for things that would help them define it, things that comforted them in their lives. Their judgment had no bounds. They asked me how old I was (I guess that was how they could justify the wisdom in the piece) where I studied, where I got a diploma that said I could paint. I saw them looking at the price (another common way to validate the work). Whether the tag said $100 or $100,000, you could see their moods change, having found a comfortable place for their opinions. Some tried to make something of the title, though it was just the name of the color. If the color was Ivory Black, they would desperately look for dead elephants (black=death+ivory=elephants), and you couldn't change their minds. When some were frustrated by having nothing but themselves to contend with, they would reach out to me, asking what I saw, asking me to give them a starting place. As hard as it was for me to hold back, I would only give an explanation that led them back to their own imagination. Some needed something to give them permission to justify the work . . . a measure to give them boundaries of judgment.

The polarizing views were hard to swallow. It was difficult for me to watch people look at the work and try to break it down logically, instead of looking *into* the work, listening to their gut reaction, trusting

the feeling . . . whatever that might be. But the hardest thing for me was taking the beating, biting my tongue, not giving them an answer or an anchor. I hated not helping more, but I didn't want to defeat the whole process. Like an animal lover watching a gazelle being attacked by a lion on the Discovery Channel, you just can't intervene. Survival of the fittest lets Mother Nature take care of the rest. This series was strongly committed to *process*, and lived truly within the realms of an operational definition. Process was the point of the work, not just technique, not just the object one might see, but *how it happens*. Allowing the color to stimulate emotion in the subconscious and trigger memory. Allowing its shape and movement to be like the ebb and flow of a symphony. Allowing the painting to become a mirror of the memory, not blatantly existing on the surface, not fragmented in the background . . . but stained, floating within the layers, faint with time, yet complete when deeply felt. Allowing the extraordinary discovery that imagination is the only definition needed to justify an opinion.

The sad thing for me: this rarely happened, if at all. However, at a certain point, I did notice a trend within viewers. In an attempt to logically accept how they saw them, most people would break the work down into three primary categories.

Given three silhouette shapes stained on the canvas in their inconsistent manner, the first group saw each as objects independent of one another (a dancer, a chair, a baseball). The people in this group were capable of accepting three unrelated objects on the surface and did not need to see the painting as a whole.

I found the second category of viewers analyzed each silhouette shape as being independent from one another, like the first category. However, they viewed each shape within the same classification (a baseball, a baseball player, a baseball bat). This second group located the most recognizable object to them among the three silhouettes (a baseball player) then envisioned the other two silhouettes around it (a baseball and a baseball bat). They, too, did not need to accept the painting as whole. They *did* need the silhouettes to be related, to logically accept them as existing in the same painting.

Within the third main category, viewers saw the painting as a whole, where no shape is independent of each other, but made up one object. They accepted the negative space as a part of the object. Their minds

created cognitive contours, making invisible lines that connected one silhouette to another.

Some variables existed among all three categories, such as the movement of these objects, which could be divided into subcategories. Also, few traveled into *why* they saw what they did—but that would require a demographical breakdown of cultural, social, religious, socioeconomic backgrounds, and individual experiences.

Having to separate myself from my work was bittersweet. But watching how people processed visual stimulation, where they entered into the process and, in some cases, where they ended, pushed me to the sweeter side of the experience. You can tell a lot about someone by what they reach for when they're trying to understand something. If nothing else, I was content to study this process; it became less about art and more of something much, much, larger. With all that I had learned so far, I could only hope that, in time, I would get the answers my curiosity sought.

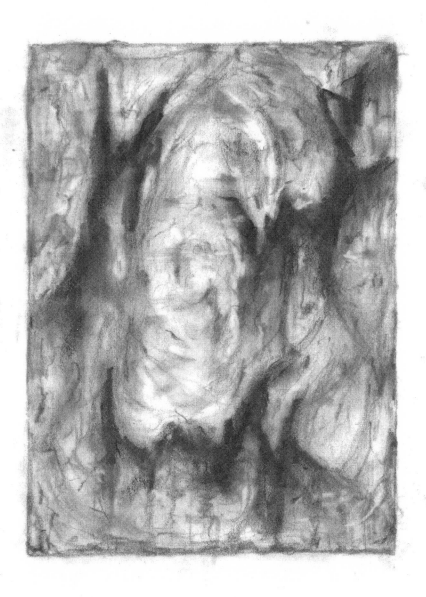

Imagination Series sketch

LAYER 5

Internal Filters

INFLICTION OF HUMILITY

It had been six months since I had first shown *Imagination Series*. Now that I had slowly removed myself from the public art world, I started to realize that I had been missing something. It was unfair of me to be asking something of others that I had failed to ask of myself. I had been afraid to intervene in the process of *Imagination Series* because I didn't want to see another Blue Duck evolve on the canvas. I realized I had distanced myself as far as an artist could from his own creation. It was time to find balance.

I was going to build a series from a truly selfish perspective. A series that would leave little room for interpretation. This would be the complete opposite of *Imagination Series*, and one I would find very hard to face, one that had been lingering in my mind whenever I looked at

that series. It was not so much what I felt, but what I didn't see. There were some questions I needed to ask and answer on my own. What was missing? What did I need to find?

When I gradually started to paint, I knew what I wanted to achieve. I first pulled from the things I remembered, things that moved me. I was determined to bring deliberate reasoning to the foreground.

I kept the stained silhouettes intact on the canvas, but this time I pulled in the horizon lines from *Creation Series*, giving the silhouetted memories a place to rest. Bound by time and the distance of a journey, not only mine, but that of any viewer.

The premise of my work was based on a poem I had once read in my youth. For the life of me, I cannot remember the name of the poem, but I will never forget its story. It was about an artist's painting of a young man and a young woman. The artist painted them as a "still life," right before their first kiss. In the poem, the young man is angry at the world, and at the artist, for leaving him frozen in time, never knowing the lips of the one his eyes would never leave, tormented forever. He will spend the rest of his life at the moment of climax, desiring nothing more than to have that kiss. As the poem unfolds, the young man begins to realize it might not be so bad after all; maybe the artist knew something the young man didn't. At last, he feels fortunate to be living with the love of his life in that moment forever.

It was sad; it moved me. Moments like these can be captured on canvas, though the reality of the moment only becomes a memory . . . one that we desperately cling to, as mortality clings to us. But even if we can't have the moment, we can have the memory.

Sunsets are this special moment for me, where the day and night meet. For me, they are among the most emotionally charged moments in life. The sky is filled with shifting colors; the eyes are stimulated, adjusting to the change, physically and mentally. The movement of the world is so clear, even as we stand still, captivated by the mortality of the day. I likened the background of my new works to this phenomenon, with its atmosphere surrounding this frozen moment.

As a child, I was fascinated with boats. I loved to watch them sail along the horizon, with the vibrant sunset as a backdrop. What are they doing out there? Are they coming to me? Are they going away from me?

These three childhood memories inspired my next series. I painted silhouettes that represented vessels floating on a horizon, moving with the ebb and flow of emotion being breathed into them.

The vessels were named for the etheric freight they transported. They hold the meaning and the reason behind the emotion of passage, and their experience transports the viewer.

The Loner is on his own.

The Big Fish knows it is stuck in a small pond.

Separation carries the heartache of not looking back.

Morning After the Battle conveys collateral damage and the hope that this too shall pass.

Cross Between Two Loves travels through the hardest part of love— its uncontrollable nature, and the effect it has on those in its path.

There was so much emotion on the canvas, moving in a poetic fashion. I explained my work with this understanding. It was a story that held truth to its origin of design and one that I openly shared. Many viewers took it in, and many favored the connection above other works of mine.

However, I could not bring myself to explain the deeper, more personal connection. It was too sad a story to share, so I never tried. It was not like me to talk about myself in public. I am a very private person. And whether people mean to or not, I've always felt they look at you and treat you differently when you open up your life to be read like a book. (Yes, I recognize the irony.) I always choose my words carefully, holding my cards to my chest, fearful of losing control. I think I was afraid to realize what little control I had; I desperately held on to the only thing I thought I could control—my past. Not until this series had I confronted the unspoken inflection covering the canvas. And I haven't shared it until now.

INFLECTION OF HUMILITY

I feel myself staring out at a ship, not knowing if it's coming or going. It moves freely in the water, in a place I cannot go. I sit and wait, reaching out as it disappears into the sunset, not knowing if it will be there tomorrow.

This is torture. Never coming to shore, yet never out of sight, a distant silhouette holding my gaze hostage, as I am too paralyzed to move. The vessel has it both ways, never making a decision, leaving me static.

This particular vessel was a shrimp boat called *The Scampi*, a raggedy craft that had been in and out of ownership. As a boy, I went to look at this boat many times, and it became an object of my affection.

These are the things that my father shared with me, in one of the only real moments between us. His eyes were innocent; the boat was something he sincerely loved. He would speak of buying that crappy boat and retiring on it one day, as if it would set him free. It was the only truth about my father I had ever known. He loved that shrimp boat because it was his future, one he shared with me, so it was mine as well.

As I got older, I would chase this obsession, too. I believed that one day I would buy this boat for him. If I could give him his future, then he could be proud of me, and I could just have that one memory, knowing I'd done that for him, that he existed on the boat, and that I could always join him there.

My mother would tell me that my father loved me, but didn't know how to show it. I never understood: how does one feel something but not know they feel it? He was floating on the horizon, one foot in and one foot out, never there, but never gone. Leaving hope lingering in the distance.

Sometimes the hardest part of love is the sacrifice we make when we leave the horizon so others can move on. I know my mother was not strong enough to walk away from my father; for a long time, she clung to what would never become reality. Over twenty years passed before she cut the cord and moved on. But I was still a teenager; I had gazed at the horizon much too long to give up hope . . . and not yet long enough to leave with my mother.

She had been the oldest of four children in a blue-collar family; she grew up early, left home young, met my father, and then had me. She was a young mother finding her own way in the world.

As I grew older, the boat became a means to finding answers. I knew little of my father, therefore I felt I knew little of myself. Whenever he and I would get together, it would be brief: at gas stations, where he would fill up my truck. Our conversations would last just as long as it would take an empty tank to become full.

He was old-school; he did not carry a phone, only a pager, refusing to change with technology. It wasn't convenient for me, but it was for him: he didn't like to be reached unless he *wanted* to be, so my pages would only be returned whenever he found a pay phone and the time.

I never knew anything different with him. Although I had seen a much different relationship dynamic between my friends and their fathers, I did not desire to have what they had. I was happy the standard father-son relationship existed, and I enjoyed being around it, but I knew it was not for me. I was okay with this; I couldn't imagine it being any other way with my father.

Eventually, others' expectations fueled a resentment in me; I was encouraged to become obsessed with knowing where I came from and who I was. So I waited, staring out at the skyline, hoping the boat would come to shore and stay long enough to give me clarity—and dictate a direction that would define me.

As I created this new series, I began to have a deeper understanding of myself. It was time to let go. I had been fixated for so long. Wanting something over which I had no control. The more I gave, the harder it was to walk away; I was afraid I would be nothing on my own.

As I walked through the emotions of this series, I began to realize that I myself had started to become a boat, floating away from the mainland. I was turning into the very thing that tormented me. I'd never turned my gaze back to the shoreline to see this. Now, I turned and saw it all.

With that, I gained the wisdom of perspective and realized that nothing on that shrimp boat could tell me who I am. My father shined shoes from the time he was eight, and had an unrelenting entrepreneurial drive to be successful. But I did not need to look outward to know I had the same in me. In the end, these things are all I ever really needed to know; the rest came from the choices I made on my own. I haven't always made perfect decisions, but I seem to find my way.

At a certain point, no matter what the experience, I still had a choice, one that was mine alone. I could either accept the reality and use it to move forward and define the best of myself . . . or I could let the bad outweigh the good, drenched in bitterness and self-pity, ultimately allowing that to define my future.

I had made my decision and, although the memory of the boat on the horizon will never fade, I had my definition. An experience is merely relative, but a choice is universal—and accepting it is a part of life.

I had to will myself to leave a shadow so I could finally see my own. This series became the essence of my self-portraits, illustrating the liberation of overcoming the hardest part of ourselves. Looking in the

mirror and realizing the only thing that can define what we see is what's staring back at us. This was the *Essence Series*.

THE BURNING

I had found my independence, a foundation of self to stand on—and it's a good thing, because it was about to be heavily tested.

Things were running smoothly, art was selling, my name in the art scene was becoming well-known. I had a healthy amount of collectors, potential clients, and followers. I was consistently receiving commissions for large paintings. Offers for exhibits and charities were coming in regularly. All was well in my world.

It was Easter morning. Kim and I had set aside the day for dyeing eggs and grilling pork chops on the back patio. We'd spent all morning being lazy and lounging around, a rare choice for the two of us.

We cooked breakfast together, played music on our built-in turntable. The sweet sounds of Motown crackled from the vinyl through the speaker, circulating like a fresh breeze of timeless memories.

It was early afternoon, partly cloudy, not too hot, not too humid—unusual weather for spring in Houston.

I had the grill heating up, chops about to be laid to rest.

A rainbow of colors in random shallow cups and bowls were spread out on the glass table top of the wrought iron patio furniture. An egg crate with ten dozen boiled eggs sat amidst the display of color.

The one unwelcome aspect of an otherwise perfect day: we were under attack by a massive swarm of mosquitoes. It was such a severe assault, we had to surround ourselves with mosquito repellant—including a brand-new wickless citronella gel candle. As we began dipping the eggs into cups of dye, Kim noticed that the candle was extinguished and needed more gel, which had to be poured into the open cylinder of the decorative ceramic casting. While she concentrated on perfecting the color of a beautiful deep emerald green egg, I took the bottle filled with gel and began to pour.

The bottle swelled from the heat and, in an instant, exploded in Kim's direction.

Kim was covered in gel, from under her chin to her tank top line, and her entire left arm—the outreached arm that held the brilliant

green egg. She leapt up in shock, then fell to the ground and curled up, screaming in sheer terror. She was on fire—but, since there were no flames, I didn't understand what was going on. Her screams were so deep, a howling of pain I had never heard before. Then I saw that the gel was acting like napalm on her skin, melting her, suffocating the oxygen with chemicals. There was no fire for me to put out, there was nothing I could do. I was helpless, my baby is melting, and I couldn't stop it. The dreadful fear in her eyes, her blood-curdling shrieks, begging for help to stop the deep, searing pain. I watched helplessly as her ravaged body shook and rolled on the patio deck.

As I struggled to get Kim to focus, our neighbors rushed over. We draped a wet towel over her wounds—Kim had been leaning over the table at the time of the chemical blast, so her face was saved—and they helped me get her to the car.

I drove as fast as I could to the hospital. The emergency room doctor had to cut off Kim's clothes, and I saw her skin falling off with the cloth. The pain worsened as the ER team cleaned the wounds for infection.

I watched the strongest, most independent woman I had ever known beg and plead for someone to take away her pain. I watched her fall apart before my eyes.

She cried even harder when she had to tell the doctor she was allergic to codeine—so, any painkillers with codeine as the base were out of the question. Morphine was the only thing that could alleviate her agony—but it couldn't be taken home.

After maybe five hours, the weekend ER staff sent us on our way, with Kim's third degree burns wrapped in gauze; they said there was not much else they could do.

When we got home, it was very still. It had the same eerie feeling as a haunted house from the Civil War. The aftermath of terror permeated the air. Half-dyed eggs sat in water, half-cooked meat lay on the grill, a dark splatter stained the place where Kim had been writhing on the patio. Our cat was nowhere to be found.

And the record was still spinning. Around and around and around.

The holiday crew of doctors had given Kim a pain killer . . . despite what she'd said, it contained codeine. So, through the first night, she burned on the outside. And the adverse effect of codeine made her want to crawl out of her skin from the inside.

A good friend did us a favor and asked a burn specialist he knew to come to the house. He cleaned her wounds in the shower. He advised her not to go back to the hospital for further care, if possible; there was a high risk of incurring a staph infection with such exposed wounds. He said to me, "The cleaning, if you can bear it, can be done here by you. That'll allow Kim the comfort and safety of home." I told him I would do anything that needed to be done, and learn anything I needed to learn, if that meant saving her from any added discomfort or danger.

After that day, Kim and I kept ourselves shut away from the rest of the world. We were in a daily routine of cleaning and crying. Crying because of the pain, crying because of the mess, crying because of the hopelessness.

I slept on the floor next to the bed, I held her hand through the night, dreaming for her instead of myself. Selfishly, I needed forgiveness, but never would ask out loud, never allowing myself to be without her pain. I believed that, if she had to suffer, then I wanted to suffer beside her. She would never be alone. It was the only way I knew to cope with my guilt, my shame for what I had done, and what I could not do to protect her.

Weeks passed, and she was mending to a bearable point. Still unsure if the skin would grow back; highly unlikely, they said. You could see it in the specialist's eyes when he'd come to check up. He would never say it directly, but what he didn't rule out said it all. All I knew to do was what I could control. I had the clinical set-up fully organized and laid out in the bathroom. Five filters with bacteria-killing light oscillating around the clock. The only unsanitary object over which I had no say was the cat, who had also been in shock, hiding in the deepest parts of the closet. When he finally came out, he never left her side. And of course, the twice-a-day skin cleaning and changing of the gauze and application of Silverdine cream, which the wounds seemed to absorb at an alarming rate. Every day was a numbing routine of pain.

I tried to ignore her plea for me to go back to work. She thought I needed it; she worried about me and the emotional weight she knew I was carrying. She was right; the guilt haunted me. But I couldn't fathom leaving her to go do something as silly as paint.

It was her eyes I fell in love with first. We are ages apart, and somehow we found each other. When I look deep into her brown teddy bear eyes, I see the youth and purity of a child. Time stands still, we exist together.

I do not know of a love deeper than one that foregoes time. Time that defines our lives. Time to live with such beauty, to know of such sacrifice.

This was beyond the naïveté of lust, as the true test lies in the depths of unconditional love.

The specialist and other doctors were certain she would need skin grafts. They said it was a miracle her deep third degree burns began to grow skin. I believe it was because of her stubbornness—and the fact that she recognized the limitations of traditional medicine and took a more holistic approach toward healing her burned body. She did extensive research and began a rigorous regimen of vitamins, herbs, teas and oxygen water. She eliminated all refined sugars, caffeine and starch from her diet, giving her skin the best chance for recovery.

We had made it through one of the hardest tests a couple can experience. But reality waits for no one. And, as quickly as the moment defined us, we looked ahead to the future, together. And we needed a win.

FROM EMOTION TO REALITY

I felt it was about time to do a big exhibition, to pull out all the stops. Kim and I knew it would take time, money and the venue that would do it justice.

For months, we looked for the right venue and found nothing. The requirements to do it right were too much. It had to be in town, particularly in the midtown Museum District, so everyone accustomed to attending art events would come. It had to have adequate parking, the right set-up for displaying and hanging art (no easels, please!) and of course, the right lighting. All of this, to be done within a budget that I could afford without skimping on food, wine and atmosphere.

During this search, we had dinner at a small French bistro with two of my top collectors, who are also dear friends. It was just the evening we needed; their company was always relaxing and enjoyable. Over appetizers, Kim and I spoke of our event idea and the challenges we were facing. We asked our companions if they knew of any venues that met our criteria, somewhere we could have complete control over the logistics. "Please think about it, will you, and get back to us if you come

up with anything." We returned to sharing the latest travel stories over a glass of fine wine as we waited for our entrees: *boudin noir* and smoked salmon, rack of lamb with an artichoke *pistou*, and chicken *paillard* in garlic cream sauce.

Later, over coffee and the *tarte du jour*, the conversation circled back around to our dilemma. At one point, they looked at each other then back at us and said, "You know, why don't you have your event at our place? We'll be glad to host it for you." I hadn't expected this; I felt a little awkward and fell silent. To be quite honest, I was hesitant. It's a tricky thing, mixing business and pleasure, and I didn't want to risk the the future of our friendship.

Even though I was touched by their generous offer, I was somewhat worried and left it up in the air to make a decision that wasn't influenced by wine and champagne. We valued their friendship more than this event, so this generous offer would need some time to be considered. I did not want to hold back in this exhibition, and those who helped me would feel the strain of my determination.

For the next two weeks, we gave it a great deal of consideration, weighing the good with the bad. The location was not in your traditional artsy part of town; more of a neighborhood in transition. People had slowly begun renovating the area, and there was no doubt that it would one day become the new trendy hotspot, but we were probably looking ten years down the road.

Their house was situated just outside Houston's old warehouse district. Originally constructed in 1935 as a quadraplex, they had painstakingly transformed their home into a warm, elegant, single-family dwelling. They had done a beautiful job with the renovations; they instilled their own version of sleek and modern transitional interiors, while keeping its unique character.

I loved the place; it was beautifully decorated with fabulous furnishings and antiques. However, it was not what I had envisioned for my show. It was not an open space with minimal distractions. It had low ceilings and minimal lighting. It did not have tall walls, nor was it accessibly located downtown. It raised all the red flags I had learned to run from.

A very long time ago, I learned something from my biology teacher—a guy who would take no BS in his classroom, but who was a

softy at heart. Even though I occasionally found myself on his bad side, I admired his stance. He sliced the bread the same for everyone, so I really couldn't complain too much, and had a lot of respect for him.

Biology was somewhat interesting to me . . . but he taught me something more, something I could use in everything I did. To this day, I remember that he repeated one thing during every lesson, letting us know how important it was: that there are always exceptions to every rule, even in biology. For instance, every vertebrate has a backbone . . . except sharks.

I have found the adage, "There are exceptions to every rule" is true in all of life. I need it to be true; it helps keep me open-minded. I never assume that one way of doing something will always stand true, no matter how the odds are stacked. You can't afford to miss the one item that changes everything.

And then, there's Murphy's Law: if there is a chance for something to happen, however small a chance it might be, it will happen. Just ask any fisherman: when he has the biggest fish he's ever seen on the end of a line and he reaches over to snare it with the fishing net . . . he will inevitably get the net caught on something, causing him to lose the giant fish, and leaving him with a fish tale no one will believe.

So, against my better judgment, I seriously considered having my collector friends host the event. It was either so wrong it was right— or was it the exception to the rule? After all, the collectors embodied taste and never did anything halfway, always elegantly over the top. I knew that, if all else failed, I was in good hands. I decided to take them up on their offer, disclosing everything we wanted to do for the event— lighting being the most important aspect. They didn't even blink. For seven months straight, they shifted the completion of their renovations into overdrive. They even installed permanent lighting for all the walls. I would normally have felt bad for requesting it, but they needed it for their personal art collection, anyway. I made sure only to have it installed where it would be useful to them later on.

Everything was figured out and under wraps. We needed to make room for a large crowd, so a minimum of furniture remained in the home and the rest was sent off site. A valet service was arranged, and the school lot next to the house handled the overflow parking. Food was hand-picked by the hosts and beautifully designed to fit the theme of

the evening. And no cheap wine for this event. We even had a signature cocktail with gin as the star.

Alas, the only thing over which we had no control was the weather: the day turned out to be the hottest day the city had ever recorded, topping out at whopping 113 degrees. Despite the temperature, the event could have not gone more smoothly. Guests came from all over the city, flowing in and out all evening long. The success became the exception, one I could not have anticipated, and one I could definitely not have done on my own. I was fortunate to have a team of people who wanted it to work as much as I did, and who put in the effort to make sure it was a triumph.

Despite all my early misgivings and the weather, this event allowed me to leave an indelible mark; it's still talked about to this day. Everyone was worn out from the months of planning and extreme attention to detail, and we were relieved when it was over. But there was more to the story.

An art dealer and gallery owner (whom I will henceforth refer to as "The Gallerist") arrived in a limo with a host of collectors and art advisors. He represented some of the finest artists in the country, was highly regarded and respected in the industry, and well-known for his historical knowledge and passion for art. He had an excellent eye for identifying quality work and was trusted for his discrimination. He was known for making careers and bringing artists to the forefront of the art scene. Obviously, I hoped he'd stop by.

The Gallerist made an entrance with his entourage, walked around the room, taking it all in. I watched him and his art consultant examine my work. I had no idea what to expect, and I was standing too far from them to hear what they were saying to each other as they conversed about every piece.

It was too much for me to keep watching. My nerves were getting the best of me, so I sent Kim in to investigate. She's a much better "front man" than I; she has an easy way of meeting and greeting strangers. I'm admittedly hit-or-miss when it comes to this, and it was not worth the risk of setting a bad tone. I'd stay in the background and wait for the appropriate time to approach. After they had viewed all my work, Kim brought me into the group. The Gallerist and his art consultant immediately began to tell me how much they enjoyed my work, describing each piece to me. It was surreal. The Gallerist asked me to follow him over to one of my pieces; this was the moment I had waited for. It was

not the fact that his consultant and art collector had just bought a piece. It was not because he believed in my work enough to buy a piece for himself, nor was it the moment when his art consultant advised him that if he didn't sign me as an artist to be represented in his gallery, someone else would. All these things were what artists dream about . . . but, as grateful as I was, they were not what made the evening for me.

The piece The Gallerist had fixated on was from my *Imagination Series*. He didn't look at it; he *felt* it, he *got* it. He was having the experience I had been fighting to achieve.

I might not have had the answers to every question I proposed in that series but, at this moment, I knew I was going to get them. I waited, studying him. I knew I was blindly going against the grain, and now I felt I was being rewarded. Even if he did not know exactly what the pieces meant, they spoke to him, and that meant everything to me.

It was a validation that I was on the right track with my work and, more important, with my thought process.

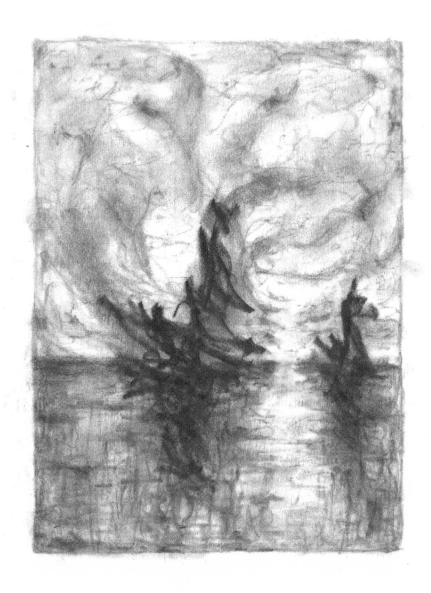

Essence Series sketch

INTERLUDE II

More Notes from the Trenches

They speak for themselves.

The Black Book . . .

. . . goes by many names, and contains every piece of crucial information from all my years of gathering collectors' business cards and emails. Artists, galleries, event venues, marketers and promoters invariably want access to my list. I protect it with my life. It's my leverage. Mine is encrypted, in an airtight lock-box, tethered to a buoy in an unknown body of water, the GPS coordinates committed to memory.

Commodities 'R Us

Dear Zelda,

Anything with a monetary value follows the laws of commodities to some degree. At its core, the tangibility of art is merely measured on the same scale, and plays by the same economic rules, as diamonds, oil, gas and produce. However unfortunate it may be, when an object is subjected to monetary value for survival, it is affected by these rules. This is where the smoke and mirrors are born, how the power is given to a few, and where the battle between what is fine art and what is commercial art exists. Art is a commodity.

<div align="right">Sincerely,
Transparency</div>

Supply and Demand

The more abundant something is, the less motivated we are to buy it. The most powerful influence on price for any commodity is when it goes out of production. In the art world, this means one thing: a dead artist.

The Chosen One

The painting used on invitations to a show. The first impression, the show pony. Nine times out of ten, it will sell—even before the event.

Sometimes it's the best piece in the series. Sometimes it's the one that photographed best. And sometimes it's a piece that simply hasn't been seen as often as the others.

Dealers, Gallerists and Designers . . .

. . . one of them will be getting a slice of my pie. 50/50, 20/80, 30/70 cut, the objective is the same; whoever sells, gets the commission.

Yes. Size Matters

The bigger the better? Everyone will rave about its powerful presence; but most people don't have that kind of wall space in their home. Also, a large painting takes up more room in the studio, and has to be packed and moved from show to show. A logistical nightmare.

Smaller pieces have plenty of options, which makes for an easier sale. And it's much easier on the wallet for a customer to buy a small painting. Or two.

Where's It Hanging?

Some work is a better bet in the city, some will be more at home in the country. The best market for the work is wherever it has the best chance to be understood and appreciated. Know your audience.

Galleries, Straight Up or On the Rocks

These days, they can put anything in a martini glass and call it a martini. The same can be said of galleries. Now, there are "galleries" and there are

galleries. And "galleries" want what *galleries* get: a 50/50 split on sales, and the prestige that comes with being bona fide.

I crave the classic, the original: vodka that only glanced at the vermouth, three olives.

Class System

As in all of life, there are the haves and have-nots:
The Hobbyist
The Starving Artist
The Working Artist
The Established Artist
The Dead Artist
Doesn't matter. In the end, we're all starving for something.

The Cost of Doing Business

Every time I've said a piece has sold, or a commission is locked down, before I have a check in hand—it somehow goes sideways. The deal isn't done 'til the check's in the bank.

I'll be depositing it in the bank today, and then we'll talk.

Real Estate

Wall space is an artist's real estate, and we all want the most coveted wall—the big one with lots of well-designed lighting, a minimum of stuff around it, and the first wall everyone sees when they walk into the joint. If we don't own the "bigger house," we want to be next door—their value splashes on my value.

"You say there's an empty wall next to a wall with a J.W. Turner original?? I'll take it!"

Raging Bull Market

A red dot on the label next to the art: SOLD. And, like a matador swirling his red cape in a *toro's* face, a red dot in front of the face of potential buyers makes them get excited. It's the damndest thing . . . nobody wants to make the first move to buy a piece at an exhibition. But, once it's

happened, people start to rethink having passed up the pieces that are left. Nobody wants to live with regret. Everybody acts on that impulse, and red dots appear everywhere on everything . . .

Paparazzi

Some of us don't care if you take pictures of our work. Some of us threaten to strangle you with your camera strap. I see both sides . . . but it always comes down to respecting the artist, the space and the hard work. Just ask if we mind . . . and credit us when you post it on the Internet.

Charity

I love charities. I'll always happily donate a piece to a worthy organization. But here's something nobody knows but the artist (and the taxman): we artists do *not* get to write off the price of the piece—only the materials we used.

True, too:
9 out of 10 times, the venue has no lighting for art. 9 out of 10 times, the work is displayed like an old toaster at a garage sale. 9 out of 10 times, the price of the work sells under market value, which tends to devalue the work and the artist, which puts a bad taste in the mouths of collectors who paid full value.
No bids?
Fine. I get my work back, and can resell for original price.
But if I get no bids, is it my work? And how does that affect my reputation? In the end, it's all a crap shoot, anyway.

LAYER 6

Conscious Unconscious

I'm not looking at you; I'm staring into you. You are The Beginnings, you are the first abstract I created . . . and you are my white whale. You hang at the edge of my bed; I greet you every morning and every night, and you never respond. I ask who you are, what you mean, where you're going. I wonder why you stand so cold and foreign, vexing me with your stoic silence.

Have I not earned the right to hear you? Have I not given enough to know you? Have I not gained your respect by creating you?

You remain mute, arousing my voracious curiosity, teasing me as I stand before you, asking aloud the same questions I would ask a sentient being. Perhaps it is impractical, perhaps it is insane . . . nevertheless, it feels right.

I will see you tomorrow my friend, and I will ask again. Maybe tomorrow you'll answer.

THE COMMON COLOR VARIABLE

Several months before the *Essence Series* event, I noticed that its predecessor, *Imagination Series*, was having a curious effect, and I wanted to explore it.

I saw that color was like an anchor, grounding the viewer's emotion. This wasn't uncommon; I had witnessed this many times in every aspect of life—from sunsets to fire trucks to a wedding dress. But the case study I had proposed in my works made this especially intriguing.

When viewing *Imagination Series*, people would find the same object among different pieces, but they'd interpret different emotions from each piece. The only true and obvious variable was color. People would access a positive memory and connect it with a bad feeling, simply because the silhouettes were black as opposed to, say, orange. The color completely changed the setting. It was like painting a clown, then painting a clown in a back alleyway. Which clown would you want handing your kids a balloon? People went so far as to formulate a memory based on the emotion, driven strictly by color. At that point, their mental and physical state would change, dictating their mood, and their demeanor and body language became noticeably different.

I knew this wasn't at all unusual, but color seemed to stimulate emotion much more than I'd ever thought. I believe one cannot truly appreciate the beauty of a thing without understanding the purpose of its existence, so I wanted to delve deeper, past common knowledge. I wanted to understand its origins, the nature of its being. How does color stimulate one's emotions so deeply?

Color affects every individual, and the way it changes us depends on many variables. This isn't a revelation—it's been a topic of discussion for as long as color has been known to exist. But I needed to know more. I needed to feel it for myself, and break it down to its most fundamental forms of understanding.

I decided that the best way for me to lay a strong foundation on which to construct my inquiry was to start with what I knew about color, examine it deeply, and slowly work inward.

I considered the role of color in society, how it is used to influence our judgment—whether we're aware of it, or understand it, our thoughts are constantly manipulated by color. When a politician's tie is

yellow, the politician is weak. Silver? Not serious. Certain shades of red or blue? Strong and powerful. We pay premium insurance rates for red cars. We are soothed by the soft greens of hospital walls—blues make patients feel cold and alone, red makes patients feel the sensation of heat or fire and creates anxiety.

However, fast food restaurants *love* red, since it invites hunger.

We even give a color its own year (Pantone annually declares a particular hue "Color of the Year"). Every culture, society and religion interprets and gives meaning to colors (in China, red symbolizes good fortune and joy . . . in Cherokee tribes, yellow signifies trouble and strife . . . in Christianity, blue is symbolic of heaven). Every business carefully picks colors for their logo and marketing materials (orange is an appetite stimulant, green makes us feel safe, black brings power, prestige and elegance). Billions of dollars are spent on the study of color and how it connects with individuals and larger groups, in an attempt to sway emotions. That's a huge expense for something that's hard to explain but easy to accept.

With so many directions in which I could go with my examination, it was hard to find a starting place. So, I scrapped what I knew for the time being and went straight to processing old memories of color, in the years before I became aware of its influence, how it was used in business for monetary gain. But everything that came to me was too superficial. Each memory led to a dead end, or in a direction that moved me farther away from what felt right.

COLOR OF LIGHT

It became apparent I was not digging down far enough. It wasn't until I started to recall childhood memories, the first being the Magic School Bus that taught me about prisms, light and colors. This began the flood of images that filled my mind. It was a good foundation to build upon, as I felt I was only scratching the makeup of color, not how we perceive color. I began delving into research and published works of others. I could have spent years studying and analyzing all the material I found, but I stuck with the main idea and key points that I felt pushed the evolution and understanding of color.

Sir Issac Newton

I followed the crumb trail and found what many already knew—that color unfolded through the works of Sir Isaac Newton. His discoveries with prisms shaped the notion of the color spectrum, and its link to light moved me forward.

Even though many in his field had already been using prisms and light, the origin of color had not been accepted from this approach. It took further investigation from Newton to forever change the way we measure the perception of color.

It was only when he began further experiments with multiple prisms that this became important. Light hitting a prism produces multiple colors, and he wanted to see if the colors produced could break down further. So, he took a sheet of paper with a small cutout and positioned it between two prisms, allowing the rainbow of color to hit the sheet, but only allowing one of the colors to pass through the cutout and into the other prism. What he found is that the color going into the second prism remained that color, thus proving the rainbow of color could not be broken down any more.

Then he took away the sheet of paper entirely and watched as the light hit the first prism, separating it into all colors, then allowed the complete rainbow of colors to enter the second prism, and found that the rainbow turned back into natural light.

On the surface, it didn't seem to be that big a deal. But at that time, it was widely accepted that the properties of the prisms were that of color, and that light manipulated the prism. Newton's experiment proved

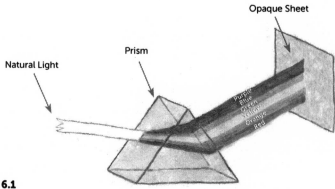

Figure 6.1

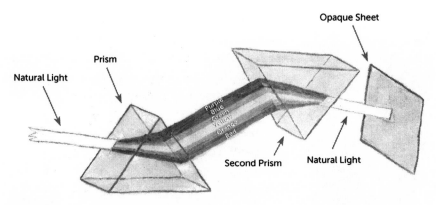

Figure 6.2

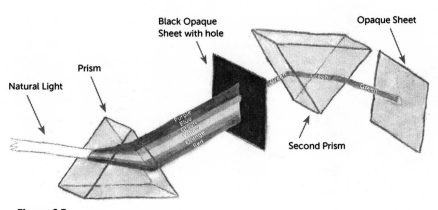

Figure 6.3

that the prism manipulated light, and the properties of light were that of color, not of the prism. This changed everything, and opened the door to the discovery of what we now know as the visible spectrum (see fig. 6.1–6.3).

COLOR OF PERCEPTION

After I'd explored the details of Newton's discovery, I came upon an English physician named Thomas Young, who not only found that light travels as a wavelength, but proposed the *Trichromatic Theory* in 1801. Until then, three types of light were accepted. Everyone concluded that, based

Thomas Young

Hermann von Helmholtz

Karl Ewald Hering

on the ability of the textiles, artists, print shops and others were able to produce any color by using just three different pigments. However, Young's proposal concluded that maybe the three colored lights are not from the mere physics of light itself, but from the human anatomy.

This concept was further developed many years later by a German scientist named Hermann von Helmholtz. He proved that the human eye used three cone receptors (photoreceptors) in detecting and processing the sense of color, concentrated roughly around red, blue and green, which led to the classification of humans as trichromats.

Over time, the development around these proposals grew. Such that, even though we have three types of cones, there are roughly six million of them, each sensitive to slightly different wavelengths of light (colors) along the visible spectrum, creating three bell curves peaking at sensitivities near blue, blue-green, and yellow-green, rather than the commonly considered blue, green and red.

German psychologist and physiologist Karl Ewald Hering proposed that, due to the overlapping of cones peaking at different points along each bell curve, the process of perception derives from detecting the differences between each type of cone, as they then are weighed against the eye's response to what it sees. Take the difference between aqua blue and turquoise: with aqua blue, your eyes detect a higher ratio of stimulation from "blue" cones rather than "green" cones; with turquoise, your eyes detect green before blue. Both are stimulated with one outweighing the other, thus the name "opponent process." The cones therefore work together rather than independently, leading to the understanding of a higher visual brain function with color perception.

THE COLOR OF ENERGY

Things really got interesting when the link to the visual process and energy was made.

Michael Faraday

Around 1845, Michael Faraday witnessed light passing through a transparent material and react to an electromagnetic field, which was the first time a form of light had been linked to electromagnetism. In 1860, James Maxwell proposed a theory that the speed of propagation, or spreading/multiplication of electromagnetic radiation (energy radiating in a form of a wave as a result of the motion of electric charges that give rise to a magnetic field), should ultimately be identical with that of light. This would prove that light is a form of radiation, as it had already been seen to interact with an electromagnetic field.

Maxwell furthered his theory by constructing four equations in the development of the electromagnetic field. Two of his equations proposed behavioral patterns of "theoretical waves" in those electromagnetic fields. From his equations, he was able to discover that these theoretical waves indeed traveled at almost the exact speed of light, which led him to believe light itself was a type of electromagnetic wave.

James Maxwell

He further concluded that these electromagnetic waves, all traveling at the speed of light, contained an infinite number of frequencies. This was a breakthrough, as it progressed beyond the understanding that light was the only source of radiation. It meant that light having the properties of color was not only a form of radiation, but had the characteristics of electromagnetic waves along with now-infinite frequencies of radiation to be discovered.

Thanks in part to Maxwell's equations, we are now capable of mathematically calculating the visible spectrum, or light.

Now we see the visible spectrum is part of a greater whole, made up of different types of radiation with different wavelengths and frequencies known as the "electromagnetic spectrum," light as perceivable color linked to a form of measurable energy.

Friedrich Wilhelm Herschel

Johann Wilhelm Ritter

I was so fascinated by the findings, I conducted further research, into infrared light and ultraviolet light, which were discovered between 1800 and 1802. Obviously, it didn't become part of the electromagnetic spectrum. Although both are considered light, they are invisible, but are capable of being found on the color spectrum, based on experiments that found physical changes occurring.

As most of us understand it, infrared light contributes to the tanning of skin. To address that phenomenon, acclaimed astronomer and musician Friedrich Wilhelm Herschel wondered whether the color spectrum produced different temperatures. His observation with a thermometer in front of a color spectrum produced by light entering a prism, found that color does hold different temperatures, with violet being the lowest, and red being the highest.

Curious to expand his observation, he moved the thermometer just outside the red spectrum, where there was no longer visible color. The temperature rose to its highest point and, with further experiments, proved the "invisible rays" performed in the same way as "visible rays" (visible spectrum); they, too, could be reflected and refracted off of surfaces.

Johann Wilhelm Ritter discovered ultraviolet light only a year later, then followed suit in the hopes of finding his own "invisible rays." Having studied science and medicine at the University of Jena, he understood that silver chloride, commonly used in photograph paper, as well in electrochemistry and medical bandages, would chemically react to light. He wanted to know if the reaction to light differs depending on color, and found that the change in silver chloride progressed slowly within the red spectrum cast from light entering a prism, and much faster in its darkening within the violet spectrum of light. Then he tested the area just outside the violet light to find the highest rate of chemical reaction. It gave way to a new type of radiation later to be defined as ultraviolet . . . but for the moment, it was just a new type of "invisible rays." It also performed like the visible spectrum, capable of being reflected and refracted.

I was humbled to see my curiosity align with those who had gone before me. I had taken what was already there one step further and found the rewards were much greater than I'd anticipated.

REALITY OF PERCEPTION

It helped me to see actual proof of physical changes, not just existing as mental states of suggestion, but applied experiments that went beyond color theory into properties of emitted energy, with links between reality measured and perception unmeasured.

Although this seemed to just be scratching the surface, knowing the technical aspects are much more in-depth, it was definitely worth understanding.

I had read about these pioneers, but never really linked them; I'd never had a reason to do so. This was the first time I had stepped back and looked at it all from a distance, as a whole, in a chronological timeline.

I had been looking for some measure of understanding, and my explorations helped me start to make more sense of it all. The origin of emotional change in a person has a place of explainable existence, even if it's just one out of many possible places. When I looked at the origin of color, it was within the human perception of color, and not the pigments in making color, that I found the origin to exist.

What is known and proven is that the color spectrum is a product of light broken down into different portions of traveling wavelengths and frequencies, which are measurable by nanometers and hertz.

This visible spectrum (light) is a small portion of the electromagnetic spectrum, existing alongside gamma rays, x-rays, microwaves, radio waves and beyond. All types of radiation, measured the same as light, are not only used externally in many ways, but are also capable of affecting human beings in many unique physical and mental ways.

So it is the small portion of emitted energy, roughly between the measurements of 380–720 nanometers, that humans can visibly perceive and process within the electromagnetic spectrum (see fig. 6.4).

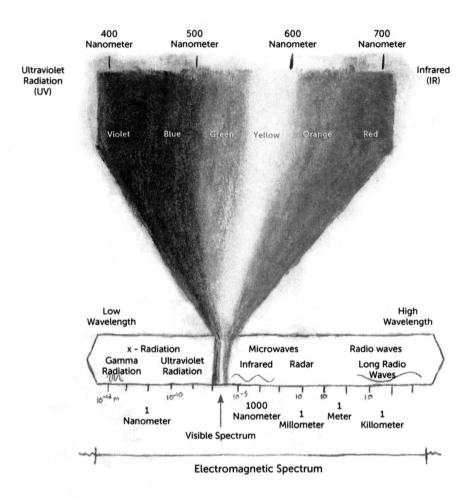

Figure 6.4 Electromagnetic Spectrum with focus on Visible Spectrum (Light)

This is the origin of color.

However, "color" is merely a label used by society to assign and identify objects—the pink hat, the green leaf, the purple crayon. We were taught the basics, starting with primary colors seen in the color wheel: red, blue, and yellow. Yet it is proven that not all possible colors can be made from that batch, nor is it even how we perceive color. We accept that the sky is blue and grass is green, yet we could just as easily accept the sky as orange and grass as red, if that's how we had been taught.

The discovery of light as the source of colors came after early man's ability to perceive color. Therefore, they most likely categorized feelings and actions based on color: red fire=hot, green grass=growth, blue water=life, and so on. This gave me a reason to believe that our emotional attachment to colors was an innate process, rather than logical and scientific.

Fundamentally, what can be said about the "color" of grass is that it absorbs all wavelengths and frequencies within the visible spectrum, except for the portion of light we have labeled green, which is reflected off of the grass, and stimulates those particular cone receptors in our eyes that are sensitive to the wavelengths and frequencies of the "color" green . . . unless you have dead grass. Then it would be yellowish brown, in which case, you have more problems than understanding the wavelengths and frequencies within the visible spectrum!

At first this was just a study out of curiosity, but it grew into a challenge that became an obsession. I wanted to create works that projected these findings, and I wanted to do this with the emotion I had used in my other series, the rawness of emotion that I found so compelling with color.

I was taking two completely different angles of approach and bringing them to a crossroads of understanding, like two sides of a coin finding the common edge they share, or like a zipper, with both sides able to stand apart or be seamlessly pulled together.

I determined that there is a gap in art, and I wanted to bridge that gap. People come at it from different extremes of understanding: minds that look at it from a technical perspective and minds that look at it from an emotional perspective. This would be about bringing some transparency, helping integrate people with art from an angle they might better understand. I have found art to be a means of communication between segments of society, the translation of words unspoken between worlds. I believed this was a challenge worthy of my obsession.

STIMULATION OF EMOTION

Constructing this series had been quite a bit harder than I'd anticipated. Every idea or process had to have a logical basis, as well as connecting an

emotional reason. Whatever I did had to be explained from both angles, maintaining my identity in the process.

Then came months of experimenting with my understudy work. I would create a transition piece that captured elements from most of my series and study it for a while, picking apart where I needed to go.

I knew right away that my focus was on the color. So the paintings themselves would be entirely covered with only one color—one that would capture emotion by its bold presence, but still let me focus on certain aspects of technical approaches. I figured that having a large amount of one color could only stimulate the cones in my eyes further, leaving little room for distractions—silhouetted shapes, for instance. This would compel viewers to reach for something more, to understand what they were looking at. Being forced to do so would trigger different parts of the brain. My ultimate goal here was to allow people to feel the energy, yet reach a logical understanding. With that in mind, I began to further develop the process I had been accustomed to using, a repetition of alternating between layering and glazing. This process was not unlike what the old masters used: layering to create depth and a lifelike feeling in their works. Back then, many would use egg whites to glaze their work, which created the glossy eyes that seem to follow you as you move about the room . . . like Mona Lisa's gaze.

We certainly have better glazing technology today, but I found that taking this process to the extreme would precipitate the right approach, one that would truly capture the technical properties of light within the work. I used the process of thinning oils to its pigment form and floating these particles within a mixture of clear mediums, allowing light to exist—not just on the surface of the work, but within the layers. I would repeat these steps over and over for some thirty layers, giving light the ability to pass through all of them and hit the background, reflecting and refracting within the layers, as well as hitting all sides of the pigments. I found light existed longer within the painting because of the mirrored reflection from layer to layer. I did, however, begin to realize diminishing returns. At a certain point in the layering process, light would cease to reach the background, rendering it pointless to add layers beyond a certain amount. The depth of layers existed much the same as the clarity of a 10-foot pool compared to a 100-foot pool. Yet, this gave me the depth and glow of said pigment (color)—no longer

stagnant, flat moments, but alive and stimulating, as the eye perceives the light, constantly interacting and moving through the canvas as wavelengths and frequencies (see fig. 6.5).

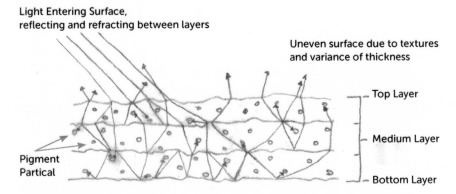

Figure 6.5 Light entering between pigments, then reflecting and refracting off of layers and background.

PERCEPTION OF EMOTION

I felt secure about the dynamic stimulation the viewer would have with the layering process, but I contemplated the role my textures would play, and whether they would be consistent in the visual experience.

I thought about the great Mark Rothko, and how he had already perfected and conquered emotion through tragedy, ecstasy and doom with raw pigments straight to raw canvas. Although I was concentrating on the process of two extremes with different layering techniques, to do so on raw canvas as he had done seemed like trying to create an already-perfect wheel. I idolized his philosophy about art, respected his work a great deal, and admired his obsession for purpose, passion and meaning as the goals to achieve.

It made me realize the importance of my textures, as they were a cornerstone in all my works, so why would I leave them out of this series? The more I wrapped my head around it, the more it made sense. The surface should also move dynamically, emulating its counterparts in emotion. Thus, the manipulation of my textures would be the act of

creating a solid performing as a liquid. Just as a sundial shifts the shadow of time, so will my textures shift the perception of time.

I had a certain resolve with the manner in which my textures would play, and with everything else. Times have changed, and I realized that, with any piece of art, simplistic or chaotic, it was crucial to maintain the stimulation of the viewer's eye (even more with the attention span of our society in the Information Age).

The influence of accessibility through technology is just too great, and growing at an exponential rate. I have come to realize through my studies that one must allow enough time to become fully absorbed in a piece of art, incubating such a thing as emotion to its most mature and climactic point. Only then can one appreciate and receive the full rewards of perception.

PROCESS OF EMOTION

In my heart, I felt like I was going in a good direction—but mentally, I had hit a wall. I found myself becoming fixated on the edges of the canvas. It just simply did not feel right to continue the consistency of pigments from painting edge to painting edge. The feeling of falling off the painting and into the wall, being defused and creating a displacement of emotion, had left me at a standstill.

So, back to the drawing board I went. I created more understudies, trying to find something that felt right. Another month passed, and I finally gave up. I was worn out; nothing seemed to make sense as an approach. I scrapped what I had, took a few weeks off, and tried to enjoy life outside the studio and away from this new frontier. Kim and I always took pleasure in trips to various museums, so we decided to visit Houston's Museum of Natural Science, where we both really enjoyed the Imax film and Burke Baker Planetarium. I'm a fanatic for documentaries and the feeling of being encapsulated by a huge screen. It comforts me in a way I can't explain, to forget where I am and become one with the scene . . . especially when I'm under the spell of Morgan Freeman's warm, silky narration.

We grabbed lunch after our excursion, and Kim could tell something was bothering me. I had a feeling I couldn't shake. The big

screen and the lighted border around the screen before the film was projected haunted me.

The more I fixated on my experience in the theatre, the more I started to remember where this comfort came from. It was something I hadn't done in a long time, but the more I thought about it, the more it made sense. I started to piece together the memory and its correlation to my new series. It fit the criteria I was looking for, and I could recall having strong enough emotions to draw from.

I was six years old. It was the end of the season for the summer league swim team, and the powers-that-be rented the pool for the evening, creating a fun opportunity for the parents to kick back while their kids enjoyed a little water mischief. The lifeguard on duty might have thought this would be an easy gig—after all, these were trained swimmers he was guarding. But it can be nerve wracking for a lifeguard to watch over and be responsible for "real" swimmers, who tend to behave as if they're above the rules. It's true that their confidence trumps the naïveté of non-swimmers; I've been in both roles, so I understand this concept all too well. It doesn't matter if there is only two feet of water—a "real" swimmer will dive in, because "they know how."

We were having lots of fun at the deep end, where divers were playing "Land Shark," leaping from one side to the other, dodging the person floating in the middle.

I was tired, and decided to leave the game and watch from the sidelines, holding onto the rope that separated the shallow end from the deep. The night was almost over, and I was still in the same spot and the only one left in the pool. I had just about decided it was time to get out, but not before giving myself a kick-start by pushing off from the bottom of the pool.

It was there and then that the memory would become embedded deep within my subconscious. I sank to the bottom and came to an abrupt stop. All above-water noise ceased to be audible, only a smothered sound echoed around me, deep murmurs of vibrations hinging on alpha waves. My peripheral vision was narrowed in the frame of the deep end, drawing my gaze into the abyss as it faded from light to dark. Completely submerged, I became absorbed by my altered senses. My heartbeat thickened, a feeling of utter vulnerability overtook me. I was floating, but frozen in time and space. The instinct of fight

or flight—or curl up in preparation for impact—came to mind, but no act of self-preservation kicked in. I just could not stop staring, waiting, allowing myself to feel the presence of overwhelming emotion. My conscious mind forgot to call for air. The moment felt like an eternity.

I was too young at the time to know what was going on. I felt scared, yet I wanted more, obsessed with the experience. I would timidly continue putting myself in this situation throughout my 15-year swimming career, each time feeling as though I had a better understanding of it, learning to control and embrace the moment. The experience of controlled vulnerability was like a drug. The raw emotion was exhilarating. At that point, nothing had ever given me such a rush.

I'd almost forgotten this memory, it had been so long ago. Sad and surprising, that I'd forget such an important moment in my life. But now, I started to understand what I could not see then. The impact I felt was void of a physical object, in the form of raw emotion, strong enough to inflict a physical state of desire. This emotion surrounded me, and in doing so, freed me from my simplistic nature of voyeurism. It allowed me to immerse in my imagination, exist in my reflection, and manifest emotion as the purest form of self. It carved a deep canyon in my mind, and repaved the memory. I began to see the process as if I were watching a skyscraper being built at high speed. The memory became a border on the canvas, reflecting what I had experienced so many times. In the new series, each painting's edge would have a lighter amount of layering that quickly faded, not too sharply, but not in a long, drawn-out fade. It would unfold just as I'd envisioned it under water.

Like blinders on a horse, the visual sense would be focused on, and trapped in, the painting. Everything beyond the enhanced stimulation of the border would fall off the conscious mind's perception. As the viewer gazed deeper into the piece, letting go of control, their peripherals would begin to color-match the border's luminosity, constantly pulling in and out, adjusting like a camera lens. The stimulation would visibly shift, becoming alive, as the viewer loses himself even more deeply in the painting, forgetting to breathe for just one moment.

I had connected my technical understanding with emotional perception.

PERCEPTION OF REALITY

After completing the first piece, I stared at it for long periods of time. It reminded me of a profound moment in a movie I had once seen, one that only made sense to me now: *The Sphere*.

A team of the brightest minds in respective fields of science is sent to investigate a massive spaceship found deep in the ocean, a vessel not created by contemporary technology. They make their way through the ship to the loading bay, and discover a huge sphere floating off the ground, even more alien than the ship itself.

They measure the orb with lasers, and find it to be perfectly shaped and solid—yet the surface moves like liquid brass-colored mercury. There are no visible seams or entryway. Awestruck, they gather in front of it, gazing intently at this inexplicable object, and Dustin Hoffman's character asks his colleagues, "Do you see this?" The camera pulls back, cued by eerie music, and Dustin says, "It's reflecting everything but us."

The moment revealed a truly profound realization (I won't spoil the ending!). But I could see it now, as I stared deep into these pieces I'd created, pairing the origins of color perception with the deep abyss of my emotions. It is not about accepting the work as merely a piece of art, but accepting the work as an *existence*, an extension of emotion over which you have control, and the ability to manifest self-awareness. It is then that the work, as an entity, accepts your reflection as reality, manifested and perceived through raw emotion. I had received an epiphany:

> Look past that which you see and into that which exists.
> Know not of boundaries to build within,
> only limitless manifestations to build upon.
> Emotion is the doorway to this place, setting you free
> from your own constraints.
> Without a reflection, you cannot exist.
> Without a reflection, there can be no place.

I named these works *Reflection Series*. I found them to be the gateway from one side to the other. Whether you are looking into the reflection or into the work, whether it is the technical or emotional aspect that guides your approach, you'll find yourself focusing in and out . . . then your transition of perception is complete.

POINT OF TRANSITION

I felt somewhat enlightened after coming to terms with what I saw. The more I created, the more obsessed I became with covering all my walls. Delving into different colors as alpha wave music played in the background brought such a comforting feeling.

But something was awry. Even after covering the origins all the way to emotion and back again, I was still missing an important piece. I suddenly noticed that color had become common, no more than a bar code—unique in its nature, yet routine in its purpose. Color had become mundane. I brushed my teeth with more purpose than the way I was using color.

The sad thing is, I see the whole of life moving in this direction: rat races on highways lined with billboards guiding you through your day:

HUNGRY? EXIT HERE STOP 'N' GO DRIVE THRU

And the meaning of your life is fed to you with high-concept expressions:

HAVE IT YOUR WAY.
JUST DO IT.
DON'T LEAVE HOME WITHOUT IT.

This haunted me for many months. I had come so far with this series, and it was not good to have this hanging over me. I had to find a reason for it, or the series would not be complete, and I didn't want to live with that. I would be stuck; I felt I would forever be unable to move on, like a person with a compulsive disorder not given the chance to finish their routine. But I continued to paint the series; it kept me distracted and gave me some time to work through the problem at a steady pace.

The answer finally came to me one evening, while I was designing an event invitation on my computer—not an activity I particularly enjoy, but it comes with the territory of being an artist. The process is as torturous to me as trying to tie down a balloon on a windy day.

Sifting through the endless background color choices offered in the program, I took notice of the numbers that coincide with each color, and saw them change with the color selection. It was not a new concept to me; I was familiar with the basics of RGB and CMYK. However, it

was my currently haunted mental state that changed the context of its existence, allowing a new sense of curiosity to spark in my mind.

I quickly began to explore this process: was it only relevant to the program I was using? My curiosity began to stimulate old and new memories. I cross-referenced similar experiences, picking up leads (however jumbled and unorthodox they seemed).

I started to piece together my trips to the paint store. I pictured specialists punching numbers into a computer and watching dyes pour out of the machine nozzles and into the freshly-opened paint can filled with pure white liquid. After hammering the lid shut, the paint-mixing machine shakes with a fury until the specialist stops it, and opens the lid to reveal the final product from his recipe. But before it's approved, he slightly dips his pinky finger in the mixture, like a chef sampling his creation, and places a dot on the top of the lid. We hold hands and stare intently at the paint dot as it dried under a blow dryer. Then the specialist pushes the gallon can to me with a smile: color match approved. As I examine the dot, a sticker with a bar code and numbers with incremental dye ratios comes into focus.

I immediately stopped designing the invitation and rushed back to my studio to examine all my various paint cans from different brands. Although the equations and pigments must have been different between each system used by each brand, the process of getting an end result could be considered fairly consistent.

As in cooking, there is always a recipe, regardless of the language; the process remains the same and, even though the technology and exact science were still unknown to me (like any good recipe) there is always a place of origin. In this case, it was the master key linking one technology to another. If perceivable energy (light) and color are one and the same, measured and calculated with the technology of wavelengths and frequency for human perception, then what technology measures and calculates the production of pigment colors of today?

At the time, I was not sure of it all, but it felt like it was the right line of questioning and worth exploring. Little did I know it would only be a short time before I was driving down a dark, unfamiliar road.

BEHIND THE CURTAIN OF COLOR

In 1931, a group of scientists had been assembled, forming what is now known as the International Commission on Illumination (CIE). It was thought that with the three cones (cone cells) humans have in their eyes, each peaking at different wavelengths and frequencies, one could formulate an objective color from the light spectrum using the three sensitivity bell curves as tristimulus values.

This gave a mathematical range of all possible color sensations through light as an actual objective description that could be derived. The experiments conducted by William David Wright and John Guild helped form one of the first mathematically-defined color spaces, known as the CIE 1931 XYZ color space (see fig. 6.6).

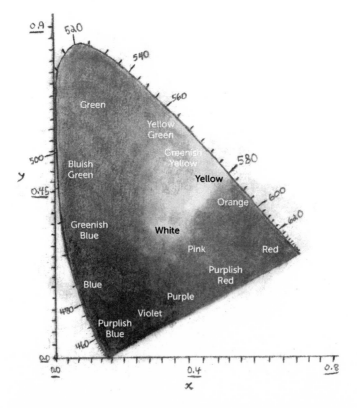

Figure 6.6 Artist rendering of CIE 1931 Color Space Chromaticity diagram. The boundary is the spectral (monochromatic) locus, with wavelengths shown in nanometers.

Because of their research, graphs were made, linking the measure of light in nanometers with plots on a graph. This makes up and represents what is called a "color space"—a space on a graph given all possible points of the color spectrum that could be mathematically plotted. The tristimulus values can be seen representing three chosen plot points (colors), resulting in a sample space within the color space.

Some give fewer options than others; regardless, one of the first tristimulus values in this case, and easiest to grasp, is to use RGB, (Red, Green, Blue) as the primary colors in a trichromatic additive color model. Anything made with those three colors is your sample space from the total visible "color space." This particular RGB model was the result of the CIE-RGB color space development (see fig. 6.7).

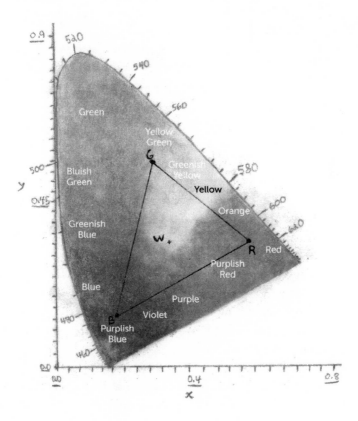

Figure 6.7 Artist rendering for sample graph using RGB as the three plotted points on a color space diagram.

An additive color model is when all three colors together equal white (as when adding the spectrum of colors back to light). A subtractive color model is the opposite, when colors added together come out black (as when adding paint). (See fig. 6.8–6.9.)

Figure 6.8 Additive color model

Figure 6.9 Subtractive color model

The depth into which this goes is infinite, cerebral, and can be very convoluted—but the overall importance of the model stands.

This technological breakthrough afforded endless possibilities. One now had a starting place from which to calculate and map color, given a set of tristimulus values and a known mathematical "color space" within the range of the visible spectrum, from which everyone is allowed to formulate and build. This concept translates across all forms of technology: computers, printers, television, and so forth. Its development provided the ability to read and synchronize color matching around the globe, and easily integrated it into technology. Since that breakthrough, the development of color spaces like HLS, HSV, CMYK, as well as the Pantone and Munsell color systems, have extended the range of colors that can be produced. Technology, however, is still constantly pushing the boundaries to find new ways to formulate and reproduce the full range of human perception.

I knew this was the point of transition, where the source of color and the emotion generated by color, connect. It was almost as if a third point of value had been created for color in the overall scope of its meaning. I would fulfill this point in the titles of the pieces in *Reflection Series*, naming each work of art after specific coordinates. The GPS of art.

Reflection Series sketch

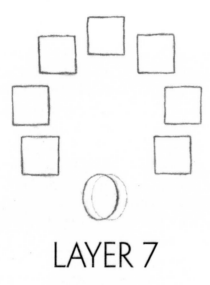

LAYER 7

Subconscious

My studio is lined with color. I walk over to my rolling table and pull it to the middle of the room. Clear some space from its surface so I can sit, and I climb on.

Lights are focused on the walls. Overwhelming emotion emanates from the reflective spectrum of pure color, radiating out of every piece of the *Reflection Series.* Now that they are completed, I want to feel them without the strain of more work to be done.

I take a deep breath and submerge into the abyss of meditation. My gaze settles. I know this place; I have been here before, floating in a sea of emotion. I am in control, body still, mind silent. A flower comes into view. I am suddenly sad. I ask, "Why do you bloom when death is inevitable?"

The flower answers patiently, "You are correct, my friend. Death is inevitable. Being is the ability to exist. But for an object to exist, it does not need to be living. It is the existence of death that reflects the effect of life. And, though dying is certain, living is still a choice. My bloom is my choice to live. The purpose of living is to die trying."

IGNORANCE OF OBSESSION

After completing *Reflection Series*, I was completely exhausted. The development of the process, the research, and the extensive study was grueling, and I was definitely feeling it physically. I no longer looked like myself. My obsession had taken a large piece out of me, and my friends and family were beginning to notice. I had been painting and studying for five straight months, in sixteen hour days, seven days a week. The work was so intense, I would forget to eat. I could not relax until I had accomplished what I set out to do. Working night and day in a windowless studio allowed me to completely lose myself in my work. I knew the dark rings under my eyes and the weight loss were not signs of good health. I began to have less and less energy to do anything outside of my studio or unrelated to my work. The power of my project was the only thing giving me enough energy to keep going.

I developed some sort of respiratory issue or virus and, instead of lasting the usual few days, this particular "bug" would not go away. My cough became so persistent, it inhibited my ability to paint. I reluctantly went to the doctor. After numerous appointments and multiple blood panels, they discovered that my body was rebelling against the long months of continuous chemical inhalation. Since my studio had no source of ventilation, and I was breathing fumes from the chemicals I was using, it's no wonder my breathing was erratic and my cough persisted. The heavy mixtures of toxic mediums and thinners, along with little to no nutrition, no sunlight, a lack of sleep and copious amounts of stress, my body had finally broken down. Unfortunately, we were not dealing with a common cold or virus. It had affected my blood and was depleting my platelet count. Now, more tests had to be conducted. Even with the use of an inhaler, my cough lingered. The list of possible diseases that could cause low platelets and red blood cell count was scary. Every few months, they would conduct more tests, which always indicated my counts weren't improving. My immune system was shot.

Ironically, if my immune system hadn't shut down when it did, I would have kept going until I ran myself into the ground. As foolish and shortsighted as it sounds for me to risk my health like this, I couldn't help myself. I was in another world; it was all I could think about. I didn't

want to lose my concentration or momentum, so everything that got in my way was pushed to the side—including my body.

Installing a ventilation system in an old concrete warehouse would take too long; I needed a dust-free area immediately. Masks helped to some degree, but most were not meant for the combination of chemicals I was using . . . and the ones that were well-suited made me look like I was in chemical warfare at ground zero. The cost and the time it took to prep, the stuffiness of paint masks, the heat generated by breathing like Darth Vader caused me to feel muggy and uncomfortable, which was too much of a distraction. Besides, I could never draw in a deep enough breath, which gave me slight anxiety tremors, which led to a hot and claustrophobic feeling.

I tried many times to use gloves to protect my skin from the chemicals, but I can't stand the disconnect between me and my materials. I need to feel the paint and texture on my fingers. You can tell so much about your mediums with a sense of touch: the texture, the viscosity, the slight chemical warmth from oil thinners versus water, the tackiness. One's hands and fingers are the perfect combination of soft and firm, between a sponge and brush, not absorbing too much, but releasing exactly what you need when you need it. Fingers are very sensitive, allowing for much more control when applying pressure. You lose all of that when you wear rubber gloves. Using just my fingers for an equal displacement of paint and making a consistent straight edge around the painting created the desirable effect in *Reflection Series*, and a glove would only have gotten in the way.

So, yes: I cared more about my work. The deeper I delved, the more entranced I became. And when I wasn't painting, I would sketch and write, or just sit and think all day. I could dive into thoughts, ideas, and build all of my discoveries on top of one another, connecting them to each other. I felt free; the hours would pass by in the blink of an eye. I never wanted to break the moment. Eventually, my body would not be able to take anymore, and the lights in my mind would slowly start to taper and dim. Returning to reality is hard; it seems to move so slowly.

I have always been one to get lost in thought, lost in my work, lost in daydreaming, lost in creating. But these works were different; they opened me wider and took me deeper than I had ever gone. I assume it

was due to the context of the series, along with the recent understanding I had achieved. But I knew the atmosphere in which I was working was not safe. I realize now that I should have taken my health more seriously at the start because, in the end, it removed a very large chunk from me. My obsession became my ignorance.

THE RABBIT HOLE

I learned a great lesson from this experience: I could finally understand where I had been trying to go in my mind.

It is a place where all types of artists, thinkers, creators, dreamers must go, whether they are aware of it or not. It is what the Aborigines call "Dreamtime." It is used as a metaphor in *Alice in Wonderland*, a passage that separates two worlds of existence: the rabbit hole

Unlike conscious reality, deep within the rabbit hole lurks the subconscious, where there is no beginning and no end. Neither time nor place exists, but all rules of conscious reality are broken, and are capable of existing all at once or not at all. This is where manifestations, through thoughts and memories powered by emotions, are limitless and wait for you to catch them as they float around you, to be pieced together in infinite ways.

This is where Einstein interpreted $E=mc2$. This is where theoretical physicist and cosmologist Stephen Hawking contemplated (among other ideas) M theory, a version of string theory which posits that our universe has untold numbers of "cousin universes." Michelangelo visualized David within a block of stone, and captured scenes from Genesis and *The Last Judgement* on the ceiling of the Sistine Chapel. Ernest Hemingway, Edgar Allan Poe, William Shakespeare, Gabriel García Márquez and George Orwell strove for literary excellence, reinventing modes of expression, feeding life organic emotion. Plato, Newton, da Vinci, Freud and Kant deconstructed and reconstructed the enigmas of humanity and the world, changing not just the perception of reality, but facets of reality itself. This is where Sun Tzu extracted the psychological strategies outlined in *The Art of War*, where Alan Watts interpreted Eastern philosophy for Western application. Unlike the conscious world, the subconscious world contains infinite possibilities, no boundaries, no gravitational laws.

We have all gone to this place; some of us go deep, while others only dip their toes in as they stay above water, perched on the tip of the iceberg. Most will experience the depth of this place while they dream, realizing that receiving the power of limitless manifestation is not always a good thing. In fact, it can be scary; without control of yourself and your emotions, what you imagine is not always pleasant and can quickly become a nightmare. So, few dare to travel so deep and so far. But you *can* learn how to control at least some parts of a dream. For instance, when you're running forward, you're trying to outrun whatever is chasing you. But if you consciously turn, face the subject head-on and run backward, you'll find you are able to run away. You may travel so fast and far that it takes you into a whole other dream. Only when I take conscious control of the activity occurring within my subconscious mind am I capable of unlimited manifestation.

Those who travel deep into the subconscious, incubating and absorbing all they can, bringing what they have seen, experienced and created back to the surface of the conscious world have a responsibility. It becomes their job to use the available materials in conscious reality to express what they have discovered deep in the rabbit hole. This allows the conscious world to build a foundation for their evolution. It is what the deep travelers find, and what they create, that challenges humanity.

But there are as many dangers as there are joys in this rarefied place; enter at your own risk. The deeper you go and the longer you stay, the more it takes from you. Stay long enough, and it can become you. Like radiation, it takes a toll on whomever is willing to absorb the energy. It is a sacrifice, one hopes, for the greater good. It's very easy to get lost . . . so much comes to you that you want and need, it becomes a haven for obsession. The longer you are immersed, the greater the demand from the conscious world grows. You are required to feed their expectations, a pressure that can trigger the ironic destruction of that on which they depend: art, music, literature, inventions. In many cases, that duress forces you to find methods to stay longer and go deeper. Less and less does the artist, poet, writer, musician, actor, innovator feel connected to the conscious world. We've seen it in all the greats: they gain more comfort in the isolation of the rabbit hole, until it consumes them completely (a loss for everyone), or they become blurred between worlds and lose their equilibrium. There is a hairline between genius and insanity, and the nature of the process should be protected.

And the willingness of those who take the risk and know the sacrifice, who accept the obsession that consumes all of one's time and energy, should be respected. One who chooses this path is contributing to the evolution of humanity; this is why the creations of great minds are so vital. Especially since the conscious world may be fed by the creation in one moment, then use the creator as its scapegoat in the next. So, the support and incubation of a creator is imperative. Without great art, music, literature and invention, we all lose.

THE ANCHORS

Kim

I finally understood my role as an artist. But if Kim hadn't forced me to go to the doctor, and hadn't been diligent about getting me to eat and rest, I don't know how far down the rabbit hole I could have gone. I'd had an experience I wasn't prepared for, and did not have the control I needed to help myself. I had made no plans to come up for air. I'm aware of that now, and I have learned the importance of having lifelines between the rabbit hole and the real world.

If I am a dreamer flying high in the clouds, then she is the one holding the string of my kite.

I trust she will never reel me in and ground me, but I also trust she will never let me fly so high I lose myself, unable to see the ground. Hers is the voice of reason, giving me balance, while I dream forward, catching the winds that pull us. As an artist, this is crucial: to have someone you respect, someone you can trust to hold on tight.

But something I had not fully grasped until this point was, what do the ones closest to the dreamer endure? Trying to keep up and acclimate, the ones who suffer most are the ones holding the string to the dreamer catching wind in the skies. We pull and pull and pull forward, hardly looking back. It takes a deeply committed position to hold on. What the outside world doesn't see are the jagged mountains, the vast deserts, and the deep seas that the trusted one must endure as they hang on. If the wind keeps blowing, the kite will keep pulling forward without rest. Rarely does the dreamer notice, as the trusted string bearer rarely shares

their struggle to maintain. I know it is not the intention of the dreamer to cause anyone to struggle . . . but a kite was made to fly, it is its nature . . . to never become complacent, never to become a static fixture in the sky or on the ground. The hope is that the reward of blue skies will be shared by both.

Friends

My close friends are my next set of lifelines. Only true friends will allow you to come in and out of their lives without question, without missing a beat, accepting you as if you've been there all along.

The duality is that, although I must dream alone, I cannot be alone in reality. For without my collectors, my friends, my family, and my love holding the string, I fear I may never see land again. They know to let me go, and to protect. It is this sacrifice that keeps me whole, for they give me the most precious and valuable thing they own: time. Time for, and time without.

So when I find myself in troubled atmospheres, when I contemplate giving up, when I get lost in this place of dreaming, I do not need to look in the mirror to seek strength, but in the faces of those who anchor me, who keep the light on so I may find my way back to reality.

THE CATALYST

It was the beginning of a new year, I had come through the latest set of trials, and I was finally ready to unveil the *Reflection Series*. But I was about to face a problem that I'd never before experienced or expected. The Gallerist, whom I had acquired as my representative after the big event, was hesitant about this new series. He could not see what I saw; he could not feel this work as I did. He even said to Kim, "I've gotta be honest; if this was the series Justin had shown at his big event, I would not have signed him." It wasn't the work itself he didn't like; he was afraid I had moved on from the original series he'd fallen in love with at the last event. In addition, he already represented two artists from what was called The Concrete Movement. One of his artists was considered

a grandfather of the movement, while the other artist was a young gun who had recently made his way onto the scene. I respected The Concrete Movement, but I did not think my work fell into that category. Unfortunately, I could not get The Gallerist past the cover and into the book. He understood the raw emotion my work represented, but he would not take the time to reach the other side. He dismissively categorized it as coming from The Concrete Movement, and that was it. From a logistical standpoint, I understood his dilemma (however narrow his perspective), but it was a bad situation for me, and the timing was even worse. On one hand, there's Concretism, which is said to be unemotional and devoid of any naturalistic associations. On the other hand, there's Abstract Expressionism, which is split into two different styles, gestural and full of contrast. Then, there is action, smooth, flat, and relatively incident-free, with large fields of color.

In any case, I've never liked labels, especially when it comes to my art.

I had been working on *Reflection Series* for over a year . . . it was only one piece of a story that led to a much bigger picture. The development of this series was far more important to me than being lumped together with other artists whose work was perceived to be similar to my own— but was decidedly *not*.

In this series, I wanted to give people a starting place to build from, so they could appreciate the simplicity of color combined with the rawness of emotion. People understand and respect an idea when they are part of it, and there is no better way to do that than to show people the origins of the idea. This allows them to realize how connected to it they really are, and how much they truly understand, if only they'd look at it from a different perspective. When you give people a key to the doorway between places, you're communicating the point of art itself, through the simplicity of an idea. The work then becomes an instrument, a conduit to that understanding.

The Gallerist's response to my work was hard for me to swallow. I was looking for more faith on the front end, and I was disappointed he seemed to have none. I wanted him to be more engaged or excited, and willing to take the time to nurture the idea. To his credit, he didn't try to sway me away from the work—probably because he realized I wasn't going to budge.

I planned to host an "unveiling" event for the series at my studio instead of his gallery. I was ready to move forward, and I didn't want to wait for his gallery schedule to open up, which would have been several months away. Oddly enough, even though he wasn't 100% behind the work, he had his staff make time for a brief showing in between some already-scheduled shows, then insisted that we have the opening at the gallery. My gut was telling me this was a bad idea for everyone involved . . . but I agreed. Sure enough, it proved to be a costly mistake. I felt ashamed that I didn't listen to my instincts. I knew from all the previous shows and events I had done, as well as those I had attended over the years, that I should have kept control of the strategy.

This is my advice to all artists: never hand over control of your career to anyone who doesn't share your excitement. Their motivation will never match yours, and you will be helpless to take proper care of your children.

They penciled me in for a one-week show, and they cut into another artist's show by a few days to accommodate the schedule. The week they chose was in the middle of a very hectic schedule of exhibitions and major art fairs. There was too much going on, and their attention was spread way too thin, leaving my exhibition to slip in importance. It became more of a painful incident than a productive occasion. They couldn't chew what they'd bitten off and, before I knew it, they had cut my show down to three days. The invitations were sent out late—which didn't really matter, since their list was already saturated with all the other invites and updates that had be sent out around the same time. It was a slow-motion train wreck. No one in The Gallerist's organization took the necessary time and consideration to make it a success—but it was too late to pull out, now. My only excitement and comfort came from seeing my work hanging in a setting other than my studio, on big, white, well-lit walls.

So, while a few of my top collectors had come to my studio before the event and bought some pieces, the gallery exhibition was a bust. When I showed my work to my top collectors in advance, I was able to explain the meaning of the series to them. The same effort was *not* made at the show by The Gallerist and his crew. It was the worst attendance I'd had for any of my shows . . . second only to the show-closing artist talk they

planned. Because I'd already explained the work to my collectors, and the gallery had exhausted its list with other shows—and it was planned at the last minute—none of the invited guests came to my talk.

I was numb. Nothing like this had ever happened to me. I was always on top of my game and making strategic moves when preparing my exhibits. It was my fault. I knew my limitations, and I knew theirs. All the signs were there; I just didn't pay close enough attention to them.

DEDUCTIVE REASONING

After repeated studio showings, and discussions with my collectors and art aficionados, I began to understand the difference between the people who "got" the work and people who were confused by it. Those who had seen the evolution from one series to the next were much quicker to grasp the meaning and purpose of *Reflection Series*. Those with whom I had no affiliation or connection were quicker to judge and take on the series independently. As for The Gallerist and his clients, they had scant references to pull from, having only been exposed to one other body of work, *Imagination Series*. The transition from *Imagination* to *Essence* to *Reflection* didn't feel right, and was given the wrong classification by the gallery. This was not a specific artistic movement . . . this was my interpretation of process. My biggest regret is that the pieces in *Reflection Series* did not get a fair opportunity to make their best first impression. They deserved better.

A few months later, The Gallerist did finally take the time to listen and understand what I had been trying to tell him. After our conversation, he understood the differences—but by then, it was too late. I never again showed that series at that gallery. I knew I would have to do the next one on my own.

SILHOUETTES OF THE PAST

There had been rumblings about The Gallerist before this exhibit that became more apparent after the whole debacle. There seemed to

have been similar issues with other artists, too. After many months of watching and observing the situation, I could see exactly what was going on: it was a familiar behavioral pattern, one I had experienced in my childhood, with my mother's self-involved drama and my father's promises for the future. The Gallerist was a yes-man, promising things over which he had no control. He'd agree to everyone's demands, with good intentions and a genuine desire to give everyone everything they wanted. He loved his artists; he just didn't know how to manage them.

From my vantage point, he didn't seem to trust or respect the opinions of his young staff enough to listen to their suggestions or delegate business responsibilities, which would have allowed him to concentrate on his forte—the art.

The Gallerist had impeccable taste in art, along with a strong knowledge of art history, and a passion for its beauty unmatched by anyone I know in the industry. He could speak fluently about every movement from any study from any decade, and I always enjoyed our conversations about art. But all that knowledge is for naught if you are consistently unable to keep your head above water. He had developed a nervous habit of solving short-term problems with long-term promises, which eventually led to long-term damage.

I was sad to see this happening to him. We had become close friends, and I believed he had the best intentions. But he was being pulled in twenty different directions, which resulted in broken and forgotten promises. I was put in an awkward situation, a conflict between business and personal interests. I began to look for another way to do it myself, knowing I could get better results.

I have a rule about giving someone your word and keeping it. The most important parts of my youth were built on broken promises. I would wait for them to be kept, depending on them to grant my future … until I finally became strong enough to let go. Out of those experiences, I've made it a point never to conduct my business or my personal life in this manner. I don't want to perpetuate the dysfunctional behavior, only to break the cycle.

My career had not gotten this far by breaking my agreements … and I had to respect and uphold the promises I had made to myself. Nothing was worth going back on that. However, despite knowing

better, I now found myself bending my own rule and pushing it to the edge. This put a tremendous amount of strain on me, my work, and my relationship with Kim.

The longer I allowed it to go on, the more dependent I became. I wanted all of his promises to come true: introductions, exhibitions, acquisitions, and publicity. I kept hanging onto a glimmer of hope, moving from one promise to another, month after month trying to believe it would eventually happen. Instinctively, I knew where this road would lead ... but I didn't want to admit it. This allowed for resentment to build over time, permeating everything I did. I no longer loved the business; the importance of creation had been overshadowed by immersion in petty and unproductive pursuits. And I had lost control over every aspect of my career. This experience, and this relationship, were costing me—financially and emotionally.

EPIPHANY

A year had passed, and I still couldn't let go. I was granted a solo show at a sister gallery in Santa Fe. Again, the attendance was not what everyone expected, and it was certainly not what I had hoped. This was yet another disappointment. When we arrived back home, a collector informed us they'd received the postcard invite for my show three days *after* the event took place. I couldn't believe it. I don't understand how that gets missed, how such an egregious error happens at this level. I'm sorry, but "It's our new mail company's fault" is not an excuse I am willing to live with. An artist at an established gallery gets maybe one solo show every year and a half. I didn't care about the reason, whether it was true or not; I couldn't live or work like this, with another major solo show tripped up by late invites and the infuriating mismanagement of basic event logistics.

Four months prior, we had a group show for the grand opening of this new location in Santa Fe. It was a big deal, and everyone was excited. But fifteen minutes before the doors opened, price tags were still being printed, cut and hung. I finally jumped in to help by taking over the cutting project, just to ensure that the tags were in place by the time people arrived. There I was, frantically cutting price tags in the bathroom!

Things like this were always happening, and plagued my relationship with The Gallerist. The constant drama was toxic, particularly the ego-clashes between management and a few artists. I don't operate like this, nor do I thrive well in an environment saturated with too much tension, where too many fires need dousing. Easy fixes couldn't be mended because The Gallerist was going in too many directions at once, while juggling too many balls. Advantage was inevitably taken of him, and he would eventually be left empty-handed.

I found myself losing focus on what was more important, on what I had originally set out to do. My anxiety and resentment intensified as I pinned my hope on each word and every promise, intuitively knowing the result (or lack thereof) would let me down. What The Gallerist had seen in my works were no longer the dynamic emotions bleeding into the canvas; I was bleeding. I had become stagnant, mired in bitterness.

This was not me, and I did not want this deleterious experience to taint me, to destroy what I had worked so hard to achieve. I no longer had the desire to hang on; I knew I had to take control, which meant letting go. So for my sanity, my career and my friendship, I had to walk away from the relationship, and take full charge of my destiny once again.

FULL CIRCLE

After I had truly let go, I felt a genuine sense of calm and focus. I had at last pulled myself out of the train wreck and walked away, safe and sound. Exhausted but relieved, I quietly returned to my studio, to reflect on the past years. I felt I had passed one of the last tests required to find my true self. Now, I didn't want to be anyone or anywhere else.

I had found reason and purpose. When I'm in my studio, looking back at my work, every experience of growth grants me something new, something I could not have seen without that experience.

It was only a few weeks after making up my mind to let go that I started thinking about a new series. The winter months were setting in; this would be a good time to hibernate and contemplate. My reflections led me back to *Imagination Series*. I performed my ritual of asking the work, "What now?" While I sat in my studio and stared at each piece, the proposed question became clear.

This time, I no longer saw the question; instead, I was being asked a question.

Having a calm sense of control over your emotions is important if you are to see clearly and have a point of focus. My life has looped over and over around various aspects of the art world, and my purpose was now evident. I was no longer worried about my future, no longer tied to false hope. I was free to concentrate on the important lessons I had learned on my journey so far. I felt no anxiety or pressure to find the answer . . . no desperate feeling about what was next. I felt in control. I even found the wisdom to gain more patience—a trait I never thought I would have, especially being a dreamer. I had found the perspective I needed, and was still standing. I didn't come out bitter, just smarter.

"If this is where I now stand," I said, "then the question should be, 'What does that look like?'"

I dove into these thoughts and began the process of working them out in my mind, linking memories that could project an understanding of what this might look like on canvas. I again found myself staring into the stained silhouettes of *Imagination Series* that hung in the studio. As my mind began to unfold into the process, the silhouettes started to move about the canvas. They rotated in unison, flowing like a ring of fire, calling me as I fell in.

"I know the shape is *looking into me*. I know this place, I know this memory."

As quickly as it happened, the moment passed, and left me wondering if it really happened at all—or was it just my imagination? The only sign that it *did* happen was the impression I received, a memory brought to the forefront of my conscious. A piece of art I had seen many years before, one I had created before my first series . . . before anyone knew who I was.

It was a dark-colored silhouette stained into my pale textures, cutting deep into the canvas . . . only this piece did not have the multiple erratic shapes stained across the canvas, but just one silhouette in the intentional shape of an imperfect oval. Stained deep scarlet red in the middle of the canvas. The title I chose for this piece was *Focus*. I knew in that moment my life had truly come full circle; the coincidence was too surreal. I would be a fool not to encapsulate in this new series my journey thus far.

I immediately started with understudies, to get my feeling for the work ready for the canvas. This was quick—there was no new learning

curve to conquer or explore this time around. I engaged in the same process as *Imagination Series*, breaking down the four elements of color, shape, depth, and movement—but instead of creating "sporadic consistency" across the canvas, I created "controlled inconsistency."

Everything—the shape, the color, the movement of textures, the demanding depth—moved in the same direction. The emotion wrapped up and flowed in harmony, the nature of its existence the same as *Imagination Series*, but controlled in an effortless calm, like the focus of fire flowing into shape, simply from your will to make it so.

I named these works *The Focal Point Series*. I felt the name fit well with what it takes to move through the world. This series was in honor of the piece that pulled my life back around.

A month after creating a handful of pieces for this series, I took some time to study them more deeply. I wanted to make sure this was my life, that I had learned something deeper than could be granted on the surface. I looked at these pieces in relationship to all my previous work, measuring my time in the art world, and what I've learned from living . . .

Evolution loops from experiences into questioned awareness, then through control, predicated by the desired state of change, and giving us the reason we strive to move forward in life. This is *humanity's sustainable infinite.*

THE IMPORTANCE OF THE STATIC NATURE

Once we become aware, we have a choice: to live or to live on, to desire a state of change, taking *control* of our needs through the process of evolution. It is when we question that we become aware and give ourselves a choice. Only then can we find the desire to evolve.

I read once that words in a book are static; I find art to be much the same, a mere snapshot of time. In the same breath, you can recite the names of geniuses like Hemingway, Fitzgerald, Shakespeare and Plato. From Rothko and Pollock to Michelangelo and Da Vinci. Their works are marvels, yet they are static marvels, they do not evolve. It is humanity that realizes their own evolution when looking through these invariable works. A reflection, a tool to measure growth, the work never changes but is simply a mirror for us to gaze into, through which we can

look back and gauge how far we have come. I must believe these works are static—a stain that never fades, that cannot be forgotten. How else can we know where we are, and where we can go, if we do not know where we were? When you look in the mirror, do you see the youth of a child or the wisdom of experience? Have you grown, or do you stand still as the world passes you by? To motivate the world forward and give each of us something to hold onto is the purpose of art, the job of the creator, and the sacrifice a creator makes for humanity's sake. These are the foundations, the cornerstones, the building blocks, upon which humanity collectively climbs.

THE ARTIST

Having a purpose is the most powerful incentive for anyone to move forward in his or her life. Without it, I'm not sure we are really living.

When an artist sacrifices, he excels beyond boundaries, reaches into the abyss, finds courage for humanity and says, "I am more than can be defined. I am with purpose, and like a stain, will never be forgotten." A muse for our survival, a foundation for meanings unspoken; the beginnings of the indefinite forevers. This I have chosen as my obsession: to rise above complacency and reach for more.

Focal Point Series sketch

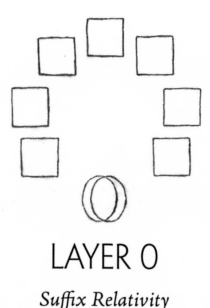

LAYER 0

Suffix Relativity

Sunset, I have seen you do the same thing every day, many times. But if you are different today than yesterday, how can I know? If I were to walk west in pursuit of you, would I end where I began? How then would I know if time and distance are relevant? If I had no timeframe—no clocks, no calendars— how would I be able to perceive you differently?

This cycle, this evolution, is the context in which I know you to exist, sunset. The information you gather each time you pass is how I gauge your difference. Thus, it cannot be time or distance that I measure, only the collected knowledge. What one has done, what one has gained; this is the most accurate measure by which one's evolution can be realized.

The difference between where I start and where I end is not time; it is the knowledge I gained since the last time I saw you. This accumulated understanding is the only true measure of self.

Walking a straight line inevitably gets me back to where I started: standing still, like the first day I laid eyes on you, surrendering to my curiosity, daring

myself to ask why. For so long, I thought finding the right answer was the most important thing; now, I see it is more significant to ask the right questions.

So, I thank you, sunset, for bringing me full circle.

THE TANGIBLE DREAM

The dawn of a new age is peeking over the horizon, technology is shrinking the world, cutting out the middleman, allowing a floodgate of opportunists to enter, and leaving behind the deeper values of connectivity. We lose touch with each other to streamline evolution, and the art form must hold its ground when faced with adversity as we step into each generation. It is the art form that the world measures itself against; this is the reason the world progresses.

It is with the same measure that we value the true nature of mankind, stripping away everything but the vulnerability of transparency. When you have no boundaries, the true test of holding yourself accountable is ever clear. Therefore, it becomes the job of both the creator and society to protect an artist's incentive to strive for greatness.

When stripped to its real purpose, the "need" that lies within all art forms has no strings, no smoke and mirrors. It is not found in the value of the art itself, but within the artist. *To measure the true value of art is to look at its creator.* The priceless value beyond the tangible strings attached is the intangible idea behind the work. The true power in art does not have boundaries of containment. The art itself will flow in and out, and eventually fade with time . . . but the meaning can last forever.

When you give humanity more than the tangibility of art, they begin to expect it. And, just like supply and demand, when the market demands something, it creates an incentive to supply it—in this case, that means bringing meaning and purpose to art beyond tangibility. The art form is the cornerstone of communication, and when you put that incentive above all else, humanity is pulled in a positive direction. We then learn to measure the success of an artist, not by what they take, but by what they give.

The true potential of mankind is not held by those who confound us with sleight of hand, and who abuse the art form and the artist for personal gain. But it is the silent akratic indifference of good people who

allow the stagnation of humanity to go unchallenged. As human beings, it is in our nature to have an opinion; it is not in our nature to do nothing.

OTG

OneTonGoldfish was the name of a T-shirt business I developed as a teenager that failed before it launched. Although the endeavor didn't succeed, I knew the name was meant for something bigger, and kept it alive in small ways through the years.

But I had to come full circle to realize the gravity of its role in my life. When I learned about myself, discovered my purpose, and realized the importance of achieving such clarity, OneTonGoldfish became a representation of my greater self, conceived to be of service to my fellow humans, to help others discover *their* greater selves in every aspect of life, and to realize *their* tangible dreams.

No matter how insignificant we may feel,
or how lost we become in the vast sea of humanity,
it does not mean we are without purpose.
A ripple, no matter how small, can shape the world,
if that ripple is created with passion, conviction and purpose.
Such ideas have no limitation of growth.
For those who seek more than complacency,
and lead with curiosity, with the faith that questioning the world
will end in reward, I leave you with this:

You are but one person among humanity,
vulnerable to your surroundings.
But your character, your purpose, and your words carry weight.
Know that the core of your humanity is never too far out of reach,
however distant the echo.
Never change who you are. Always be heard.

—OneTonGoldfish

"To develop a complete mind:
Study the science of art.
Study the art of science.
Develop your senses—especially
learn how to see.
Realize that everything connects
to everything else."

—Leonardo da Vinci

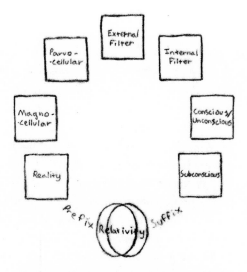

TRANSPARENCY

Revealing The Tangible Dream

If you have made it this far, maybe you are willing to go a little farther.

I have shared with you my experience of the artist's process; perhaps you've gathered that it is akin to the process of life in which we all find ourselves. But it was never my sole intention to simply give you the story of an artist. I always hoped to offer something much greater, something unforeseen—and my hope was fulfilled when, through these creative explorations, I became aware of the place at which art and science connect. Here, you will see that each layer of this book represents something more, each series was designed for something greater.

The tangible object will fade in time, but the intangible idea behind the work can change our lives, and it lasts forever.

Layer 1: *Mélange de Rêveur* / Reality

The soft undertones of sporadic color spread over the length of the canvas, then masked with layers of textures hushed across, like aging walls. I tore up my abstract charcoal dreams drawn on sketchpads, now carefully broken apart and collaged in minimal fashion, allowing the background to breathe. The severed black and white dreams began to form fresh lines that flowed into newly-acquired spaces in between, feeding a sense of connectivity. Each dream fragment collapses from edges into background, with the fading of colors that once dominated the canvas, yet are subdued underneath the layers of texture, formulating a subtle indication of evolution. The colors moved like any good trend, circling around to face a new generation. The movement of angles along the integrated dreams demanded change, becoming an over-bowing, unapologetic line, pulsating in the livelihood of their fight for existence. Taking that which was, into what will come, birthing new dimensions from pieces once whole, as abstract dreams become pieces of reality.

Reality is a whole made up of many parts, like a jigsaw puzzle. It may be broken down to the fundamentals of physics, the very elements that make us and the objects existing in it. Or it may be a breakdown of the structural and spatial knowledge of reality in relation to self and other individuals or objects. Reality can be said to exist through many parts becoming realized by the individual, and a part of us must exist within it for us to understand and interpret reality through the cognitive process. Therefore, reality can be seen as the physical state of being.

Layer 2: *Exploration Series* / Magnocellular

My idea was to incorporate the abstract world I was familiar with, and merge it with architectural structures in a seamless fashion, depicting the two worlds meeting and interpreting each other. As I had found with the last series, reality is made of abstract pieces becoming whole, but the first step to seeing it is in the formation of primal lines and shapes.

I first started to sketch the intricate structures in their entirety and, after much iteration, I could not find myself at peace with the idea. The structure had already been created, and any recreation would never do it justice. It did

not fit my interpretation, as it came from the place of contact between the two worlds, not the re-creation of both worlds, thus missing the mark and ruining the whole concept.

I decided the structures would have to remain predominantly untouched, captured on the canvas without rendition or alteration. I settled on an altered collage process, one that would be able to handle itself well, while allowing me to concentrate on balancing the timing of layers in and around the structure.

The composition of the structures had to consist of at least ¾ to ⅘ of the canvas, to fully represent the sheer magnitude of the structure itself; the eye prematurely forms a relative idea of size based on the structure's relative size to canvas.

Finally, I found my rhythm in bridging the two worlds of structure and texture. I used ink, oil, and charcoal to form fine lines from the structures, off into loose angles of open textured spaces. The transition was pulling one in and out of the two worlds through the most primal purpose of lines, while keeping the respect for each standing independently.

The next layers in the process of cognition are Magnocellular and Parvocellular. They are the two subdivisions that hold the main pathways concerning visual perception. Although we have several senses that allow us to understand and interpret reality, the one used for this book is the sense of sight, specifically chosen for discovery of the seven layers. The significance of these layers is directly related to the order of the cognitive process. They are the first to perceive reality, breaking down the information to accurately create an understanding of the environment: form, color, movement and depth. Each layer takes on a specific role but, as a whole, represents vision.

Magnocellular covers a broad scope of the visual system. Magno cells perform parallel to the visual system of the non-primate mammal, as they both tend to the primal purpose of detecting its environment, prey, predator, and or object. They are sensitive to movement and the overall layout of the visual world (reality), and carry information about movement and depth, definable edges and individual objects, and organizing the three-dimensional scene. Yet, these cells within the Magno layer are truly colorblind, as they read like black and white photography, detecting the wavelength inputs from the three cone cells (Red, Blue, Green) as either on or off. For example, a dark red next to a high luminescent yellow would be read as dark grey next to light grey.

In short, the Magno layer organizes information perceived as reality from its most primal parts, with little or no bias of color playing a role in the interpretation and understanding of reality, outside of necessity.

Layer 3: *Creation Series* / Parvocellular

There is nothing more intimidating than a white canvas staring back at you, like Rocky meeting Apollo Creed in the ring for the first time. With warm studio lighting in place of cool fluorescents, music vibrating off of the brick walls, I studied my opponent until I was ready to make a move. When I hit the canvas, I started in hard. Techniques confident. Moves of the brush a mere glimpse of déjà vu.

I was looking for something. Like digging into an old chest, I wouldn't know what it was until I saw it. Painting my way through. Staining the canvas. Losing my surroundings. Curiosity drove me deeper. Feeling through each choice; stains became darker. I went deeper still. Time and food became irrelevant.

Then, for the moment, the fight is over. I stepped back, taking in the work in its surroundings. Weak, with paint-stained hands, brush still dripping. I couldn't make sense of where my creation came from.

I had not traveled anywhere, bringing conclusions to the madness. I had no epiphanies, just flooded with emotion. I had realized it, but not by any conscious means.

Parvocellular (Parvo) is Layer 3, and has been found to cover a much greater function of analyzing the scene (Reality), scrutinizing in much more detail the shape, color and surface properties of the scene, capable of interpreting and assigning many attributes to a single object. Ninety percent of the Parvo cells are sensitive to wavelengths, reading the inputs of cone cells (Red, Blue, Green). Ten percent of the cells are color blind, yet can still distinguish a divisible line between two colors of the same luminosity, as Magno would read the same grey tone (for example, dark red next to dark blue, both at the same luminosity). The information from these layers transfers to the higher visual system in the brain and is seen as the evolved portion of the subdivision pathway, as this visual system is only highly developed in primates. This could be seen as the evolution of interpretation.

The Parvo layer allows for a more complex interaction with Reality through the sensations that coincide with a wide array of electromagnetic radiation (visible spectrum of color), offering more information to be analyzed.

Layer 4: *Imagination Series* / External Filters

I started sketching in charcoal, random nothings, to allow my brain to be elsewhere. I gazed at the paper, looking past it. It began simply, the idea rooted in what I had learned from processes thus far. If I am to capture the essence of a question, and I am to do this by only having imagination to create from, without any bias, then I must trigger curiosity. Curiosity leads one into the act of questioning, and if imagination is the only thing I leave for people to hang onto or pull from, then that is where the origin must exist.

The last time I imagined something, or dreamed of something, I pieced it together from memories. If I want to represent the act of questioning, I must paint the trigger of memories. This is where the process began. The paintings must not be a specific memory. It must contain only the basic primal parts of a memory, to give the viewer complete control of their imagination through their thought process.

I reviewed all my Creation Series and previous works, studying the basic elements, and began formulating the evolution of the new series. I stripped out the landscape from Creation Series, leaving nowhere one could settle on the familiarities of a specific time. No journey, no past, present or future.

A memory is like a stain, and it would exist as one on canvas. I broke it down to the basic parts of vision found in the basic aspects of art. Depth, movement, shape and color. This would represent a memory.

What began to take place looked like a silhouette of shape and color stained on the canvas. I started with two, then moved to a consistent three silhouettes floating on the washed-out backgrounds. I kept the strokes sporadic, without any object in mind, leaving as much distance as possible between myself and the mark-making process. These gestures were like the ones I had sketched in charcoal. I was keeping inconsistency consistent. The strokes of shape, depth and movement were random, but their randomness constituted the act of consistency.

We can comfortably arrive at the next layer within the cognitive process because the last two layers—particularly the Parvo layer—have sent information to the higher visual system of the brain. The External Filter is where the breakdown of Reality becomes changed and re-categorized. It is an outside influence, imposing itself on us through religion, culture, environment and other external forces. Imagine this layer as a filter . . . widening, narrowing, clouding, clarifying what and how we perceive reality, limiting the full amount of information coming in. Even though we may *see* Reality, an *opinion* of Reality starts to be formed at Layer 4.

Layer 5: *Essence Series* / Internal Filters

I decided to build a series from a truly selfish perspective, completely opposite from Imagination Series, and one I would find very hard to face. It had been lingering in my mind whenever I looked at that series. It was not so much what I felt, but what I didn't see. There were some questions I needed to ask and answer on my own. What was missing? What did I need to find?

When I gradually started to paint, I knew what I wanted to achieve. I first pulled from the things I remembered, things that moved me. I was determined to bring deliberate reasoning to the foreground.

I kept the stained silhouettes intact on the canvas, but this time I pulled in the horizon lines from Creation Series, giving the silhouetted memories a place to rest. Bound by time and the distance of a journey, not only mine, but that of any viewer.

The premise of my work was based on a poem I had once read in my youth. It was about an artist's painting of a young man and a young woman. The artist painted them as a "still life," right before their first kiss. In the poem, the young man is angry at the world, and at the artist, for leaving him frozen in time, never knowing the lips of the one his eyes would never leave, tormented forever. He will spend the rest of his life at the moment of climax, desiring nothing more than to have that kiss. As the poem unfolds, the young man begins to realize it might not be so bad after all; maybe the artist knew something the young man didn't. At last, he feels fortunate to be living with the love of his life in that moment forever.

Sunsets are this special moment for me, where the day and night meet. For me, they are among the most emotionally charged moments in life. The sky

is filled with shifting colors; the eyes are stimulated, adjusting to the change, physically and mentally. The movement of the world is so clear, even as we stand still, captivated by the mortality of the day. I likened the background of my new works to this phenomenon, with its atmosphere surrounding this frozen moment.

As a child, I was fascinated with boats. I loved to watch them sail along the horizon, with the vibrant sunset as a backdrop. What are they doing out there? Are they coming to me? Are they going away from me?

These three childhood memories inspired my next series. I'd feel the silhouettes floating on the horizon; the boats became vessels moving along the ebb and flow of emotion being breathed into them.

After we pass through the External Filter, we face another layer: the Internal Filter, the personal environment built from our individual experiences. Unique to self, this is the last layer before the Conscious Unconscious layer and, like the Layer 4 External Filter, it shapes our perception of reality. Filters can change, by one's will power, making the filters clearer and wider, or narrower and cloudier. Through the application of Internal Filters, the individual can will a change in their perception. Yet this layer, with its power in forming individual perception, can be hard to control. Some experiences that shape us are simply impossible to change.

Of these two layers, the most predominant is the External Filter, yet the most powerful layer (at its core) is the Internal Filter. For instance, propaganda (external) is a potent tool for mass influence, but forming one's own opinion (internal) is a more involved and individual process. The first experience of reality is a pure and primal experience that has not yet been filtered externally or internally, both of which are necessary to form a fully-realized opinion out of the raw information.

Layer 6: *Reflection Series* / Conscious Unconscious

I knew right away that my focus was on the color. So the paintings themselves would be entirely covered with only one color—one that would capture emotion by its bold presence, but still let me focus on certain aspects of technical approaches. I figured that having a large amount of one color

could only stimulate the cones in my eyes further, leaving little room for distractions—silhouetted shapes, for instance. This would compel viewers to reach for something more, to understand what they were looking at. Being forced to do so would trigger different parts of the brain. My ultimate goal here was to allow people to feel the energy, yet reach a logical understanding. With that in mind, I began to further develop the process I had been accustomed to using, a repetition of alternating between layering and glazing. This process was not unlike what the old masters used: layering to create depth and a lifelike feeling in their works.

I found that taking this process to the extreme would precipitate the right approach, one that would truly capture the technical properties of light within the work. I used the process of thinning oils to its pigment form and floating these particles within a mixture of clear mediums, allowing light to exist—not just on the surface of the work, but within the layers. I would repeat these steps over and over for some thirty layers, giving light the ability to pass through all of them and hit the background, reflecting and refracting within the layers, as well as hitting all sides of the pigments. I found light existed longer within the painting because of the mirrored reflection from layer to layer. I did, however, begin to realize diminishing returns. At a certain point in the layering process, light would cease to reach the background, rendering it pointless to add layers beyond a certain amount.

In my heart, I felt like I was going in a good direction—but mentally, I had hit a wall. I found myself becoming fixated on the edges of the canvas. It just simply did not feel right to continue the consistency of pigments from painting edge to painting edge. The feeling of falling off the painting and into the wall, being defused and creating a displacement of emotion, had left me at a standstill.

I began to see the process as if I were watching a skyscraper being built at high speed. The memory became a border on the canvas, reflecting what I had experienced so many times. In this new series, each painting's edge would have a lighter amount of layering that quickly faded, not too sharply, but not in a long, drawn-out fade. It would unfold just as I'd envisioned it when I'd held myself under water.

Like blinders on a horse, the visual sense would be focused on, and trapped in, the painting. Everything beyond the enhanced stimulation of the border would fall off the conscious mind's perception. As the viewer gazed deeper into the piece, letting go of control, their peripherals would

begin to color-match the border's luminosity, constantly pulling in and out, adjusting like a camera lens. The stimulation would visibly shift, becoming alive, as the viewer loses himself even more deeply in the painting, forgetting to breathe for just one moment.

I had connected my technical understanding with emotional perception.

This is the wall between two worlds of existence. Information from reality travels into the visual sense impression layers (Magno/Parvo), then through the External and Internal Filters. From here, the information hits the Conscious Unconscious, where it is broken down and fueled into the Subconscious. It acts as a barrier to the Subconscious, with rules and boundaries of containment for what we are capable of perceiving, translating and transmitting between two worlds of existence: Reality and its physical state, Subconscious and its cognitive state. Information must pass through this wall when coming in or going out. We are consciously aware of some information; other data—like the ambient sounds of an A/C unit or the ticking of a clock—pass through unconsciously. Simply, as it can interpret laws (like the order of time and place), it is a boundary that allows us to accept reality.

Layer 7: *Focal Point Series* / Subconscious

My life has looped over and over around various aspects of the art world, and my purpose was now evident. I was no longer worried about my future, no longer tied to false hope. I was free to concentrate on the important lessons I had learned on my journey so far. I felt no anxiety or pressure to find the answer . . . no desperate feeling about what was next. I felt in control.

"If this is where I now stand," I said, "then the question should be, 'What does that look like?'"

I dove into these thoughts and began the process of working them out in my mind, linking memories that could project an understanding of what this might look like on canvas. I again found myself staring into the stained silhouettes of Imagination Series that hung in the studio. As my mind began to unfold into the process, the silhouettes started to move about the canvas. They rotated in unison, flowing like a ring of fire, calling me as I fell in.

"I know the shape is looking into me. I know this place, I know this memory."

As quickly as it happened, the moment passed, and left me wondering if it really happened at all—or was it just my imagination? The only sign that it did happen was the impression I received, a memory brought to the forefront of my conscious. A piece of art I had seen many years before, one I had created before my first series . . . before anyone knew who I was.

It was a dark-colored silhouette stained into my pale textures, cutting deep into the canvas . . . only this piece did not have the multiple erratic shapes stained across the canvas, but just one silhouette in the intentional shape of an imperfect oval. Stained deep scarlet red in the middle of the canvas. The title I chose for this piece was Focus. I knew in that moment my life had truly come full circle; the coincidence was too surreal.

I immediately started with understudies, to get my feeling for the work ready for the canvas. This was quick—there was no new learning curve to conquer or explore this time around. I engaged in the same process as Imagination Series, breaking down the four elements of color, shape, depth, and movement—but instead of creating "sporadic consistency" across the canvas, I created "controlled consistency."

Everything—the shape, the color, the movement of textures, the demanding depth—moved in the same direction. The emotion wrapped up and flowed in harmony, the nature of its existence the same as Imagination Series, but controlled in an effortless calm, like the focus of fire flowing into shape, simply from your will to make it so.

Unlike Reality—the physical state of being—the Subconscious exists as the cognitive state of being. The information fed in by the Conscious Unconscious is fueled by emotion that stimulates the Subconscious. Fragments of memories are connected, creating a whole thought to which you can react, one you can contemplate and analyze. Now you are processing thoughts, mapping thoughts, connecting thoughts and making new ones, all being formatted and stored in the boundless space of the Subconscious.

When your perceived reality enters through your Conscious Unconscious, where it can be processed by your Subconscious, then sent back to your Conscious Unconscious and formatted into an acceptable understanding, then projected back out through all the layers and onto reality—you have come full circle.

HUMANITY'S SUSTAINABLE INFINITE
The Mechanics of Creation

Through the creation of my seven series, and my exploration of the creative process, I found a way to see, identify, understand, and explain that which I have always yearned to know. *Humanity's Sustainable Infinite (HSI)* is a working theory expressing the process of cognition within and among individuals through three fundamental points of cognitive evolution: experience, awareness and control.

THE SEVEN LAYERS OF COGNITION

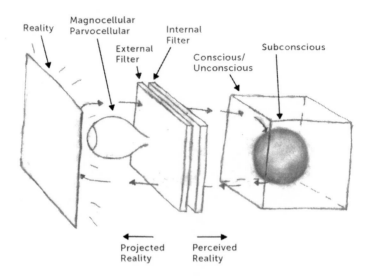

Diagram 0.1 The Seven Layers of Cognition in order of process.

Diagram 0.1 is a depiction of all seven layers in the order of cognition, constantly changing from one picture to the next in seamless fashion. The arrows indicate the direction of transmitted information and can be seen as two different categories. Information traveling from Reality to Subconscious is classified as *Perceived Information,* and the information traveling from Subconscious to Reality is classified as *Projected Information.*

Imagine a mirror as the Reality layer. As you look into the mirror, you decide to move your arm. You are perceiving the action while you are creating the action simultaneously. In an instant, you are seeing, knowing and reacting.

When information is perceived from Reality, filtered through all the layers and into the Subconscious, it is analyzed, stored and then reacted upon, sending new and updated information back out to be projected onto Reality. And the loop starts over when the next information is ready to be perceived.

THE ARC CONTINUUM

The first step was to reconstruct the Seven Layers of Cognition into a workable schematic for transferring information: two arcing hemispheres that create a continuous information transfer loop. Each hemisphere is a mirror image of the other; the only difference is the direction in which the information travels. One side is considered the *Projected Hemisphere*; the other, the *Perceived Hemisphere*. In Diagram 0.2, we see the Seven Layers of Cognition, with the pathways of projected and perceived information separated. The only two layers not divided into two hemispheres are the Subconscious layer and the Reality layer, as these two states of being—cognitive and physical—are considered to be transition points for information. These two layers act as the border between perceived and projected information.

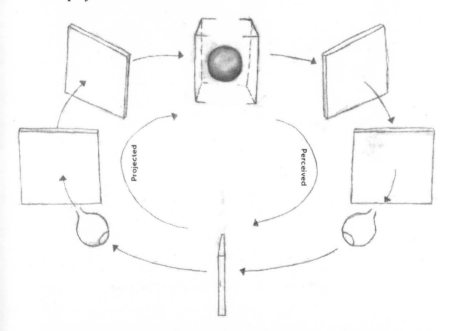

Diagram 0.2 The Seven Layers of Cognition divided into two hemispheres for directional cycle of information.

The containment of information capable of traveling in a loop is best proposed by the concept of fiber optics, in which a flexible cylindrical shape acts as a container for the transmittable information. Its ability

to bend light and/or signals is a practical example that opens the door to the possibility of this cognition thesis. Diagram 0.3 illustrates the applied concept. Each layer interacts with the traveling information and manipulates it, per each layer's specific function, until it reaches the Subconscious layer or Reality layer, where further processes occur.

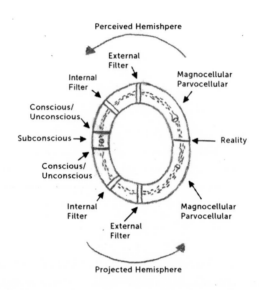

Diagram 0.3 Taking the seven layers into a working schematic with "fiber optic" ring (Arc Continuum), supporting two hemispheres of layers and a continual information feed.

In a practical sense, the performance of this Arc Continuum is identical to the understanding and process of the Seven Layers of Cognition.

The layers containing the sense impressions are the first to receive information. For our purposes, the sense of sight will be used in ongoing examples, which means the layers used are Magnocellular and Parvocellular. Much like the transmitters for Subconscious and Reality, they analyze the basic information through their functions. This information then reaches the External Filter and Internal Filter layers, at which point the raw information is altered—some blocked, some added—changing the raw information into data unique to the individual. At the end of this phase, the information reaches the Conscious/Unconscious layer.

All the layers are important and unique, however these layers are the only layers that can compute and transmit from both worlds (Subconscious and Reality). Essentially these layers are the gatekeepers for the Subconscious. The Conscious/Unconscious is the machine that translates the data into billions of ones and zeros so the Subconscious can make use of it ... breaking down Reality into fragments of thoughts, all the pieces that comprise the core data, the fundamental components of a memory. In the Subconscious, these fragments are stored and mapped in billions of sequences that overlap with other fragments of thoughts and memories, all capable of being triggered in billions of ways, creating links between thoughts connecting old to new thoughts, pulling old memories and creating new ones, by the simple act of receiving information as energy triggering these mapped fragments. As this is happening, it is simultaneously sending out updated information to the Conscious/Unconscious, where it is reconfigured and formatted into Reality (in a way that allows us to consciously react), projected back through the External and Internal Filters and through the sense impressions, then back onto Reality. Thus the Arc Continuum as a sustainable cycle is completed.

Here, we're speaking of a single arc (vision) from a single source (the eyes). But for human beings, there are six sources of information to be processed, through six senses: sight, touch, taste, smell, hearing—and the last sense impression, called the "sixth sense." This internalized feeling—an often inexplicable (and frequently accurate) intuition—is not always included in most scientific research, still considered a phenomenon in which things are felt, yet cannot be classified under the other five senses. The most recent research proposes that the "sixth sense" is located in the pineal gland; in a spiritual context, this is referred to as the "third eye." The suggestion that intuitive knowing exists as a sensory faculty is, at the very least, still a placeholder for knowledge we cannot prove.

SIX ARC CONTINUUMS

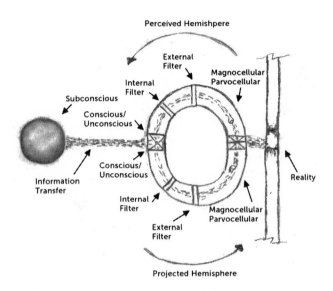

Diagram 0.4a Arc Continuum (Seven layers of Cognition schematic) with Subconscious and Reality outside of Arc Continuum.

Diagram 0.3 depicts only one sense impression, though the Arc Continuum also applies to the other five sense impressions. The Seven Layers of Cognition are assumed to be identical, yet each is unique in its ability to transmit and analyze incoming and outgoing information. It is directly because of these Six Arc Continuums that the concept of Subconscious and Reality exist outside of them. Assuming an evolved and more efficient layout, the need to have six Subconscious layers and six Reality layers becomes redundant. Instead, at each point of the Subconscious and Reality layers within each Arc Continuum are "transmitters," designed to receive and transmit to the "whole" Subconscious and Reality (Diagram 0.4a). As an example, imagine these transmitters are like prisms, breaking light into single-colored wavelengths, then back together into one beam of light (Diagram 0.4b). In this case, each prism (transmitter) is synced to each individual sense impression, picking up and transmitting only the information that is pertinent to itself, from Subconscious and Reality.

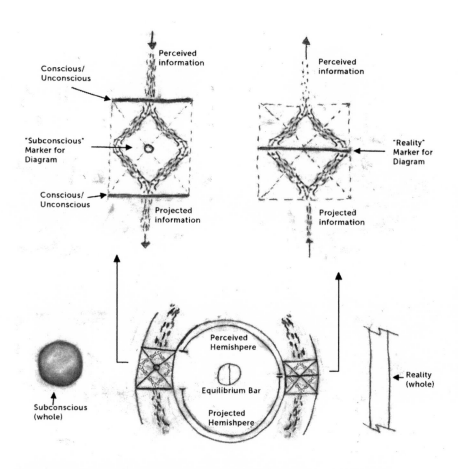

Diagram 0.4b Breakdown of Diagram 0.4 and the "transmitters" as prism-like receivers for information output and input.

Diagram 0.5 depicts the use of all Six Arc Continuums in conjunction with each of the six sense impressions, with transmitting "prisms" between the "whole" Subconscious and Reality. We also see a ring that loops inside each Arc Continuum. In Diagram 0.6, we get a closer look at this ring in a dissected side view of Diagram 0.5, labeled the Equilibrium Bar. Its sole purpose is to keep all arcs in equal alignment around Reality and equidistant from each another. If we were to look at Diagram 0.5 and give each object a magnetic polarity, then we can see the practical uses for the concept of the Equilibrium Bar (Diagram 0.7).

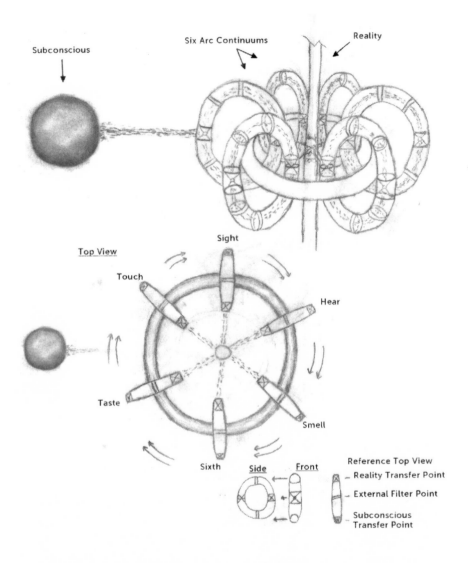

Diagram 0.5 Six Arc Continuums around Reality and outside of the Subconscious. Both Subconscious and Reality are now seen as interacting with, but separate from, the Arc Continuum.

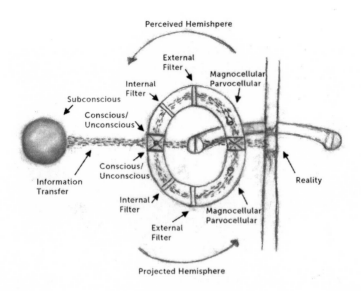

Diagram 0.6 Dissection with a look at the equilibrium and information transfer between Subconscious, Arc Continuum, Equilibrium Bar and Reality.

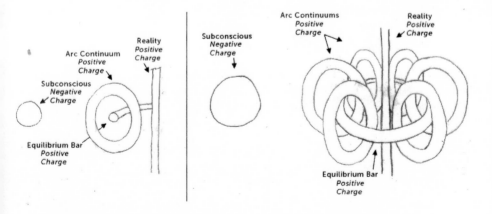

Diagram 0.7 Magnetic polarity between Arc Continuums, Equilibrium, Reality, and Subconscious.

Another element is the rotation around Reality of the Arc Continuums. This rotation allows the Subconscious to feed and receive information from all Arcs. Diagram 0.8 explores this concept by looking at it in

motion. Reality becomes active as all the Arcs spin around it, with overlapping information going in and coming out. When struck with information in this manner, Reality is created. At the same time, the Subconscious is able to send and receive information from all six Arc Continuums.

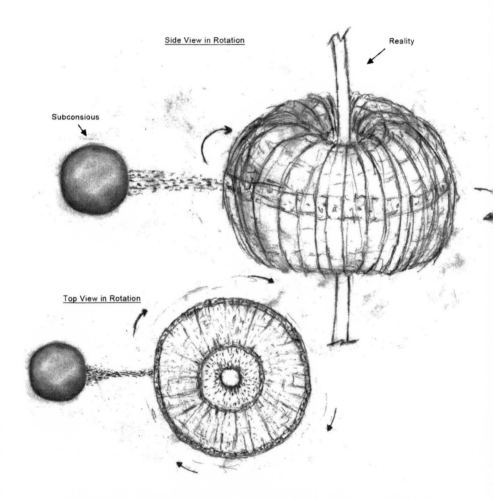

Diagram 0.8 Top and side view of all six Arc Continuums revolving around Reality and actively transmitting information between Subconscious and Reality.

In Diagram 0.9, we widen our view, and what we once saw as a straight line with regard to Reality is actually curved. And as we continue to pull

back, we realize that Reality actually orbits around the Subconscious; the concept of Humanity's Sustainable Infinite (HSI) begins to take shape (Diagram 1.0). We now see that there are three identical and fully operational sets of Arc Continuums we will now refer to as *Cognitive Orbs*.

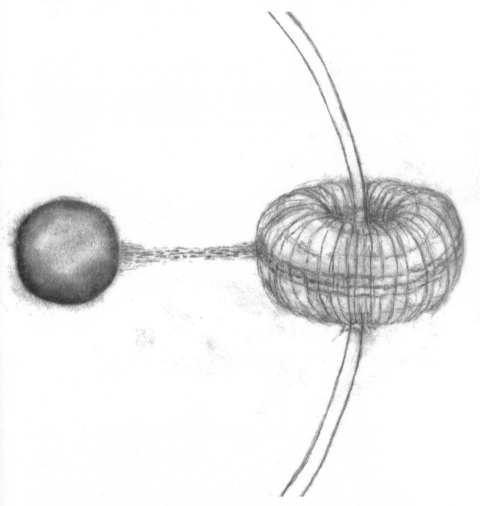

Diagram 0.9 Interaction of Subconscious and Cognitive Orb rotating around Reality. Full picture comes into view as we pull back.

Each of the Cognitive Orbs in Diagram 1.0 represent the three points of the process for HSI evolution. These three properties necessary for

completing a cycle of evolution are *experience, awareness* and *control.* This theory encompasses both the evolution of physical and mental occurrences; a cycle can be as quick as completing a simple thought, or as extensive and complex as a profound biological change. The scope of consequences are as delicate and extensive as the butterfly effect, ranging from an individual person to the entire sea of humanity. The logic behind the concept, and its ability to cover evolution in its entirety, is based on content and context, whereas the content may change over time, but the contextual process of existence is the same—that being the process of completing a full cycle. For a thought to occur, an experience must take place. Awareness of the experience provokes a choice from which a thought can spark a controlled reaction. At the very least, these three steps must take place. The Cognitive Orbs create the ability for a complete and sustainable being to evolve.

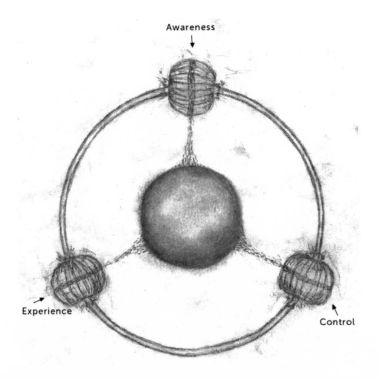

Diagram 1.0 Humanity's Sustainable Infinite with information transfer between Subconscious and Reality through three Cognitive Orbs.

The rotations of all components depicted in Diagram 1.1 move in a clockwise direction. However, to do so, the concept of a two-dimensional plane must not exist; depending on the view from which we observe the rotation, we will either see a clockwise or counterclockwise rotation. Therefore, we cannot assume any one view is from the top down or the bottom up; they are only relative to a fixed plane of existence we created, just as the fixed external directions North, South, East, or West make us unable to hold a "true" fixed position. The only points of reference we can accept are the objects themselves and the space between them.

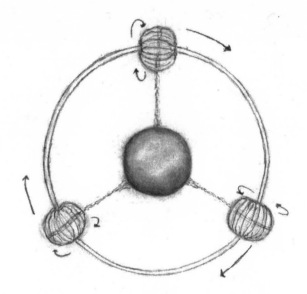

Diagram 1.1 HSI rotation.

INFORMATION TRANSFER: EXTERNAL AND INTERNAL FILTERS

How does each Cognitive Orb know it has made a complete revolution? Like the Equilibrium Bar balancing between the Subconscious Layer and Reality Layer, how do the Cognitive Orbs balance between themselves? We must consider a means of communication that creates an equilibrium between all three Cognitive Orbs; this happens through the Internal Filter

layer. which filters information within its Arc Continuum. It also receives and sends information to the other two Cognitive Orbs. In Diagram 1.2, we see a schematic of the complete information transfer through one of the Cognitive Orbs. The angle of each Internal Filter allows information

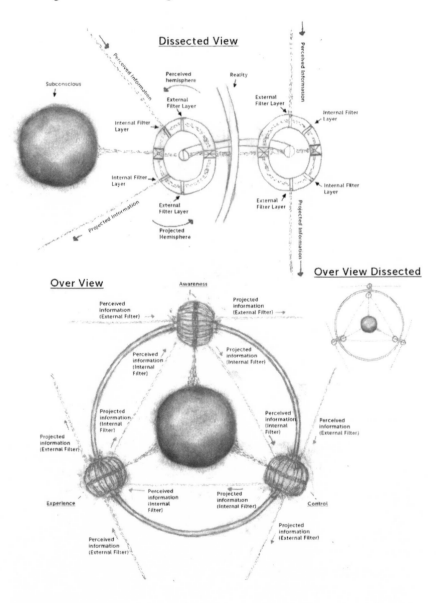

Diagram 1.2 Dissected view of complete information transfer. Adding Internal and External Filter transfer.

to be sent to the next Cognitive Orb. The process in the Internal Filter layer follows the rules applied to the two hemispheres of the orb: information can only be received in the *Perceived Hemisphere* and can only be sent through the *Projected Hemisphere*. The route of information follows the evolutionary path of HSI: experience>awareness>control>experience. Each must be in sync with the others, sharing information as it evolves. It measures the process of a thought, and is the way the orbs rotate around the subconscious in unison. When thinking of how this three-way process works, consider the technology of triangulating one's location using three points. The Internal Filter contains the ability to measure one's self, in comparison with the mental place of one's self, allowing information (thought) to travel and evolve through the process of experience, awareness, and control from each respective orb. Although at our core (Subconscious) these three points are connected, it is critical that on the "surface" there is a connective balance and measure.

The External Filter layer works in much the same way; however, the angle of approach from both the Perceived and Projected Hemispheres would suggest the information received and sent are not self-contained, but infer the accepted understanding of more than one "being." The way this works is in conjunction with the alignment of other HSI cognitive beings. This is further contemplated and deconstructed in the next section.

MULTIPLE COGNITION

We have seen the build of only one Cognitive Being through the HSI process of experience, awareness, and control. But we know there are billions of beings, all presumably functioning in the same manner. Like molecules aligning themselves in a pattern, a certain shape becomes repetitive in HSI. Diagram 1.3 shows the Subconscious layer and Internal Filter layer information transfer; it also shows how the External Filter layer communicates between surrounding Cognitive Beings. Just as the Internal Filter layers follow the rules of the Projected and Perceived Hemispheres, so does the External Filter layer. The key differences are that the information travels to others, as well as where the information is received and sent. Unlike the Internal Filter layer—which sends

information from experience to awareness to control, and back to experience—the External Filter layer sends to like Cognitive Orbs: Projected Experience to Perceived Experience, Projected Awareness to Perceived Awareness, and Projected Control to Perceived Control. The logic is that each point, whether at experience, awareness or control, are all at different levels of information.

Diagram 1.3 Information transfer within each individual HSI and with other individual HSIs.

When dealing with information transfers among others, the information needs to be at the same progression of understanding. As in the missed beginnings of a conversation, or an experience that hasn't been shared with others, the information being transmitted may need more context for those to perceive and understand it—else it can be lost in translation. It is generally harder to follow someone else's train of thought if you were not there at the beginning.

Diagram 1.4 expands our view yet again to see more Cognitive Beings in a molecular pattern. It is important to note that these models and their interactions between Cognitive Beings through the External Filter information transfer and the distance from one another are set in perfect alignment. When referring to the distance between each Cognitive Being, we can apply the concept of asymptotic freedom (in

Diagram 1.4 Expanded view of Diagram1.3.

which the strong force between quarks becomes weaker at smaller distances and stronger as the quarks move apart, which prevents the separation of an individual quark). As we have come to understand from previous diagrams, each component in the individual Cognitive Beings are in constant rotation around Reality and the Subconscious. Therefore, the information transfer of the External Filter will not always be in exact alignment with those that are directly adjacent. This opens the door for the limitless ability to send and receive External Filter information beyond the surrounding Cognitive Beings, where alignments will be made at some point.

HUMANITY'S SUSTAINABLE INFINITE

This isn't simply about the process of cognitive evolution, but a depiction of its existence within a human being in the cognitive state. The infinite isn't just a single repetitive loop; it is a continuum of the cognitive constitution, in which three points recur along an infinite spiral and form a triple helix. The three Cognitive Orbs are three points (experience, awareness, control) for us to express the complete and infinite self in a cycle of evolution and existence. Like the infinite loop along the spiral, when we evolve our cognitive thought, we move to a new plane of understanding. The content may change in the process of evolution, but the process does not. In this representation, the Subconscious is realized as an infinite "bar" in the middle of the spiral, Reality the infinite spiral looping around the Subconscious, and the Three Cognitive Orbs repeating themselves—just as we have seen in human DNA. The information transfer stays consistent: Reality to the Arc Continuums, Arc Continuums to the Subconscious, Internal Filter to Internal Filter within each individual being, and External Filter to the External Filter of another individual being. Diagram 1.5.

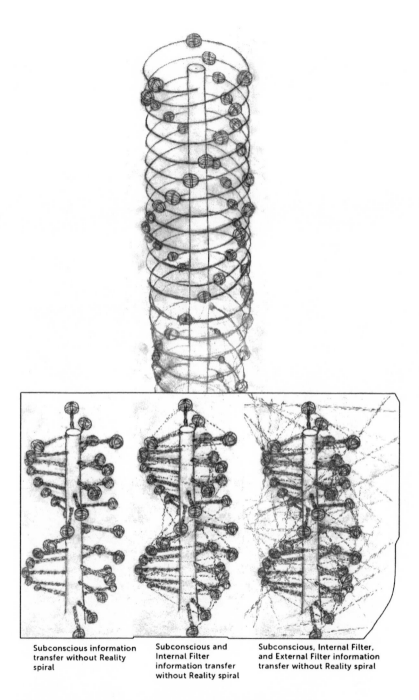

| Subconscious information transfer without Reality spiral | Subconscious and Internal Filter information transfer without Reality spiral | Subconscious, Internal Filter, and External Filter information transfer without Reality spiral |

Diagram 1.5 Image of single DNA and breakdown of information transfers with Subconscious, Internal Filters and External Filters.

222 Humanity's Sustainable Infinite

IN THE END, THERE IS THE BEGINNING

Walk a straight line in the physical state of being (Reality), and you will eventually end up where you started. In the cognitive state of being (Subconscious), Humanity's Sustainable Infinite expresses the same concept.

In both the Subconscious and Reality, there is infinite depth and expansion. Because of the concept of infinity, there is no truly defined direction; no up/down, left/right, backward/forward. There is only a relative concept of place, size, time, and direction around each individual. But if we let go of the relationship to ourselves, the physical state of being (Reality) and the cognitive state of being (Subconscious) become the same, as they are only products of the infinite.

The question becomes how to measure infinity in both Reality and the Subconscious on the same scale, where place, time, size and direction are found equally, relative to human perspective—yet remain infinite.

The discovery of the same repetitive shape found in the most minute objects, as well as the most massive entities, helps to answer this question. However, it is not the objects to be measured, but the formation for creating the tool of measure itself, bending what we know as a three-dimensional graph into its true form, representing the concept of infinity for Reality and the Subconscious.

Diagram 1.6 takes the three-dimensional plane into an infinite loop. The fourth dimension (time) is the relative measure for the space between. The infinite loop quantifies the unification of physical and cognitive states of being, linking between the relativity of space, with no constraints of size, place or time by any measure. Whether an object is physical or cognitive, it is the same; it is your perception that changes it. The size, the place, and the time one applies to the object is dependent on the individual's perspective.

Time is the space between, size is relative to perception, and place is relative to size, yet remains the same. No matter the direction, the turning point from the physical state to the cognitive state—ascending to descending, or vice versa—is realized as the farthest radial point, where the transition of arc takes place and is explained in HSI as the point of awareness.

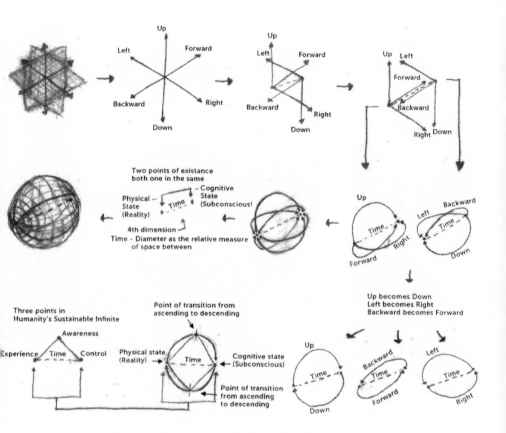

Diagram 1.6 Reconfiguring the concepts of measure relative to Subconscious and Reality. Compatible with HSI process (Experience, Awareness, and Control). Builds a foundation for Quantum Cognition and other related studies.

There is only one true fixed position for both Reality and the Subconscious, and that is the individual. We are the sole conduit between the worlds of stars and memories that float in infinite space. When we employ science, we are investigating the properties of creation. And when we manifest a work of art—a painting, a book, music, a film—we are engaged in the process of creation. Thus, the precise foundation from which we calculate is also the foundation from which we create. Both perspectives are eminently viable and, especially when used in balanced combination, are powerful instruments with which to develop human innovation and strengthen humanity.

Whether deciphering unified field theory or depicting an open field in a painting, Humanity's Sustainable Infinite offers a methodology about the process—from experience to awareness to control, and back again. The mechanics of creation put forth in HSI initiate the next level of conversation about the theory of quantum cognition, and is a compelling system for anyone who wishes to discover and understand their purpose in the world, so they may excel as a creative and productive human being.

ACKNOWLEDGEMENTS

Kim Jessup, to endure the life of an artist is both exhausting and emotional, but never boring. It seems intriguing to those outside looking in; but in reality, it's work, more than most are willing to give. I am so fortunate to have you in my life. As a ship, I must sail; but having a place to land calms me. You never waver, you're always there. This is home . . . a home I trust. A man can go to the edge of any frontier with just that single thought to hold on to . . . to give him comfort on his journey into the uncertainty of the unknown that calls him. Thank you for believing in me; I know that, without you, I would be but a dream forever lost at sea.

Alexandra Leh, this book needed someone who could be dedicated and invested. Not in me, but in the idea that is bigger than I am. It takes more than just an editor; it takes wisdom, patience, and an understanding about the importance of curiosity. This is what you gave to the book; to the idea that people like your father George Barnes fought for, struggled for, and never stopped believing in. Thank you for continuing his legacy by believing in this idea.

Family and friends, thank you for sacrificing the most valuable thing we have: time with, and time without.

Collectors, a dream is not possible to create alone. Thank you for entrusting yours with me, as I will always be there for yours.

Special thanks to . . .
Jose Marquez and Christian Alvarado
Evelyn Barnes
A.J. Costa
Naz Kaya Ph.D
Aaron Reissig

ABOUT THE AUTHOR

"Having a purpose is the most powerful incentive for anyone to move forward in his or her life. Without it, I'm not sure we are really living."

—JUSTIN GARCIA

Native Houstonian Justin Garcia learned as a young boy that he would succeed in life with a combination of self-reliance and an insatiable curiosity about his place in the world. In school, he received a solid foundation of practical knowledge. But his true purpose relentlessly beckoned, and when he renewed his commitment to painting, morning 'til night, by sunlight and flashlight, he discovered his artistic voice.

After producing and showing his first series, Garcia was encouraged by the warm reception he received from the art community, and continued developing his unique process. The evolution of his works began to gather greater recognition among collectors and art appreciators in Houston. Now, Garcia's works grace the walls of many prestigious spaces across the country.

Garcia believes that art is a vehicle for global transformation, and often donates his art, and his time, to charities. He creates art programs for young children, and teaches older students the business of art . . . all in the interest of supporting human connection through artistic endeavor.

With his first book, *One Ton Goldfish: In Search of the Tangible Dream*, Garcia "reaches into the abyss, finds courage for humanity," makes a potent connection between art and science, and encourages the reader to find their own purpose . . . as he says, "to rise above complacency and reach for more."